JOHN R. RASAVAGE

Silver Masters of Mexico

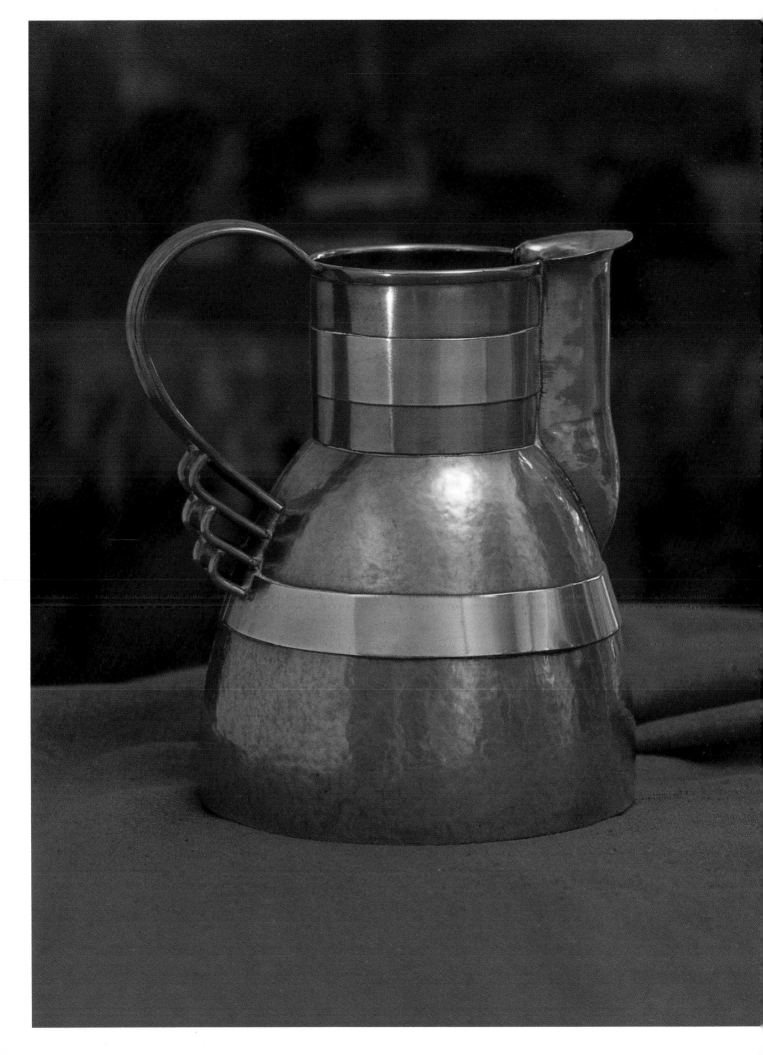

Silver Masters of Mexico

Héctor Aguilar
and the Taller Borda

Penny C. Morrill

77 Lower Valley Road, Atglen, Pennsylvania 19310

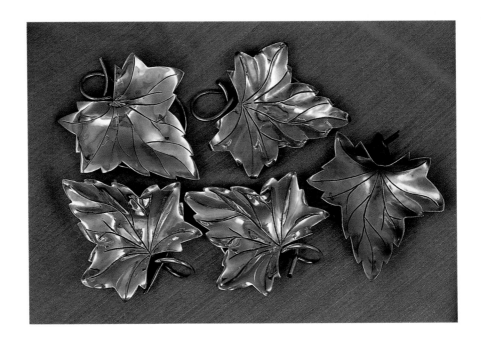

Héctor Aguilar *Four Silver Leaf
Dishes* (B) c. 1940 940 silver; *Brass
Leaf Dish* (R) c. 1940 brass
Collection of Gunther Cohn and Marc
Navarro

Graphic Design: Dick Markey, Frederick, Maryland

Photography: Eugenia Lebherz, McLean, Virginia

All photographs were taken by Eugenia Lebherz unless
otherwise stipulated in the caption.

Printed in Hong Kong
ISBN: 0-88740-961-X

Library of Congress Cataloging-in-Publication Data

Morrill, Penny C.
 Silver masters of Mexico; Héctor Aguilar and the Taller
Borda/Penny C. Morrill.
 p. cm.
 Includes bibliographical references and index.
 ISBN 0-88740-961-X (hard)
 1. Silverwork–Mexico–Taxco de Alarcón–History–20th
century. 2. Aguilar, Héctor. 3. Taller Borda (Workshop:
Taxco de Alarcón, Mexico) 4. Silversmiths–Mexico–
Taxco de Alarcón. I. Title.
NK7114.T39M63 1996
739.2'3772'73–dc20
 96-1984
 CIP

Published by Schiffer Publishing Ltd.
77 Lower Valley Road
Atglen, PA 19310
Please write for a free catalog.
This book may be purchased from the publisher.
Please include $2.95 for shipping.
Try your bookstore first.
We are interested in hearing from authors with book
ideas on related subjects.

Jacket Front: Héctor Aguilar *Seahorse Pin* (O) c. 1955
940 silver
Collection of Gunther Cohn and Marc Navarro
Jacket Back: Héctor Aguilar *Gravy Boat* (J) *with Tray* (T)
c. 1950-55 925 silver
Collection of Gunther Cohn and Marc Navarro
Héctor Aguilar *Carved Malachite Faces Necklace* (A) c.
1939 980 silver/malachite
Private Collection
Spine: Héctor Aguilar *Jaguar Head Pin* (B) c. 1940 990
silver
Private Collection
Frontispiece: Héctor Aguilar *Pitcher with Stepped Handle*
(R) c. 1945 994 copper/brass
Collection of Gunther Cohn and Marc Navarro
Title Page: Héctor Aguilar *Taller Borda and Coro Lilies of
the Valley Pins* (C/E) c. 1940-45 925 silver
Collection of Gunther Cohn and Marc Navarro

Contents

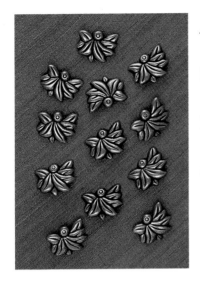

Héctor Aguilar *Twelve Flower Buttons* (B) c. 1940 940 silver
Collection of Peregrine Galleries

Héctor Aguilar *Pre-Columbian Brooch* (B) c. 1939 990 silver
Collection of Susan McCloskey

Dedication

This book is dedicated to the silversmiths, copper-smiths, administrators, designers, and artisans of the Taller Borda.

José Asención Monroy Duarte
Julio Carbajal López
Fuljencio Castillo Hernandez
José Luis Flores
Manuel Gutierrez Morales
Agustín Jacobo Rodriguez
Ermilo Jaimez Díaz
Bertoldo López García
Luis Reyes Ramirez
Benito Reyes
José Sagal Gómez
Eduardo Vizzuett Nova

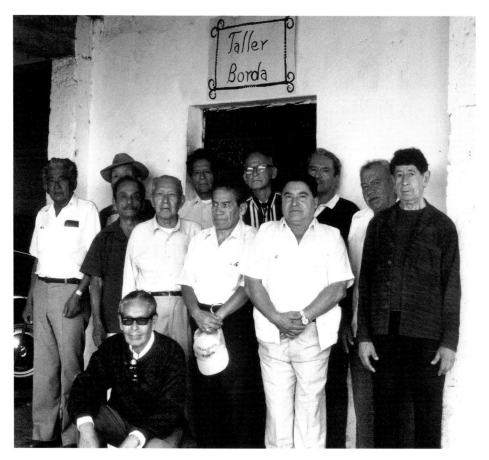

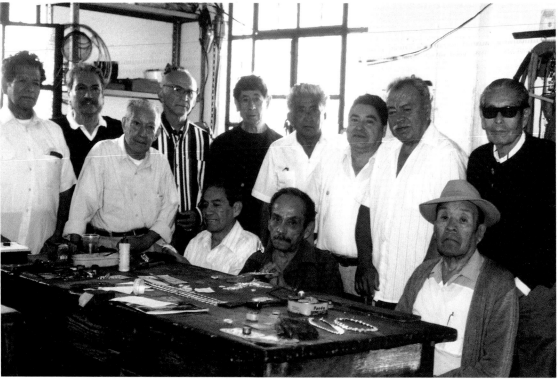

Silversmiths and Coppersmiths of the Taller Borda 1995
Photographs in the Collection of Penny C. Morrill

Acknowledgments

An author does not write in isolation. Scholars and record keepers become collaborators as the author researches what has already been written. Time given freely by interested new and old friends is as precious. In the case of *Silver Masters of Mexico*, support and enthusiasm came from family, the community in Taxco, and from a group of devoted collectors.

I am most fortunate to have as friends several people whose generosity is always unconditional. My appreciation is especially reserved for Stella and Fred Krieger, Luis Reyes, and Jaime Quiroz who were always happy to assist, no matter how many times I asked. Gene Lebherz, next-door neighbor and good friend, worked hard and creatively to produce the spectacular photographs for this book. I must also express my gratitude to Ron Belkin, Carole Berk, Jim Black, Jill and Byron Crawford, Leah Gordon, Federico and Ellen Jimenez, Chuck Kaplan, Andrés Mejia, Eric Salter, Cindy and Stuart Tietze-Hodosh, and Marlene Vitanza (Peregrine Galleries) for their enthusiasm and good faith.

In Taxco, Luis Flores and a group of silversmiths from the Taller Borda gathered to demonstrate silver techniques and to answer any questions I might have for them. It was a memorable afternoon, to have this group come together for the first time in over thirty years. My appreciation is extended to José Asención Monroy Duarte, Fuljencio Castillo Hernandez, Julio Carbajal López, Manuel Gutierrez Morales, Agustín Jacobo Rodriguez, Ermilo Jaimez, Bertoldo López García, Benito Reyes, Luis Reyes, José Sagal Gómez, and Eduardo Vizzuett Nova. I also want to thank Javier Ruiz Ocampo, the historian for the city of Taxco. What I have learned about Mexican silver haciendas is a result of the hours he has been willing to spend with me.

One of my favorite rooms in Washington, D.C. is the Columbus Memorial Library of the Organization of American States. My thanks go to Ken Gaulteau, Virginia Newton, Héctor Rocha, Miguel Rodriguez, and Stella Villagrán of the library for all their assistance. And one of the most beautiful spaces I have experienced is the Museo Dolores Olmedo Patiño in Xochimilco. I so appreciated the gracious hospitality and assistance offered me by Dolores Olmedo Patiño and Irene Phillips Olmedo de José.

I enthusiastically acknowledge the generosity and support of Yona Bäcker of Throckmorton Fine Art, Inc., New York; Margaret H. Bradford; Javier Castillo; María de los Angeles G. Castillo; the members of the Cartwright family and in particular Meli; Lolly Commanday; Roberto Cuevas Bárcenas; Richard L. Davies; Jan Duggan; Nancy Elby; Leslie Flynt; Anni and Ed Forcum of Rosebud Gallery; Charlotte Freeman of "Mollie's Sister"; Beatrice Fuchs; Antonio Gallegos; Thomas Guarrera; Dayle Kolbrenner; Jean Lawrence; Amador Lugo; Dick Markey; Tom McCloskey; Victoria Olson; Linda and Steve Nelson; Carl Pappe; Eva Carbajal Pérez; Virginia Redondo Pérez; Antonio Pineda Gómez; David Read; Orlando Rigono; William and Pauline Roed; Edwin J. Schwartz; Nauman Scott; Jamie Snow; Dr. Oscar Talavera Mendoza; Ezequiel Tapia Bahena; Christine Till; Jim Tracy; Alberto

Héctor Aguilar *Circular Flower Pin* (C) c. 1945 925 silver Collection of Leah Gordon

Ulrich; Tony Vaccaro; and Adriana Williams. I would also like to acknowledge the assistance of Mikka H. Gee at the Georgia O'Keeffe Foundation, Abiquiu, New Mexico; Lee Miller at Tulane University Special Collections; and the numerous people who were of assistance at the Library of Congress in Washington, D. C.

Gunther Cohn gave time and enthusiasm for the project. Questions were answered and problems approached with innovative solutions. As passionate collectors, Gunther Cohn and Marc Navarro have served as catalysts for the project. But I will allow them to explain:

"Over 20 years ago, our eyes were opened to the incredible world of twentieth century Mexican silver. Enamoured with its wonderful design, patterns, and construction, we began to carry the silver in our gallery. This in turn led to our collecting pieces which we consider particularly remarkable.

"As our collection increased, our interest became more focused on one name — Héctor Aguilar. We admire his designs for their beauty, structure, and execution. The intricate yet simple elegance, occasionally expressed with some humor, was what attracted us to this master. The quality of his work is equal to none.

"Then we met Penny and became instant Mexican silver soulmates. We expressed to her our idea of a definitive study of Héctor Aguilar and she concurred. We placed our entire collection at her disposal, and the many pieces we have so lovingly collected over the years are now well represented among the book's illustrations. Our reward is to help preserve Héctor Aguilar's art in this book for future generations.

"As devoted collectors, we find collecting a never-ending quest for which we are very grateful, since it means that out there somewhere there is more to discover, love, and enjoy in the work of Héctor Aguilar."

Bob Tarte and Rob Cartwright gave me a special gift — they returned to a place which had been very important in their lives and they allowed me the pleasure of accompanying them. What they had to say about the people they had known, about the Taller Borda and the hacienda was insightful and rich in meaning and sometimes really funny.

My family sent me off to Taxco three times over as many months. Thanks to Jim, Jackson, and Julia, my parents Dorothy and Jack Chittim, and my sisters Susan and Mary Jane for their willingness to share in the adventure. I am really grateful.

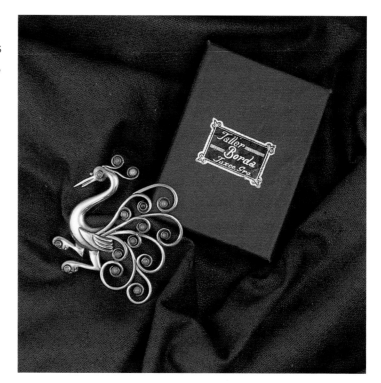

Héctor Aguilar *Peacock Pin, Original Box* (A/U) c. 1940 940 silver/ turquoise
Collection of Gunther Cohn and Marc Navarro

Introduction

The Casa Borda from the Plazuela de Bernal
Postcard in the Collection of Penny C. Morrill

This book is a gathering of memories. Recollections of Héctor Aguilar's presence at the celebration of a silversmith's saint's day. . . of nights on the porch of the Hacienda San Juan Bautista in complete darkness watching the light of fireflies. . . or the careful description by an artisan of a method that he had invented to solve a technical problem — these are the memories which, when brought together, present a picture of a distinguished and beautiful past.

In the mid-1930s, the lovely hill town of Taxco had become a destination for tourists and the center of a handwrought silver industry. William Spratling had inaugurated the Taller de Las Delicias in 1931, a group of workshops producing silver jewelry and objects, tinware, wool sarapes, and furniture. Spratling's success led to the development of other ateliers in Taxco.[1] In 1939, Héctor Aguilar, who was Spratling's workshop manager at Las Delicias, urged several of the silversmiths to leave the workshop and join him in a new venture.

Héctor and his wife Lois, with money of their own and the financial support of their friends, renovated the historic Casa Borda on the *zócalo* and outfitted a workshop and a store. Héctor was the principal designer and visionary who worked closely with the *maestros* [masters] and the other designers, Valentín Vidaurreta and Gabriel Flores. Under the supervision of the *maestros*, the artisans produced objects from the designers' ideas. Lois, with a staff of administrators, provided practical guidance and was responsible for pricing the objects and managing the store.

For almost twenty-four years, this community of silversmiths, carpenters, designers, leatherworkers, administrators, and coppersmiths worked together to achieve success. Today most of these artisans continue to be active as silversmiths in small talleres in their homes. They were the ones who were willing to reconstruct the story of the Taller Borda. Everyone who was interviewed looks back on his years in the Taller Borda as productive and happy. In fact, many remember that time as "the golden age."

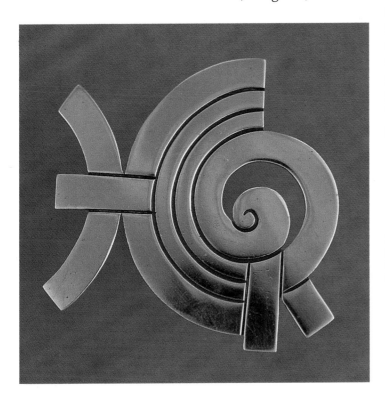

Héctor Aguilar *HA Pin* (J) c. 1950
940 silver
Collection of Gunther Cohn and Marc Navarro

Even though they are no longer living, Héctor and Lois Aguilar, Valentín Vidaurreta, the silversmiths Pancho Galindo, Reveriano Castillo, and others remain present in everyone's minds and their contributions live on. The Casa Borda and the Hacienda San Juan Bautista are still standing and have new uses, although both are in need of extensive repair. The copper and silver jewelry and objects hallmarked *HA* are still admired, worn, used, and avidly collected. In Taxco, the hundreds of silversmiths and *maestros* who started out as apprentices in the Taller Borda have known the satisfaction that comes from a life devoted to the pursuit of beauty.

[1] See *Mexican Silver* by Penny C. Morrill and Carole A. Berk.

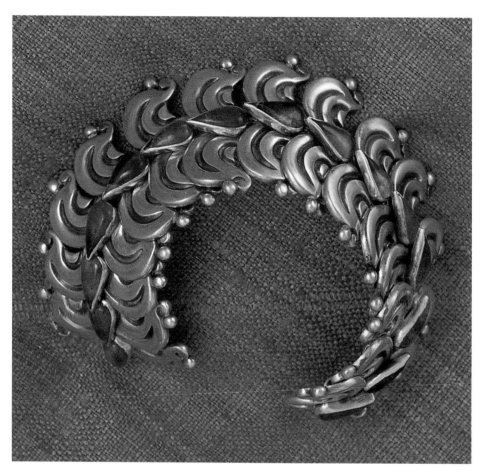

Héctor Aguilar *Hinged Curved Amethyst Bracelet* (F) c. 1945 925 silver/amethyst quartz
Collection of Gunther Cohn and Marc Navarro

Hallmarks of the Taller Borda

There is a surprising number of hallmarks for the Taller Borda. Most of them are based on the original *HA* with minor variations. According to Héctor Aguilar's stepson Rob Cartwright, the evolution of the hallmarks was more a factor of creative license than forethought. The cylindrical tool with the raised stamp at one end was made by hand, resulting in subtle changes to the hallmark over the years.[1] Dates have been assigned to different marks, but always with an overlapping of years to compensate for the time a stamp might have been used before it was retired.

Throughout the book, the name of the designer is given first in the photograph's caption. What follows is the name used by the workers and administrators at the Taller Borda to describe the object. Letters indicate the marks on the pieces that are pictured, and dates of manufacture and silver content are also provided.

Each of the Taller Borda hallmarks presented in this book has been assigned an alphabetical letter. If the silver or copper piece was not given a hallmark, no letter will appear in the caption. In these cases, where there was no hallmark, an attribution of the object to a designer was made by the author after taking into consideration information gleaned from interviews. When the jewelry or decorative piece was made by a designer outside the Taller Borda, the letter will not appear but is replaced by a description of the hallmark.

[1] Rob Cartwright, interview by Penny C. Morrill.

Héctor Aguilar's signature
Courtesy of Rob Cartwright

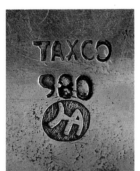

A 1939-40
The earliest hallmark is an *HA* in a circular indentation. The word *TAXCO* and the number representing the silver content (usually 990 or 980) are struck without indentation.

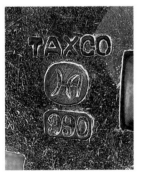

B 1940-45
Beginning in 1940, the indented circle with *HA* appears with rectangular indentations for *TAXCO* and for the silver content number or the word, *STERLING*. If the silver content is above 940, the piece is early.

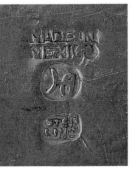

C 1940-45
The indented circle with *HA* and rectangular indentations for *TAXCO* and the silver content appear with *MADE IN MEXICO*.

11

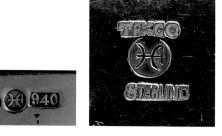

D 1940-48
The winged *HA* is in a circular indentation. *TAXCO* and *940* or *STERLING* are indented and appear on either side of the *HA*.

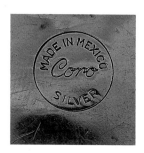

E 1943-50
Coro inscribed in script is in the center of a circle. Above are the words, *MADE IN MEXICO*, and below, the word *SILVER*.

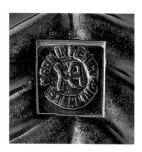 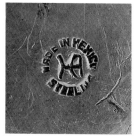

F 1943-48
The *HA* appears in a circle with *MADE IN MEXICO* above and *STERLING* below. This mark resembles the Coro hallmark.

G 1943-45
There are two hallmarks on the Army Air Corps wings produced at the Taller Borda: *HA* in a circle with *MADE IN MEXICO* above and *STERLING* below, and the words *NATL SILVER CO.* in capital letters.

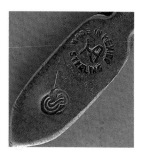

H 1943-48
The *HA* in a circle with *MADE IN MEXICO* above and *STERLING* below is occasionally accompanied by the hallmark, *JB. JB* may have been the mark of a North American company that had a contract with the Taller Borda because it appears not only on jewelry designed by Héctor Aguilar, but also on one of the Army Air Corps insignia.

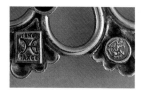

I 1948-55
This particular detailed eagle or "*quinto*" was struck with one of the earliest dies ordered from Germany. The hallmark for the Taller Borda has the flared *H*, with the *A* barely indicated. The *940* is above the *HA* and *TAXCO* is below.

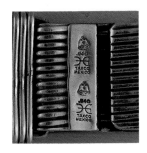

J 1948-62
This hallmark is prevalent on later pieces and appears with an eagle. Within a rectangular shape is *940*, the flared *HA*, and the words *TAXCO MEXICO* printed in capital letters. The silver content *940* is replaced by *Sterling* when this mark appears on holloware.

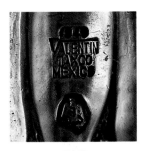

K 1948-62
The eagle is stamped with the rectangular hallmark of *940* and *TAXCO MEXICO*, but instead of *HA*, the mark is *GF* or *Valentín*.

L 1948-62
The rectangular hallmark made up of *940*, the flared *HA*, and *TAXCO MEXICO*, appears with an eagle stamp and the words *TALLER BORDA* in capital letters.

M 1948-62
The rectangular hallmark consisting of *940* and *TAXCO MEXICO* and appearing with the words, *TALLER BORDA*, is used when the *HA* is replaced by either Gabriel Flores's (*GF*) or Valentín Vidaurreta's (*Valentín*) hallmark. Regardless of who the designer was, the eagle number is always 9.

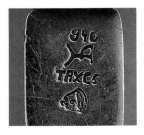

N 1948-62
On cufflinks, rings, or small pins, the eagle stamp appears with a tiny rectangular mark which reads, *TAXCO* above, *HA* and *940* below.

O 1955-62
This slightly askew *HA* has the *940* above and *TAXCO* printed in capital letters below. This rectangle appears with or without an eagle stamp.

P 1948-62
The old indented hallmark, *TAXCO*, the winged *HA* in a circular indentation, and the silver content, are accompanied by an eagle stamp.

Q 1949-55
The words *TALLER BORDA* are next to *Sterling, Taxco* in a circle.

R 1939-62
The *HA* in an indented circle can appear on copper and brass either alone or in various combinations with the words *TAXCO, MEXICO*, or the number *994* for copper content.

S 1939-62
The *HA* is branded into wood.

T 1949-55
This hallmark, which consists of an eagle 31 and the words *Hecho en Mexico* around *925*, resembles the Conquistador mark.

U 1939-62
The *Taller Borda* label which was used on the store's packaging was taken from the wrought iron sign on the facade of the Casa Borda.

V 1940-45
This hallmark, consisting of the *HA* in a circular indentation with the words *Silver Mexico*, is rarely seen.

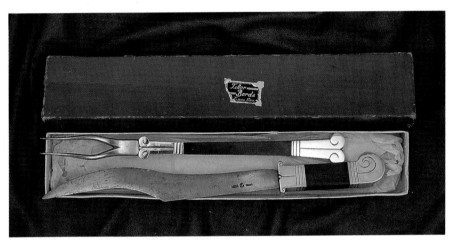

Héctor Aguilar *Carving Set in Original Box* (fork– O knife – C box – U) c. 1945-55 silver/ebony
Collection of Carole A. Berk, Ltd.

RELATED HALLMARKS

Manuel Altamirano - *Altamirano*
Carlos Castillo — *CC*
Pedro Castillo — *PC*
Reveriano Castillo — *RC* or *Reveri*
Conquistador — shield with rider astride a horse or the word *Conquistador*
Roberto Cuevas — *R within a C and a separate B*
Gabriel Flores — *GF*
José Luis Flores — *JLF*
Dámaso Gallegos — *DG*
Enrique Ledesma— *Ledesma*
Gustavo Martinez— *GM*
Manuel García Martinez — *Manuel* or *MGM*
Rafael Melendez — *RM*
Alberto Díaz Ocampo — *ADO*
Horacio de la Parra — *Parra*
Antonio Pineda:
 1. *AP* 1941-49
 2. *Jewels by Toño* 1949-53
 3. *crown mark* 1953 to the present
Lorenzo Rafael — *LR*
Rancho Alegre — *Rancho Alegre*
Melecio Rodriguez — *MR*
Valentín Vidaurreta — *Valentín* or *VV*

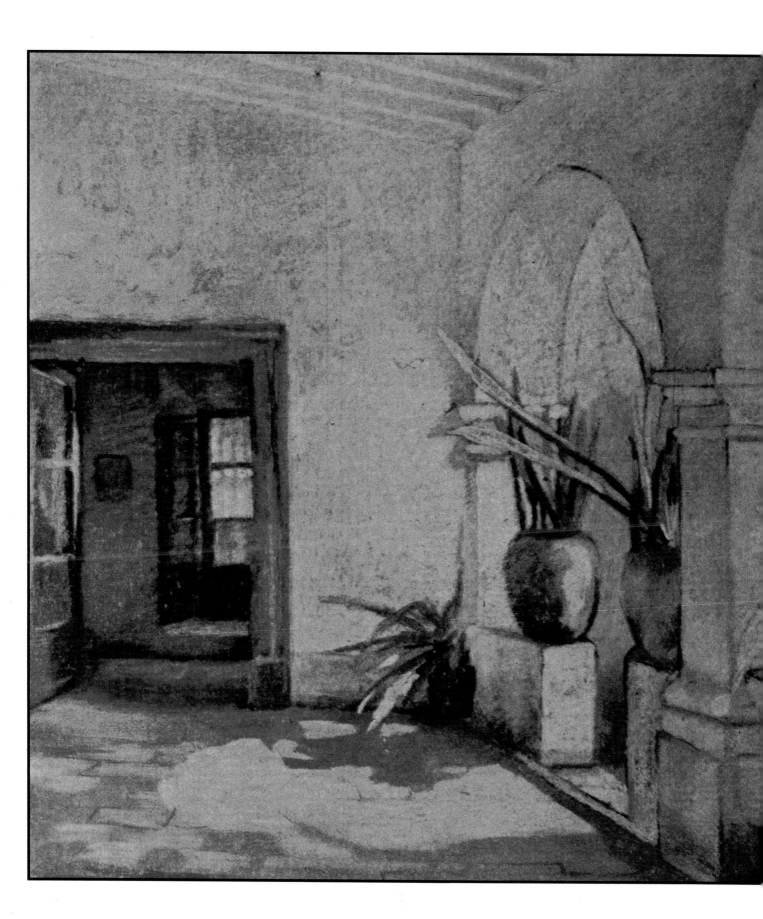

CHAPTER I

Héctor Aguilar

I-1 Valentín Vidaurreta *A Cuernavaca Patio* December 1930 cover of *Mexican Life*
Courtesy of the Columbus Memorial Library

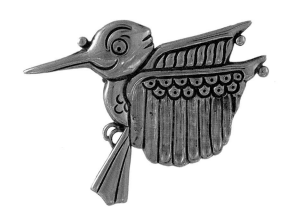

I-2 Héctor Aguilar *Hummingbird Pin* (D) c. 1940 940 silver
Collection of Gunther Cohn and Marc Navarro

Héctor Aguilar

Héctor Aguilar was born on the eve of All Saints' Day on October 31, 1905, into a prominent family. His father served as Mexican Consul to Texas during the Mexican Revolution. His mother Celeste Ricketson had come from San Francisco, where, according to family legend, she had lived through the great earthquake. She was a Scot on her father's side and is said to have been a member of the Castro family, one of the oldest Spanish dynasties in California.[1]

Héctor grew up with his two sisters Celeste and Beatriz and brother Rolando in the town of Teziutlan near Puebla.[2] The family compound was a large square-shaped colonial structure centered around a courtyard where carriages arrived after passing under a massive portal. The family lived on the upper floors above the offices and storerooms that served as the center of an extensive agricultural trading business.

I-3 Héctor Aguilar *Grasshopper Pins* (B/I) c. 1940-50 940 or 990 silver
Collection of Gunther Cohn and Marc Navarro

Héctor received his education in Mexico City, where he was living when he met Lois Cartwright. He was working as a portrait and landscape photographer, with a penchant for photographing colonial haciendas. At the same time, he was traveling all over Mexico as a tour guide for Aguirre Guest Tours. Young men from his social class were inclined to enter this vocation because it provided an opportunity for travel and required a knowledge of history, art, and archeology. Héctor lived a carefree lifestyle, distinguishing himself as the first person to ride from Mexico City to Acapulco on a motorcyle, an adventure which almost cost him his life. On one of his trips, he was involved in a serious accident in which the motorcycle's gearshift punctured his leg and caused such severe hemorrhaging that he came close to bleeding to death before he was rescued.

THE AGUILARS MEET

In the winter months of 1935, Lois Cartwright left Kansas to tour archeological sites in Mexico, a subject which had always interested her. After losing her husband the year before in an oil field drilling accident, Lois wanted time away from the constant reminders of the tragedy. While on tour, she and Héctor met and fell in love, and were married late in 1935 in Mexico City. On March 20, 1936, Lois signed the guest register at the Hotel Taxqueño as Mrs. Héctor Aguilar.[3] Héctor was hired to manage the workshop in Taxco for the acclaimed silver designer William Spratling, whom he had gotten to know when he had brought tour groups to Spratling's Taller de Las Delicias.[4] The Aguilars found a house to rent in Taxco above the Plazuela de Bernal and sent for Lois's two children Bunny and Rob eight months later.

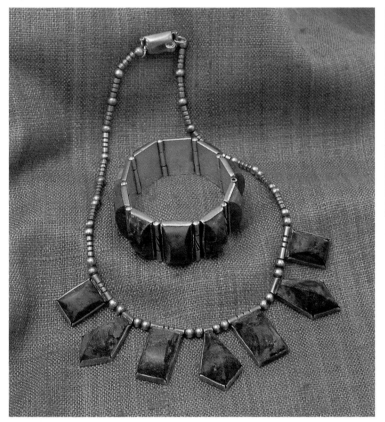

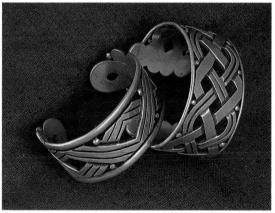

I-5 Héctor Aguilar *Double V Cuff* (B) c. 1940 940 silver; *Intertwined Curved X Cuff* (B) c. 1940 990 silver Collection of Gunther Cohn and Marc Navarro

I-4 Héctor Aguilar *Necklace* (D/I) *and Bracelet* (I) c. 1950 940 silver/malachite Collection of Gunther Cohn and Marc Navarro

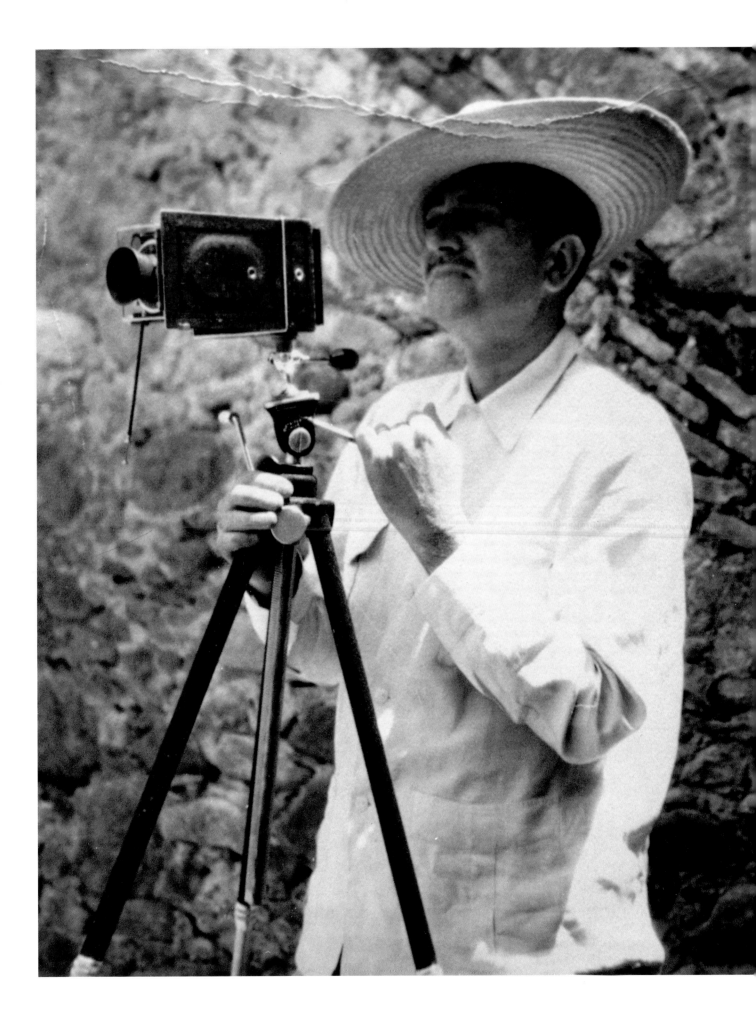

Héctor and Lois began construction on their home, the Casa Aguilar, a year after moving to Taxco. They worked together on the design but may have had some assistance from Valentín Vidaurreta, who was building his own colonial-style house on the Calle de Estacas. The Aguilars had purchased the lot from Pedro Galindo who ran a bakery next door and whose son Pancho later became a master silversmith in the Taller Borda. Another neighbor, Natalie Scott, with whom the Aguilars would share a common wall, had finished her house several years earlier.

The Casa Aguilar was built in double adobe. The wooden entry gate in the high adobe wall (Pl. I-8) led into a small garden with a fountain. The garden entrance into the house was beneath a covered porch, where meals were served when the days were pleasant (Pl. I-9). The living room was about thirty feet long, with a masonry fireplace and window architraves and recessed wall shelves of carved wood. Up the stairs were two bedrooms and baths, and at the end of a short hallway, a terrace and Héctor's photography studio where he did his own developing and enlargements. About 1940-41, Héctor began having his film developed in Mexico City, and the studio was converted into his son Rob's bedroom. Valentín Vidaurreta was commissioned to paint a mural in the stairwell, a luxuriant jungle scene with a waterfall. Unfortunately, the mural was painted over after the Aguilars sold the house.

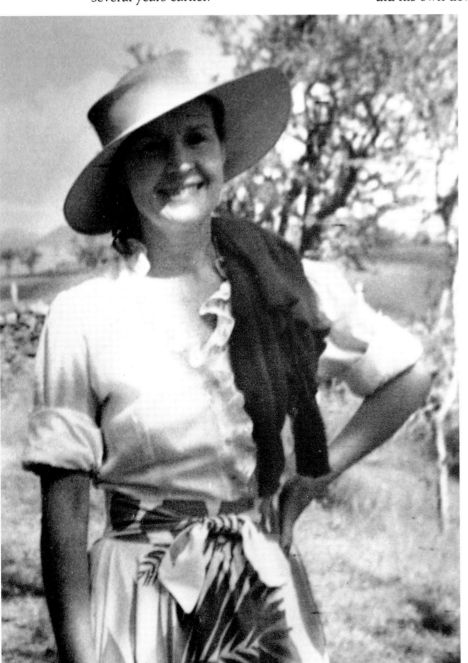

I-7 *Lois Cartwright Aguilar*
Photograph in the Collection of Rob Cartwright

Opposite page:
I-6 *Héctor Aguilar at his Camera*
Photograph in the Collection of Rob Cartwright

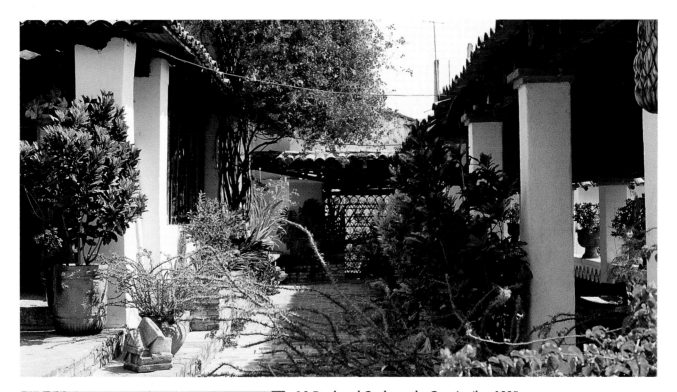

I-9 *Porch and Garden at the Casa Aguilar* 1995
Photograph in the Collection of Penny C. Morrill

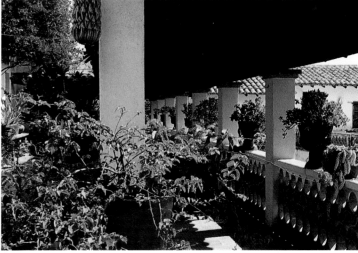

I-8 *Garden Entry Gate of the Casa Aguilar* 1995
Photograph in the Collection of Penny C. Morrill

I-10 *Columned Portico in the Garden of the Casa Aguilar* 1995
Photograph in the Collection of Penny C. Morrill

THE TALLER BORDA

When Héctor Aguilar joined Spratling's Taller de Las Delicias in 1937, the business had reached a level of unprecedented success. After only seven years, the workshop William Spratling had founded in 1931 had grown from one silversmith and a handful of teenage assistants to nearly one hundred artisans. Spratling had created a large-scale industry based on good design and fine craftsmanship and had developed a marketplace for the handwrought jewelry and objects in silver he designed and produced. He masterminded a workshop system in which young men could start out as *zorritas*, running errands for the silversmiths, and eventually grow in technical and aesthetic understanding to become *maestros* of their craft. Spratling's concern was, in his own words, "to create a tradition where none had existed, but always keeping within a style which had a right to exist in Mexico."[5] In the spirit of the Revolution of 1910, Spratling found inspiration for his designs, not in European forms, but in the newly valued art of Mexico's Pre-Columbian past (Pl. I-11).

What Spratling built became the foundation for the success of many others in Taxco, including Héctor Aguilar. He had set the stage for growth and thus made room for other creative people. In 1939, the Aguilars put together the $20,000 that Lois had received at the time of her former husband's death with financial support from their friends Kim and Tamara Schee and Valentín Vidaurreta to establish the Taller Borda. In a letter dated November 30, 1939, Natalie Scott writes, "Do you remember my next-door neighbors, the Aguilars? Héctor was Bill's shop-manager, you know. They decided to go into business for themselves. The Schees are backing them financially, and they are to open a store about the tenth of the month. Héctor is planning to stock all kinds of things."[6]

Lois and Héctor each brought something important to their partnership. Héctor was talented as a draftsman and designer and was respected for his leadership. Lois was a skilled manager who took on financial

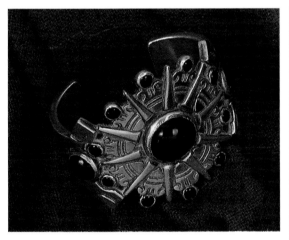

I-11 William Spratling *Heavy Aztec Sun Cuff* (oval Spratling Silver. Spratling, Made in Mexico around WS) c. 1944 980 silver/obsidian
Collection of Penny C. Morrill

I-12 William Spratling *This Pre-Columbian Necklace strongly resembles the ensembles by Héctor Aguilar in Plates I-44, 103.* (oval Spratling Silver. Spratling, Made in Mexico around WS) c. 1944 980 silver/obsidian
Collection of Carole A. Berk, Ltd.

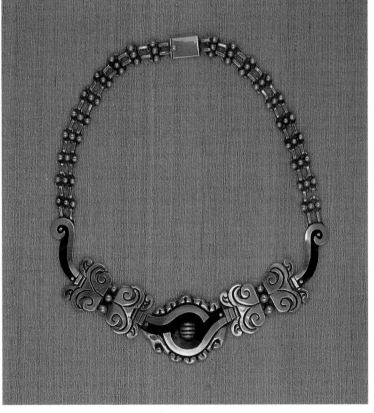

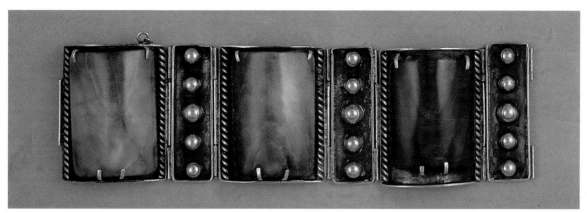

I-13 Héctor Aguilar *Large Green Stone Bracelet* (A) c. 1939 980 silver/
jadeite
Private Collection

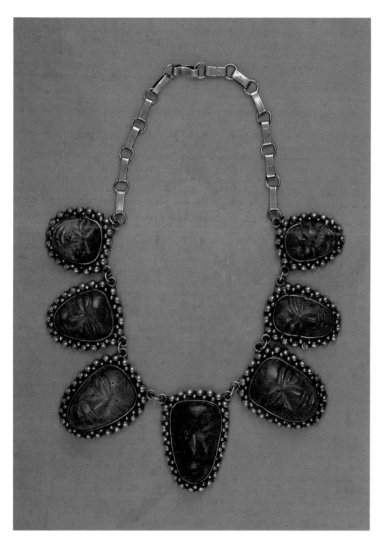

I-15 Héctor Aguilar *Olmec Head Bolo* (L) c. 1955 940
silver
Private Collection

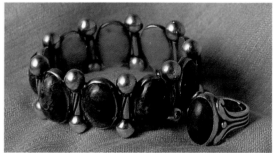

I-16 Héctor Aguilar *Bracelet and Matching Ring* (B) c.
1940 940 silver/malachite
Collection of Penny C. Morrill

I-14 Héctor Aguilar *Carved Malachite Faces Necklace* (A) c. 1939 980
silver/malachite
Private Collection

oversight of the new enterprise. According to Lois's son Rob Cartwright, "My mother was definitely a guiding force in my father's life. She recognized his ability and convinced him that he could work on his own."[7]

In 1939, Doña Guadalupe Martinez Vázquez put the imposing eighteenth century residence, the Casa Borda, up for sale to pay for her daughter Vicki's elaborate wedding in Mexico City and reception at the elegant Club France in Coyoacan. Héctor Aguilar was able to acquire the historic building from Doña Guadalupe for 85,000 pesos. It became the remarkable setting for the Taller Borda.[8]

The Casa Borda was originally the private residence of the great mining engineer and philanthropist Don José de la Borda. Borda had made a fortune mining silver in Taxco, and in gratitude to God and to the Taxqueñians, he commissioned the extraordinary Church of Santa Prisca in 1751. The year that the church was finished, 1759, Borda built the house for himself and the priests on the north side of the town square (Pl. I-19).

This mammoth structure encompassed two residences around a central courtyard, which is divided by a wall. Built into the side of the hill, there are four floors on the back of the building which faces the Plazuela de Bernal and two floors on the front, so that the third floor is actually at ground level on the *zócalo* (Pl. I-17). In his book, *Tasco*, architectural historian Manuel Toussaint points out the stylistic disparity between the two facades. In his view, the rear of the building resembles a Spanish or Italian medieval palace, with its massive wall supported by buttresses and the windows positioned with little thought to symmetry. In contrast, the measured formality of the facade is expressed in the carved stone pilasters and door and window architraves and the stucco ornamentation.[9]

In 1931, Manuel Toussaint commented in his book on the ruinous condition of the Casa Borda (Pl. I-18) which he considered "one of Tasco's most valuable jewels."[10] It was fortuitous that the house was purchased by the Aguilars in 1939. Their love of colonial architecture inspired them to

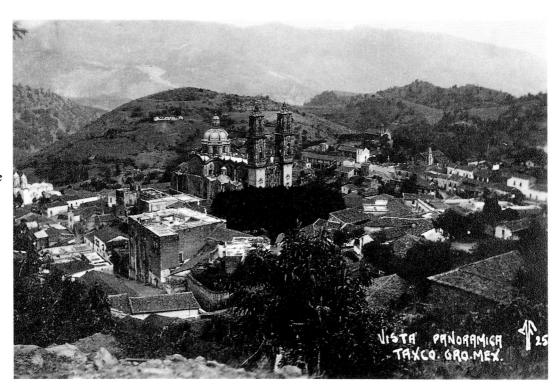

I-17 *The Casa Borda is the Large Square Structure to the Left of the Church of Santa Prisca. Note the Opening in the Roof for the Central Courtyard.*
Postcard in the Collection of Penny C. Morrill

restore the building appropriately and to bring life back to its historic spaces. No doubt that is why the Casa Borda remains standing today.[11]

The Taller Borda occupied the eastern half of the building and was organized around the courtyard. The entrance on the *zócalo* was marked by a wrought iron sign and led into a large showroom (Pl. I-20). Multi-faceted mirrors reflected the light from copper lanterns and the wall shelves displayed copper and silver trays, candlesticks, and bowls. Long tables were covered in black fabric to provide the best setting for the silver jewelry and objects. Héctor's office was behind the cashier's window at the back of the display room (Pl. I-21).[12]

Most of the workshops were on the third floor at the same level as the showroom. A leather workshop produced quantities of purses and belts with silver buckles (Pl. I-22). It was phased out during the Second World War, and the area was used as a showroom or an extension of the silver division.

The largest space on the north side was dedicated to the production, by hand, of silver jewelry and objects. Hundreds of necklaces, brooches, bracelets, and earrings were made in a week, many as ensembles, and were kept in production as long as they were selling well. Designs by Héctor Aguilar that remained popular for many years were the fertility bracelet (Pls. I-23-24), the Aztec flower cuff (Pl. I-25), and the lyre ensemble (Pl. I-26). The involvement of the mind and hand of the artisan is apparent in each one of these necklaces or bracelets. Even though the Aztec flower cuff was produced over the lifetime of the Taller Borda, slight variations define each bracelet as a unique creation.

I-19 *The Facade of the Casa Borda* c. 1954
Photograph in the Collection of Robert D. Tarte

I-18 *Market Day on the Zócalo in Front of the Casa Borda* c. 1935
Photograph, Inscribed "To the Sutherlands from Anita Brenner,"
Taken by Hugo Brehme
Collection of Dorothy S. Chittim

Héctor was fascinated by the technical challenges presented by the construction of a bracelet or necklace. The hinges, especially for his bracelets, were so unique that *Popular Mechanics Magazine* featured a diagram for the *libro macizo* [solid book] bracelet (Pl. I-32). Greta Pack and Mary L. Davis wrote in *Mexican Jewelry*, "The construction of his jewelry is always interesting. A good example is the bracelet of alternating balls and flat units with concealed swivel hinges, a bracelet which has been copied many times by other silversmiths but which originated in the Aguilar shop."[13]

I-20 *Silver and Copper on Display* c. 1954
Photograph in the Collection of Robert D. Tarte

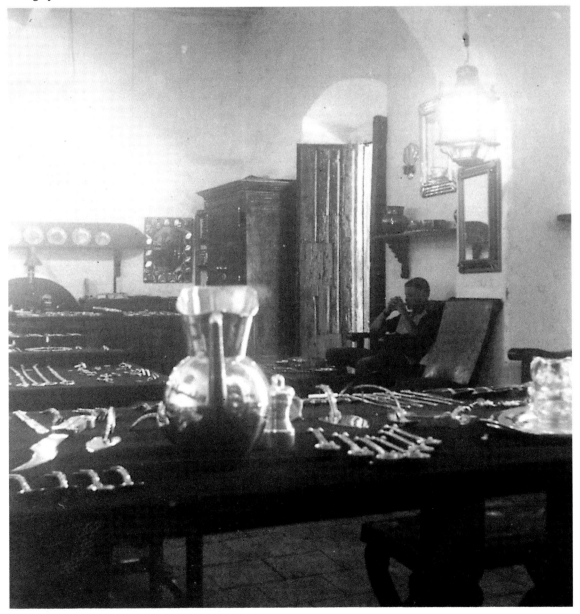

I-21 *The Cashier's Window in the Taller Borda Store* c. 1954
Photograph in the Collection of Robert D. Tarte

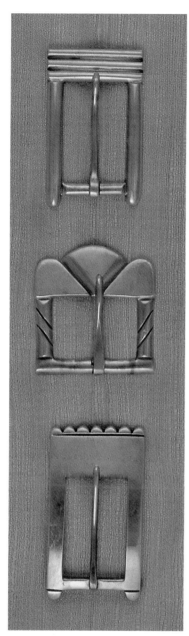

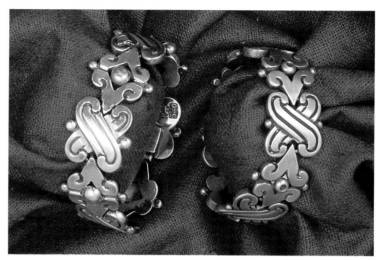

I-23 Héctor Aguilar *Fertility Bracelets with Dimpled or Dome Dots* (B) c. 1940 940 or 990 silver
Private Collection

I-22 Héctor Aguilar *Banded Rectangle and Scalloped Edge Buckles* (D) c. 1945; *Fan Buckle* (B) c. 1940 940 silver
Collection of Gunther Cohn and Marc Navarro

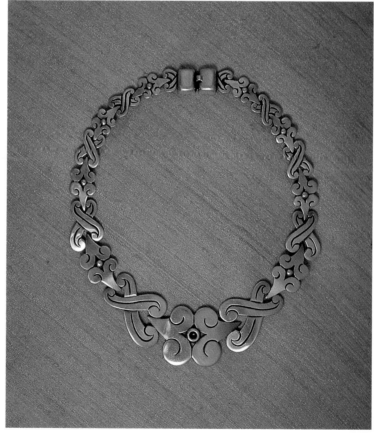

I-24 Héctor Aguilar *Fertility Necklace* (I) c. 1950 940 silver
Collection of Penny C. Morrill

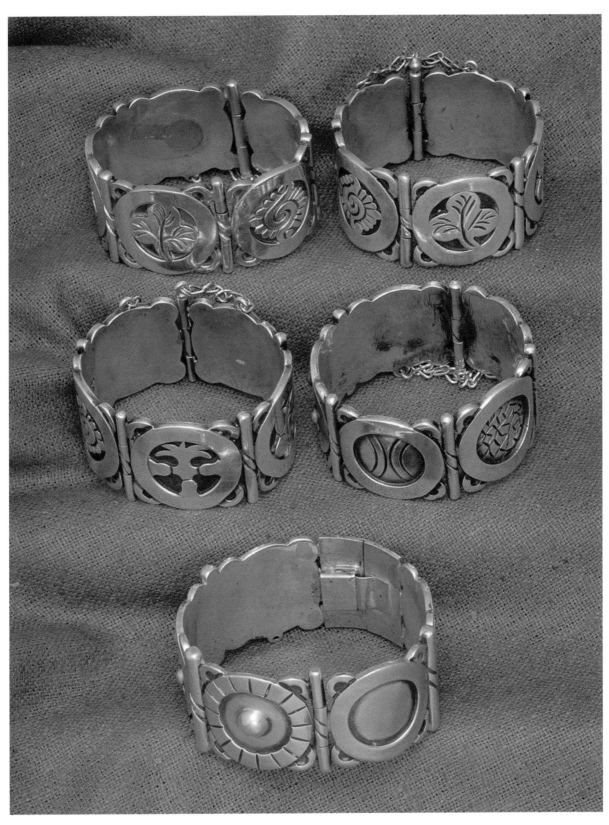

I-25 Héctor Aguilar *Aztec Metal Symbols Cuffs and Aztec Flowers Cuffs* (A/B/
L) c. 1940-55 940 silver
Collections of J. Crawford, Gunther Cohn and Marc Navarro, and Frederick
and Stella Krieger; Private Collection

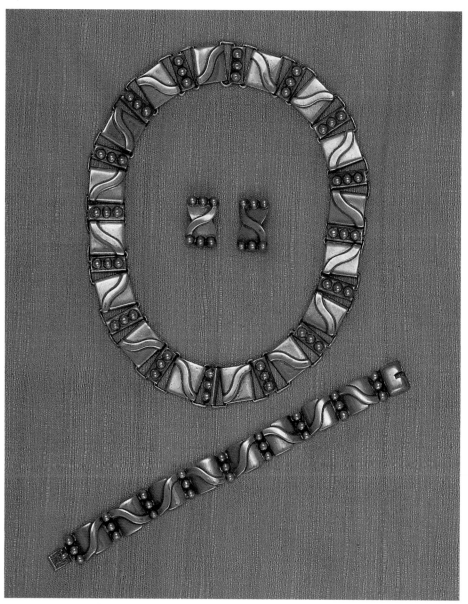

I-26 Héctor Aguilar *Lyre Necklace, Bracelet, and Earrings* (B) c. 1940 940
silver
Collection of Gunther Cohn and Marc Navarro

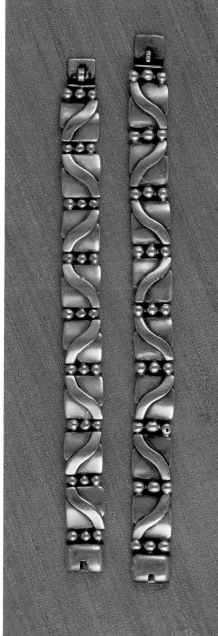

I-27 Héctor Aguilar *Two Lyre Bracelets* (B) c.
1940-45 940 silver
Collection of Lolly Commanday

Héctor Aguilar had a distinctive style which remained consistent but never static. The powerful impact of his jewelry, holloware, and flatware can be attributed to his manipulation of line. Whether a brooch or necklace was a simple composition of circles and triangles, or a representation of animals and plants from nature, Héctor found delight in heavily formed, contorted, twisting, overlapping lines. The thick gauge and purity of the silver heightened the strong, almost organic quality of his jewelry and decorative objects, as in the jewelry ensemble in Plate I-44. The bird pin (Pl. I-34), an exotic interpretation of a Pre-Columbian image, was produced in the simplest technical format. The design was cut out of a flat sheet of silver, with no embossing or *repoussé*. What distinguishes the composition is the uncompromising abstraction and decorative pattern of line. This characteristic is at the heart of Héctor Aguilar's ability as a designer.

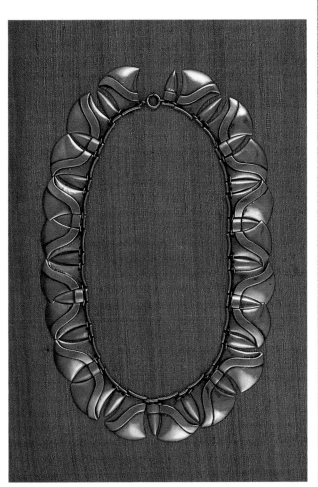

I-28 Héctor Aguilar *Lyre Necklace* (B) c. 1940 990 silver
Collection of Gunther Cohn and Marc Navarro

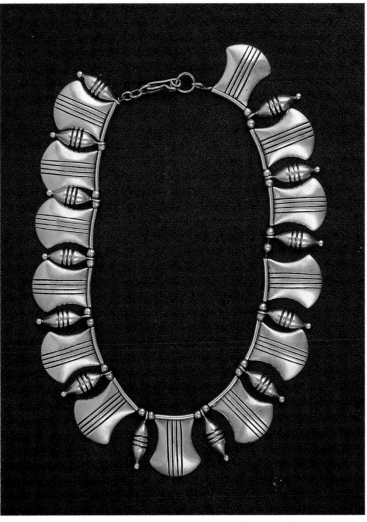

I-29 Héctor Aguilar *Tubular Drops with Curved Squares Incised Necklace* (B) c. 1940 990 silver
Collection of J. Crawford

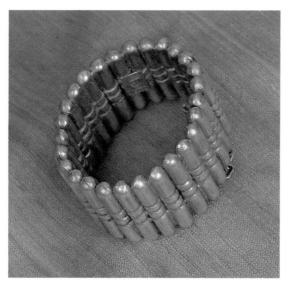

I-30 Héctor Aguilar *Large Tubular Cuff* (C) c. 1940
925 silver
Collection of J. Crawford

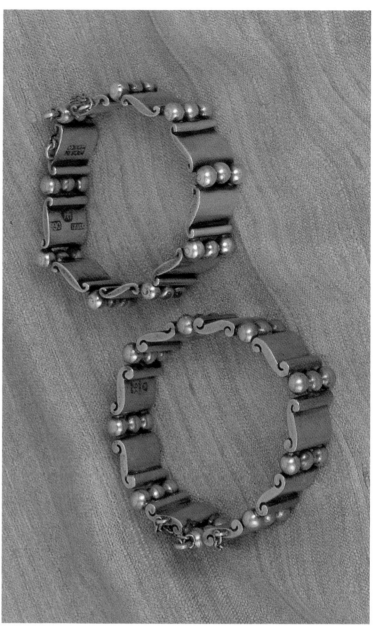

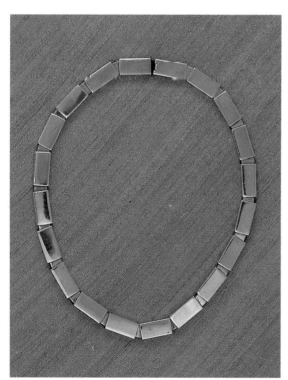

I-32 Héctor Aguilar *Book and Three Beads Bracelets* (O) c. 1955 940 silver/
goldwash; and (C) c. 1940 990 silver
Collection of Gunther Cohn and Marc Navarro; Private Collection

I-31 Héctor Aguilar *Necklace with Invisible Hinges* (J) c.
1955 940 silver
Collection of Gunther Cohn and Marc Navarro

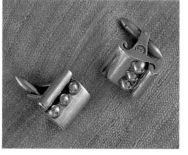

I-33 Héctor Aguilar *Book and Three
Beads Cufflinks* (N/J) c. 1955 940
silver
Collection of Frederick and Stella
Krieger

Overlooking the Plazuela de Bernal were the copper and carpentry workshops. Originally the carpenters' shop and iron-works were at ground level in the open courtyard, where wrought iron objects were produced at a charcoal forge, with bellows and an anvil (Pl. I-41). Scraps of silver were also melted down in the forge and rolled into sheets, using a small German rolling mill in an adjacent room. Access from the lower level was by way of a spiral staircase that has since been removed (Pl. I-42).[14]

I-36 Héctor Aguilar *Copper Mirror with Spiral Forms* (R) c. 1945 copper/glass
Collection of Gunther Cohn and Marc Navarro

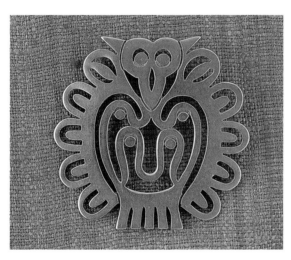

I-34 Héctor Aguilar *Bird Pin* (I) c. 1950 940 silver
Collection of Gunther Cohn and Marc Navarro

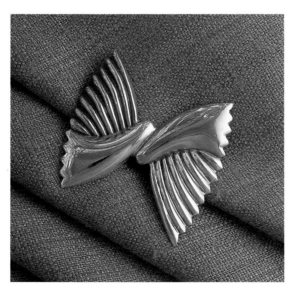

I-35 Héctor Aguilar *Bow Pin* (B) c. 1945 940 silver/copper
Private Collection

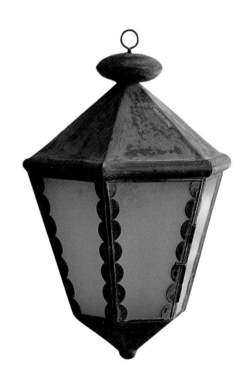

I-37 Héctor Aguilar *Copper Lantern* (R) c. 1945 copper/glass
Collection of the Cartwright Family

I-39 Héctor Aguilar *Copper Sugar and Creamer* (R) c. 1950 copper
Collection of William and Pauline Roed

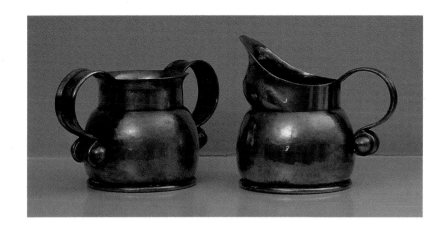

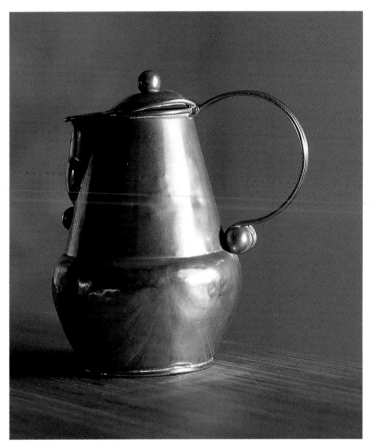

I-38 Héctor Aguilar *Copper Pitcher* (R) c. 1945 copper
Collection of Ronald A. Belkin

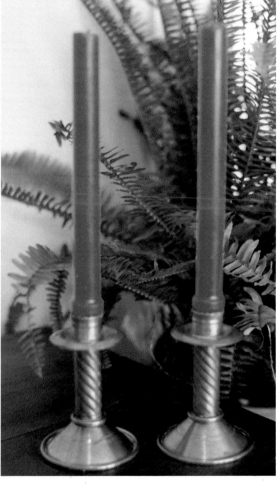

I-40 Héctor Aguilar *Copper Candlesticks* (R) c. 1940 copper
Collection of Dorothy S. Chittim Photograph by Tom McCloskey

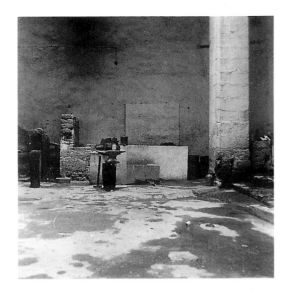

I-41 *The Courtyard at the Casa Borda* c. 1954
Photograph in the Collection of Robert D. Tarte

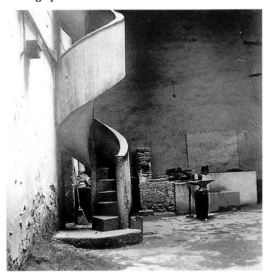

I-42 *The Spiral Staircase in the Courtyard* c. 1954
Photograph in the Collection of Robert D. Tarte

I-43 *The Third and Fourth Floors in the Casa Borda's Courtyard* 1995
Photograph in the Collection of Penny C. Morrill

During the Second World War, the entire lower floor was turned over to machine production. Héctor Aguilar sold half the Casa Borda to go into partnership with Gerald Rosenberger, owner of Coro, a North American costume jewelry company. The Taller Borda expanded considerably to produce military insignia and silver costume jewelry on a large scale. The circular Coro hallmark appears on pins, bracelets, and necklaces made from 1943 to right after 1950 when Héctor ended the partnership.[15]

The Aguilars had an apartment and library on the second floor where they could stay when the river overflowed and blocked the road to the hacienda at Taxco el Viejo. Elegant apartments on the fourth floor were rented out to North Americans who came down to Taxco for extended stays (Pl. I-43). One of the Aguilars' guests, Robert McCloskey, the author of *Make Way for the Ducklings*, wrote *Blueberries for Sal* while living at the Casa Borda.[16]

35

In 1952, Lois and her daughter Bunny opened their own shop in the southwest corner of the Casa Borda. What had been Don Donato's pool hall and bar became a gallery of four rooms with large archways, displaying silver by Valentín Vidaurreta, Bill Spratling, and Héctor Aguilar. Lois also carried "Maja," ceramic tableware which was hand-painted by Maja Gruebler, a Swedish artist in Mexico City. The Aguilars' nephew Robert D. Tarte remembers that Spratling's double serpent pendant, the ebony bracelet with silver dots, and the hands necklaces were displayed in the front showroom. In 1953, his parents bought the Spratling "Aztec duck" spoon, marked with the Conquistador shield and eagle stamp, in the store.[17]

Six years earlier, right after the war, Lois had owned a shop with her sister-in-law Beatriz Aguilar de Carriles at a very fashionable address in Mexico City, 29 Avenida F. L. Madero, a block up from Sanborn's.[18] The partnership only lasted about two or three years, whereas the shop in the Casa Borda continued to be successful until the closing of the Taller Borda in 1962.[19]

The silver designs that emanated from the Taller Borda enjoyed widespread popularity. In describing a party given at her house in the early forties, Rosa Covarrubias, the wife of well-known artist and author Miguel Covarrubias, wrote, "Inside we always use bright red table cloths or mats, yellow Talavera pottery dishes and our best citron vaseline glasses imported from the U. S. A. in Victorian times. The silver comes from the renouned [sic] Taxco silversmiths William Spratling, Hector Aguilar, and Frederick Davis."[20] A friend of Rosa's, Georgia O'Keeffe, was photographed in 1960 wearing the X-belt (Pl. III-26). According to Tony Vaccaro, who took the picture, "Silver was her metal.

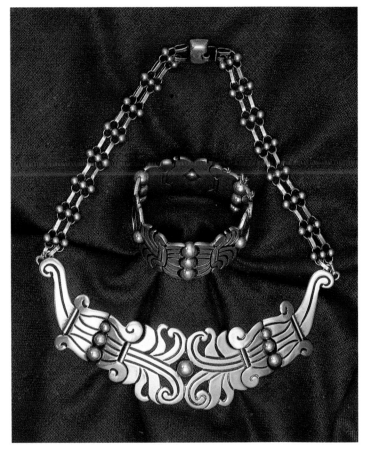

I-44 Héctor Aguilar *New Maguey Necklace* (B) c. 1940; *New Maguey Bracelet* (J) c. 1950 940 silver Private Collection

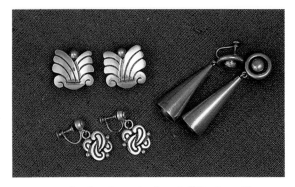

I-45 Héctor Aguilar *Long Pendant Bell Earrings* (J) c. 1955; *Interlocked Curves Earrings* (A) c. 1940; *New Maguey Earrings* (O) c. 1950 925 or 940 silver Collection of Gunther Cohn and Marc Navarro

She never wore gold or diamonds; instead she loved the silver against black which she mostly wore. The X-belt was a favorite, but she had many pieces of Mexican silver—rings, bracelets, necklaces."[21]

The Taller Borda shop was also recommended in many of the travel books in the 1940s and 1950s. Right before the workshop was closed, Héctor's flatware and holloware were photographed with the Maja ceramic tableware for Verna and Warren Shipway's book *Mexican Interiors.* The Shipways also published copper mirrors and lamps from the taller. Even after the close of the workshop in 1962, Héctor's designs continued to appear in books and magazine articles describing Mexican silver.[22]

According to Rob Cartwright, Héctor was friendly with the guides who came to Taxco because he had known many of them when he himself was giving tours. He paid a commission if a guide brought a tour group into the Borda. The guide would stand in the center of the store and give a presentation on the history and wonders of the Taller Borda, and when he had finished, the tourists were given time to shop.[23]

Part of the shop's success also resulted from the quiet efficiency of Luis Reyes, its manager. Robert Tarte remembers that "it was he who, more than anyone else, represented the Taller Borda to the thousands of casual tourists who walked through over the years. On a typical day, Luis opened the store; arranged the items on the tables; and was in charge effectively all day long. He spoke English well and could talk about technical and aesthetic aspects of the pieces; took the time to explain receipts and customs matters; offered and arranged packaging and shipping; and graciously fielded the great variety of questions that his congenial manner elicited from the tourists regarding everything from the history of Taxco to the best places to have a meal. He was a great asset to the business."[24]

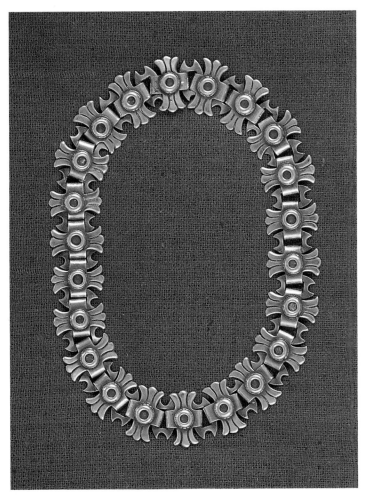

I-46 Héctor Aguilar *Pre-Columbian Necklace* (B) c. 1940 990 silver
Collection of Ronald A. Belkin

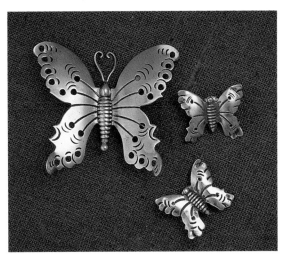

I-47 Héctor Aguilar *Butterfly Pin and Earrings* (B) c. 1940 940 silver
Collection of Gunther Cohn and Marc Navarro

Lois's choice of merchandise for the store reflected her good taste, business sense, and the friendships she had made. She and William Spratling had been in business together once before. In the late 1930s, the only place to get a drink in Taxco was at a cantina, so Lois and Bill put up the money and established the Bar Paco. They hired Paco Arredondo from Mexico City to act as bartender and manager while they retained ownership anonymously for about five or six years. They commissioned Hubert Harmon, the irrepressible and inventive silversmith and artist, to decorate the walls (Pl. I-48).[25] The murals were described in a letter dated February 24, 1944, from Freddie Jennison, who was living in Taxco, to Natalie Scott, while she served in the Red Cross during the war: "They [the murals] are very clever if slightly unsuitable for the place. Burros that are quite human, two dancing ones with lush Mae West bosoms and one doing the splits that looks just like

Tamara and another that is like little Patsy Heine. None of the nice Mexican girls are allowed up there by their families any more and the other day they had a wedding breakfast there and Enrique went about hanging calendars over the objectionable parts!"[26]

Héctor Aguilar owned a silver mine near Taxco with the Schees and Enrique Carriles, his brother-in-law, a venture which lasted only a short time because it was not successful.[27] Héctor involved himself in civic duties which included his participation as adviser to the Board of Conservation of Colonial Taxco. In 1943 he was one of the founders

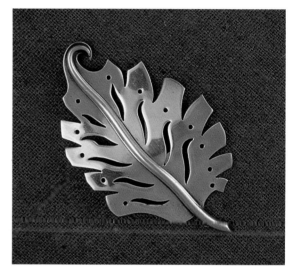

I-49 Héctor Aguilar *Leaf Pin* (J) c. 1955 940 silver Collection of Gunther Cohn and Marc Navarro

Below:
I-48 *The Donkey Paintings by Hubert Harmon at Paco's Bar* Collection of Penny C. Morrill Photograph by Jackson F. Morrill

I-50 *Eagle Stamp and the Taller Borda Hallmark from the Leaf Pin*

of the Union of Silver Industrialists in the Mexican Republic and later served as its president.[28] The mission of the Union was to organize the silver industry by bringing order to the exportation process, regulating the wholesalers, and by reducing government fees and duties. A primary goal was to reestablish the official use of the *"quinto"* from colonial times, the eagle mark on silver indicating its purity (Pl. I-50). The Union also appealed to the government to regulate the commissions paid to tour guides who brought tourists to the silver shops. Of equal importance was the effort to protect the integrity of a silversmith's designs in the formation of the Union de Diseñadores [Union of Designers].

A committee was formed with representatives of various government agencies, including the newly created Cámara Nacional de la Industria de la Platería

[National Council for the Silver Industry]. The result was the Ley de Contraste de la Plata de la Secretaría de Economía [Law for the Hallmarking of Silver from the Department for the Economy], which stipulated that all silver, sterling or better, must be marked. Héctor Aguilar wrote a description of the law in his book, *Artesanía de la Plata*:

"The law establishes that in order to sell a work in silver hallmarked with the eagle [*quintada*], it must contain a legal measure of 0.925 of the metal. In order to obtain the "*quinto*," or assayer's mark, one must approach the Assayer's Office with the pieces, where they are weighed, struck with the eagle stamp, and the fixed tariffs are paid when the weight is proven to be of the required legal measure.

"Some workshops of recognized integrity are granted the use of their own *troquel* or punch by means of a bonded guarantee, in which case a government inspector periodically visits the stores of these workshops with the object of obtaining samples for the purpose of taking collective measurements, and thus determining compliance to the legal measure of purity."[29]

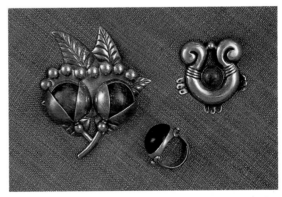

I-52 Héctor Aguilar *Two Fruits Amethyst Pin* (F) *and U-shaped Pin* (C) c. 1945-50; *Amethyst Ring* (I) c. 1950 925 or 940 silver/amethyst quartz
Collection of Gunther Cohn and Marc Navarro

I-51 Héctor Aguilar *V-chain Necklace* (B) *with Amethyst Pendant* (D) c. 1945-55 940 silver/amethyst quartz
Collection of Penny C. Morrill

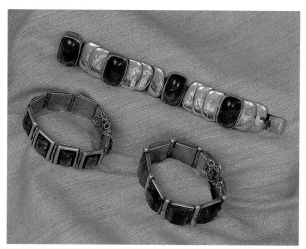

I-53 Héctor Aguilar *Square Amethyst Bracelet* (C) c. 1940; *Amethysts with Silver Rounded Squares Bracelet* (F) c. 1945-50; *Large Square Amethyst Bracelet with Tubular Hinges* (B) c. 1940 925 or 940 silver/amethyst quartz
Private Collection

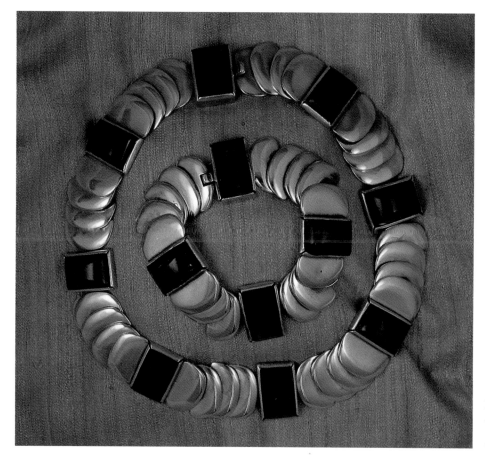

I-54 Héctor Aguilar *Rectangular Amethyst Necklace and Bracelet* (J) c. 1955 940 silver
Collection of Linda and Steve Nelson

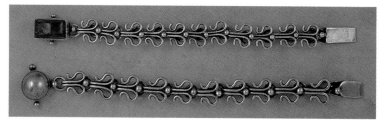

I-55 Héctor Aguilar *Wire Bracelets with Amethyst or Dome Clasp* (F) c. 1945-50 925 silver/amethyst quartz
Private Collection

THE HACIENDA
SAN JUAN BAUTISTA

The biographical sketch in Héctor Aguilar's *Artesanía de la Plata* [Art of Silver], which he wrote after leaving Taxco, provides a summation of what he must have considered his most important achievements. He is described as the founder and personal administrator of the Taller Borda where hundreds of silversmiths and artisans were trained. His designs in silver won several first and numerous second prizes in the annual competition which occurred during the Fiesta de la Plata [Silver Festival]. Given equal significance was his extensive restoration of the Hacienda San Juan Bautista in Taxco el Viejo. He spent eighteen years renovating and furnishing this sixteenth century silver hacienda.[30]

Valentín Vidaurreta had owned San Juan Bautista in the thirties and had done some minor work, cleaning out the debris and constructing a roof over a portion of the residence. In 1945, Héctor Aguilar bought a half-share and three years later bought out Valentín.[31] The hacienda, twenty miles south of town on the road to Iguala, became a weekend retreat and an ongoing project for Héctor and Lois. They continued to live in town until 1950 when they sold the Casa Aguilar and moved out to the hacienda. Héctor took photographs of the hacienda over several years, chronicling the progress of the restoration. These photographs reflect the deep appreciation Héctor had for the historicity and beauty of San Juan Bautista.[32]

The Hacienda San Juan Bautista, with its complex system of aqueducts, towers, buildings, pools, and canals, is an architectural and engineering marvel. It remains isolated from the highway in a valley between two rivers, the Río Taxco, and the Río San Juan. The massive walls of uncut stone from the river beds have stood for over four centuries in an area considered sacred long

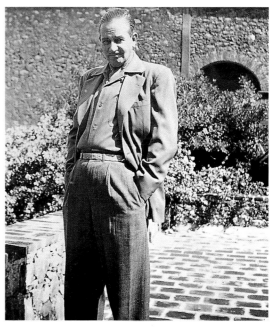

I-57 *Héctor Aguilar at the Hacienda* c. 1950
Photograph in the Collection of Robert D. Tarte

I-56 Héctor Aguilar *Dagger Letter Opener* (A) c. 1940 940 silver
Collection of Gunther Cohn and Marc Navarro

before the Conquest. The original town of Taxco, now known as Taxco el Viejo, received its name as the Place of the Ball-Game, or *Tlachco*. Before the arrival of the Spaniards, ritualized conflict took on cosmic significance during games on the ball-court. "This ancient ritual ball game was apparently played for two purposes: as sport and as rite. . . . At the heart of this ritual lies the celestial combat between the sun and the stars, and of day against night, the polemical duality that moves the world."[33]

According to Robert Tarte, who spent his youthful summers with his Cartwright cousins from about 1949 to 1957, the region around the hacienda, "clearly had been heavily populated in the past – fragments of pottery and obsidian items were literally everywhere. . . . A favorite activity of mine while staying at the hacienda was to take a sack lunch and bucket into the surrounding countryside to collect the obsidian arrow points and pottery fragments that abounded in the area. . . . A typical afternoon's adventures would yield several pounds of such items and frequently an especially cherished small piece of amethyst. Uncle Héctor had a standing offer of $1,000 if I would bring him an intact obsidian sewing needle. I never found it, but I know it's still out there."[34]

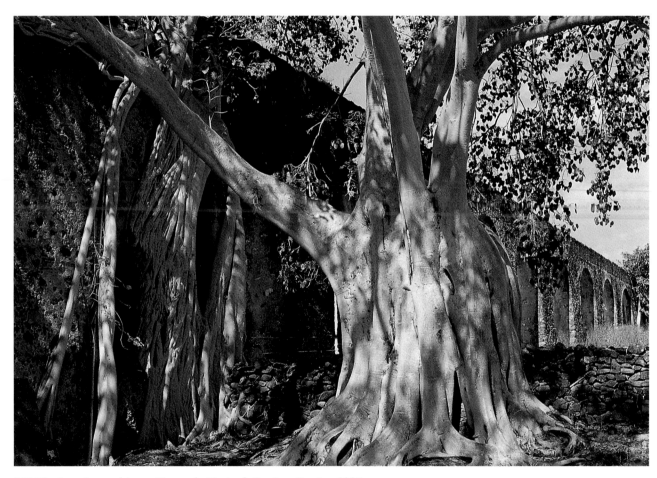

I-58 *The Aqueduct and Amate Tree at the Hacienda San Juan Bautista* 1995
Photograph in the Collection of Penny C. Morrill

The Aztecs had exacted tribute from *Tlachco*, and only two decades after the Conquest, the Spaniards had established an extensive silver mining operation. In 1539, Hernán Cortés gave to his legitimate son Martín and his two "natural" children, Martín and Jesús, one hundred Indian slaves, iron tools, and the silver mines he had purchased from Antonio Albarez de Madrid, which had previously belonged to Diego de San Martín. This silver hacienda was in the barrio de Cantarranas, a portion of which later became Spratling's workshop La Florida. In 1573, the hacienda was comprised of several houses and a church; three mills for crushing ore, one of which was powered by water; and tanks for washing the metals.[35]

Luis de Castilla, who arrived in Mexico in 1530, was the first to work the mines in Taxco and is thought to have built the Hacienda San Juan Bautista. According to a government document dated 1544, Luis de Castilla had acquired a substantial fortune in the mines. He was *Alcalde mayor* [mayor] in 1542, a further verification of his accumulation of wealth and power.[36]

A Spaniard, Bartolomé de la Medina, invented the patio process of amalgamation in 1555 at the Hacienda Purísima Grande in Pachuca in the state of Hidalgo. This very successful process was immediately adopted by miners who were refining silver. Between 1556 and 1562, twenty-seven Taxqueñians contracted with Bartolomé de la Medina to institute the patio process.[37]

Hacienda San Juan Bautista is historically significant because the complex of patios built to accommodate Medina's method of refining silver reveals a highly sophisticated level of engineering and architectural planning. The hacienda's patios, the gardens, and the residence relied on a system of canals and wall tunnels, and the process of amalgamation was dependent on hydraulic power.

For this reason, the hacienda was situated between two rivers, one of which was carried by aqueduct to the edge of the first patio. The water was captured in a cistern at the base of

I-59 *One of the Towers in the Main Patio. The Small Square Openings Descending Along the Wall Indicate the Location of the Tunnel that Provided Water for the Tank.*
Photograph by Héctor Aguilar in the Collection of Rob Cartwright

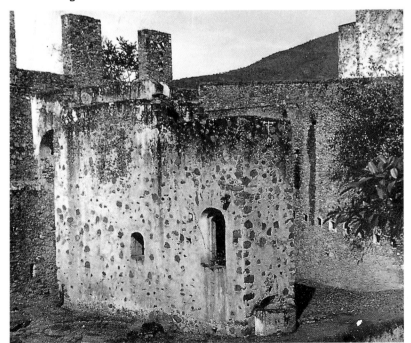

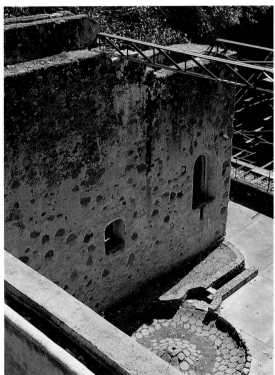

I-60 *A Tower and the Sunken Basin Where the Ore was Pulverized*
Photograph in the Collection of Penny C. Morrill

43

the aqueduct, now overgrown by a yellow *amate* tree (Pl. I-58). The flow of water was controlled by gates at various points in the canal system. In the main patio for silver refining, water flowed from the cistern into canals along the tops of two monolithic stone towers and across stepped openings onto large wooden paddlewheels inside the towers (Pl. I-59). The movement of the paddlewheels drove booms on either side of the towers to which were attached large grinding stones. These stones ground the ore in sunken basins eight feet in diameter, three feet deep, and lined with basalt (Pl. I-60). There was a second patio for refining on the south side of

the residence, with one tower and a smaller tank (Pls. I-75-76).[38]

The ore was purchased at the mines and brought on the backs of mules to the hacienda. The animals approached the patio on a path which was a series of steps especially designed for the purpose. Each step was three meters long and the incline was gradual so that the animals would not balk. The entry for the mules was through a beautifully constructed archway in the patio wall with a circular opening to lighten the weight of the masonry above the arch (Pl. I-61).[39]

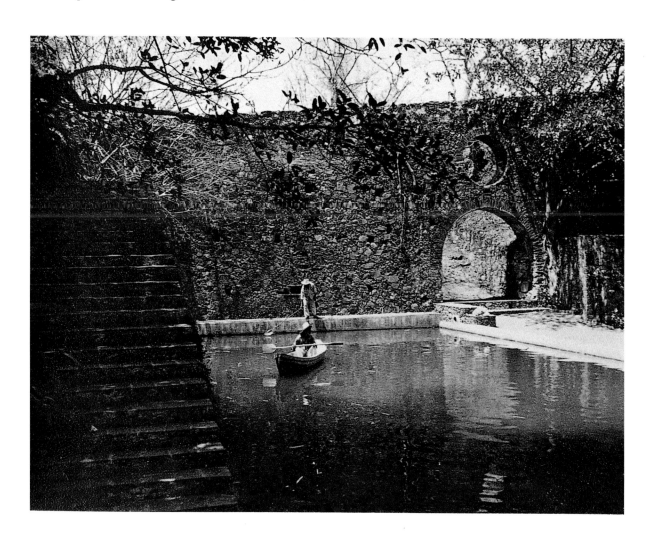

I-61 *The Swimming Pool and Entrance for the Burros*
Photograph by Héctor Aguilar in the Collection of Rob Cartwright

After the rock from the mines was broken up by workmen with sledge hammers into small pieces, it was ground by the mills to a fine powder, resembling flour. Substantial amounts of the ground ore were accumulated and dampened to create large *tortas*, or cakes on the patio floor two feet thick and up to one hundred feet in diameter. This was the point in the process that called for the valued expertise of the *azoguero*, or chemist.

Silver existed in small amounts within the rock in the form of silver sulfide. Since silver sulfide was insoluble, the *azoguero's* task was to add the right amount of salt to the already moistened *torta* so that in the presence of salt, the silver sulfide would dissolve in water as silver ions. After the salt was added, teams of horses or mules were drawn across the *tortas* to mix the salt into the dampened ore and to provide the oxidation necessary for the chemical reaction.[40]

After several days, the *azoguero* performed the task for which he was held in such high esteem, adding the metallic mercury to the *torta*, which now contained silver in ionic form. Again the *torta* was agitated with teams of horses. The resulting chemical reaction was the creation of metallic silver in the form of particles. Within the torta, the finely ground rock became suspended in a solution of mercury salts, a byproduct of the chemical process that had just taken place.

A second larger amount of pure mercury was added to the *torta*, not as a chemical reactant but to dissolve the metallic silver particles. The silver would actually "plate" onto the tiny liquid globules of mercury. The *azoguero* watched these processes

I-62 *The Canals Along the Tops of the Towers and the Stairs into the Swimming Pool*
Photograph by Héctor Aguilar in the Collection of Rob Cartwright

I-63 *The Location of the Capellina, Where the Silver was Smelted*
Photograph by Héctor Aguilar in the Collection of Rob Cartwright

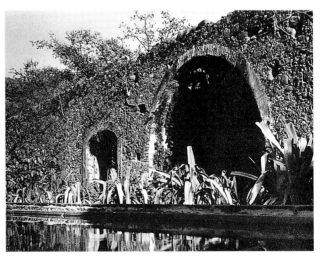

carefully by taking samples of the *torta* in a bowl or *jícara*, which hung from his belt as the symbol of his office.[41]

The *jícara* was made from the fruit of a tree called *jicalquahuitl*, the gourd tree. The bowls for the *azogueros* were made by the Indians of Olinalá, a pueblo southeast of Taxco. According to a description of the patio process written in 1825, the gourds were cut in half and cleaned to make bowls for the *azogueros* that were seven and a half inches in diameter and three and a half inches in depth. They were painted with "pleasing and bizarre figures on the exterior," and black or blue on the inside of the bowl so that the *azoguero* could watch for the formation of the silver amalgam.[42]

When the *azoguero* felt that the silver amalgamation process was complete, the entire contents of the *torta* were placed in the large tank. It is also possible that this tank may have been where the *tortas* were formed in the first place because another raised, divided tank exists to one side of the arched opening. In Plate I-59, the tunnel from the aqueduct is visible as a series of small openings descending along the wall, bringing water to the large tank. Once water was added to the *torta*, the lighter solution containing the mercury salts and ground rock floated above the heavy amalgam of mercury and silver particles. This lighter solution was flushed out of the tank and drained through a separate tunnel and aqueduct to the river which carried off the tainted water (Pl. I-65).

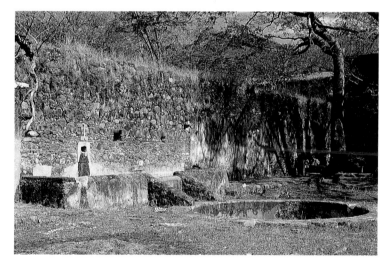

I-64 *This Fountain for the Livestock was Fed by the Hacienda's Complex Canal System.*
Photograph in the Collection of Penny C. Morrill

I-65 *The Aqueduct that Took Water Away from the Hacienda*
Photograph in the Collection of Penny C. Morrill

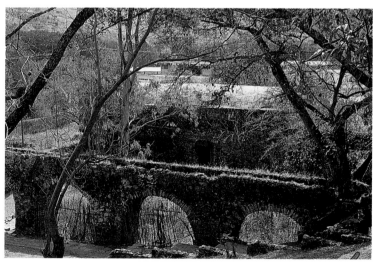

The two sets of stairways into the tank were used by the Indians to carry the amalgam out of the tank (Pl. I-62).[43] The heavy amalgam was piled in a cone of silver-coated globules and heated in a *capellina*, a bell-shaped form which was part of an apparatus known as a retort. A fire burned beneath the mercury and silver amalgam, causing the mercury to vaporize along the interior surface of the *capellina* (Pl. I-63). The mercury was almost as precious as the silver, so great care was taken to keep from losing the mercury vapor into the air. The vapor condensed and the mercury was gathered to be reused. A silver sludge was left behind, which was heated to the melting point and poured into molds to make silver ingots. This method of silver extraction was used until the beginning of the twentieth century.[44]

Clean water could be channeled through another set of canals beyond the main patio for refining. These canals provided water for drinking fountains for the workers and for the animals at several locations throughout the hacienda. (Pl. I-64). The gardens around the reflecting pool were watered by a series of fountains that lined the wall (Pl. I-81). Water cooled the house as it ran through a tunnel that led to the second patio for refining.

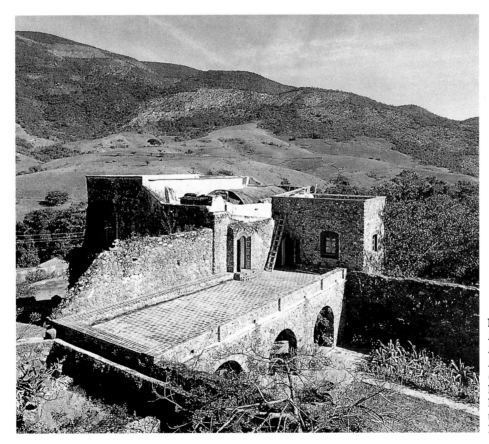

I-66 *The Main Residence and the Reflecting Pool Before it was Cleaned Out* Photograph by Héctor Aguilar in the Collection of Rob Cartwright

Héctor and Lois were devoted to the sensitive restoration of this remarkable hacienda. They seemed to appreciate the significance of San Juan Bautista and made only those changes they deemed necessary. The buildings retained their rugged monumental character. The ancient stone walls provided a dramatic backdrop for the profuse gardens and beautifully appointed interiors. There were no telephones or electricity. The softly mysterious quality of the light, provided only by candles and kerosene lamps, must have increased the sense of antiquity and isolation that enveloped the hacienda.[45]

The approach to the house was through a gate with stone piers and onto a cobblestone driveway, lined on either side by a low stone fence. On the sloping lawn of the front garden were flowering fruit trees, a small decorative pool, a sundial, and several peacocks.

The east wall of the main residence, which faced the front lawn, was partially supported by an arched buttress, enhanced with the flaming color of a bougainvillea in bloom (Pl. I-67). A small courtyard on the house's north side set the stage for the low-arched patio that faced the reflecting pool and for the stone stairway which led up to the main *sala* or living room (Pl. I-68). An arched stucco shell over the door on the interior wall gave importance to the entrance (Pls. I- 69). The large sofa in the living room was made from an antique church door and the chairs, heavy settee, and the table were produced at the Taller Borda by the master carpenter Roberto Cuevas, who made most of the furniture and some of the doors at the hacienda.

In a small private sitting room (Pl. I-70), the rounded door opened onto a terrace overlooking the reflecting pool and garden. Héctor and Lois had acquired a substantial collection of works by contemporary Mexican artists which included the painting of a child by Jesús Guerrero Galván.[46]The vents on the vaulted ceiling provided ventilation and were part of the original construction.

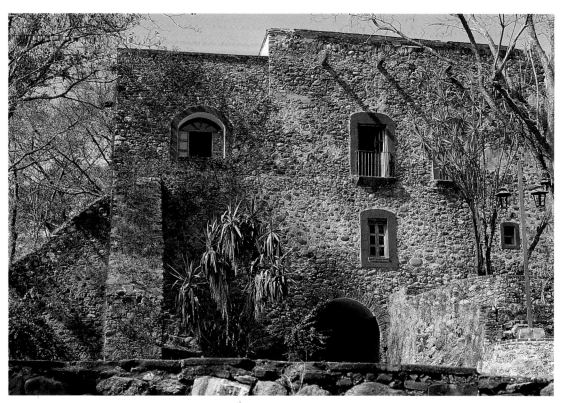

I-67 *The Facade of the Main Residence with its Medieval-style Buttressing*
Photograph in the Collection of Penny C. Morrill

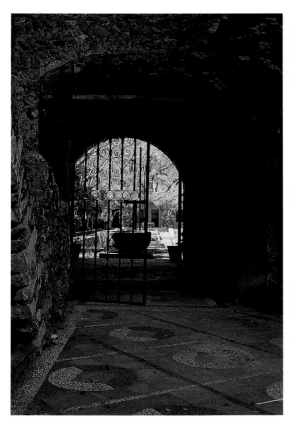

I-70 *Ventillating Shafts in the Barrel-vaulted Ceiling of the Sitting Room*
Photograph by Héctor Aguilar in the Collection of Rob Cartwright

I-68 *The Hacienda's Main Entrance — Stone Steps up to the Living Room on the Left and the Reflecting Pool Visible Beyond the Arched Veranda*
Photograph in the Collection of Penny C. Morrill

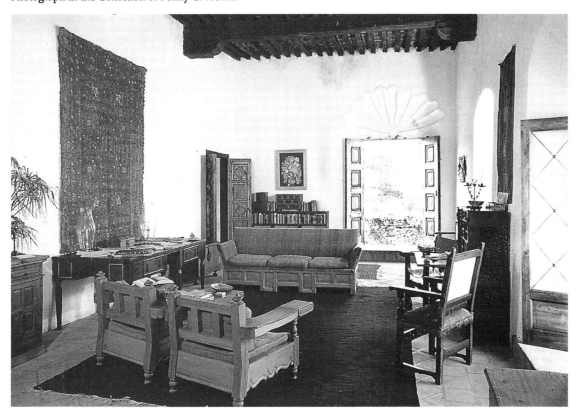

I-69 *The Stucco Shell over the Entrance into the Living Room on the Second Floor*
Photograph by Héctor Aguilar in the Collection of Rob Cartwright

On the far side of the entrance to the living room was the door into Héctor's bedroom and study. The room was furnished with a large wooden desk and a wall cabinet where he kept his gun collection. Lois's bedroom looked to the south onto a private garden (Pl. I-71). On the tile floor, Lois had placed a very large polar bear rug, with glass eyes and its claws and teeth intact. The short hallway beyond the door that appears in the photograph gave access to the one bathroom in the house.

One of the entrances to the first floor was from a terrace with a massive arch on the south side of the building (Pl. I-72). This doorway opened into the billiard room, which contained Héctor's Pre-Columbian collection arranged on mahogany shelves along one wall. He was an avid collector of art from the Balsas region, an interest he

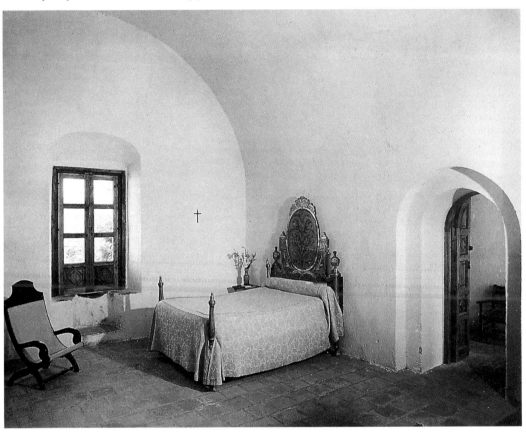

I-71 *The Antique Bed in Lois's Bedroom*
Photograph by Héctor Aguilar in the Collection of Rob Cartwright

I-72 *The Arched Veranda that Overlooked Lois's Garden*
Photograph by Héctor Aguilar in the Collection of Rob Cartwright

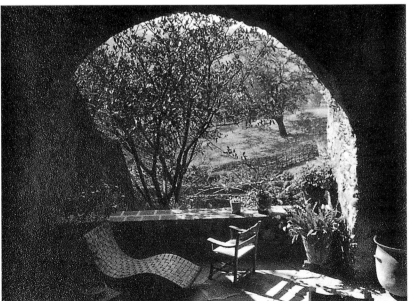

50

shared with William Spratling. The billiard table had a plaque with the letters "SJB" (for San Juan Bautista) in silver and was lighted overhead by kerosene lamps held in the suspended pans of a large antique beam balance of cast brass. Also on the first floor, were Rob Cartwright's bedroom in the northeast corner and a living room to the south (Pl. I-73). Again, all of the furniture had been made at the Taller Borda.

Through the doorway of the living room was a fresco of the Virgin painted by Valentín Vidaurreta above a small altar. This had been Valentín's bedroom, the only part of the house that he had finished. The fresco was painted in a niche created when a window was filled in to provide privacy. This window, deeply set in the wall and beautifully ornamented with flowers and vines in carved stucco, has been reopened (Pl. I-74). The door in this room is surrounded by a rope motif, also in carved stucco.

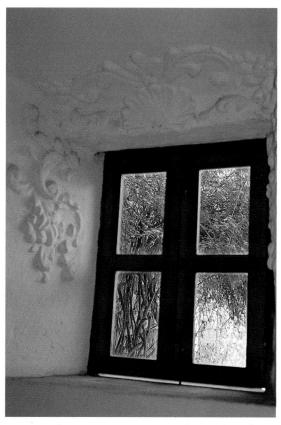

I-74 *Carved Stucco Ornamentation in the Window of Valentín's Bedroom*
Photograph in the Collection of Penny C. Morrill

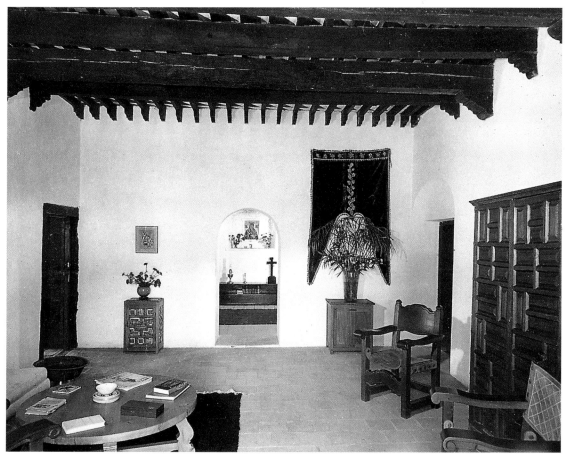

I-73 *The Living Room on the First Floor with a View into Valentín's Bedroom*
Photograph by Héctor Aguilar in the Collection of Rob Cartwright

51

A walkway on the south linked the house with the dining room and kitchen. Old mining lamps of iron hung on the exterior walls to light the way. Below the walk was the garden Lois had planted in the second patio for refining. Lois put a stairway into the tower to give access to the garden. Plate I-76 is a recent photograph of the tower's interior, showing the brick vault which accommodated the great wooden wheel that drove the grinding stones. Those stones can still be found lying to one side of the *arrastres*, sunken basins lined with basalt.

The dining room was built by Héctor in the colonial style with tile floors, stuccoed adobe walls, and a traditional brick vaulted roof supported by wooden beams. Over the mantlepiece hung one of Valentín's landscapes (Pl. I-77). Below were wrought iron fireplace tools and andirons with copper detailing, which were forged at the Taller Borda. To the left in the photograph is a large window which provided light and a view of the garden. The large cedar dining table and the chairs were also made at the taller.

I-76 *The Interior of the Tower, Revealing the Brick Vaulting*
Photograph in the Collection of Penny C. Morrill

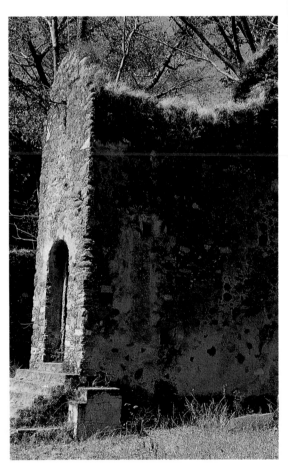

I-75 *The Tower with its Inner Stairway Gave Access to Lois's Garden.*
Photograph in the Collection of Penny C. Morrill

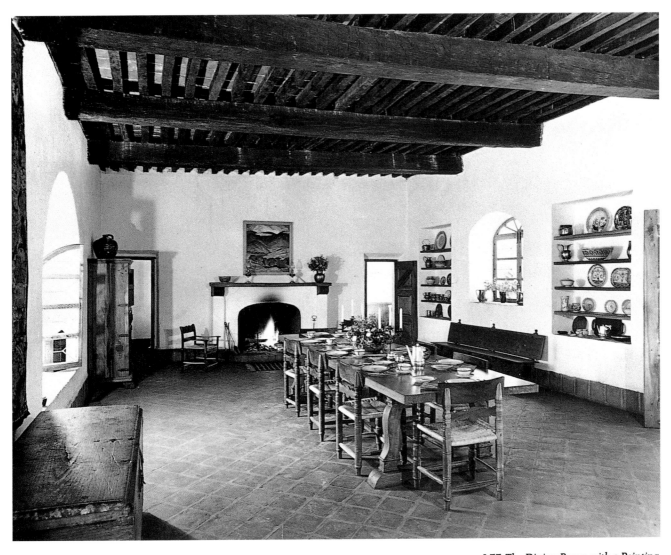

I-77 *The Dining Room with a Painting Over the Mantelpiece by Valentín Vidaurreta*
Photograph by Héctor Aguilar in the Collection of Rob Cartwright

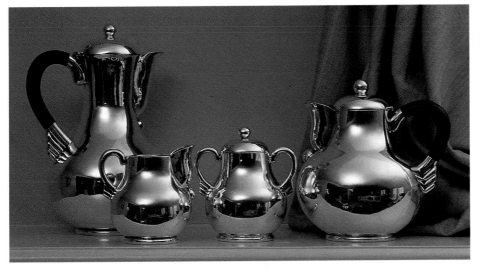

I-78 Héctor Aguilar *Tea and Coffee Set* (J. 3060, 3109, 3066, 3088. eagle31) c. 1950 925 silver/wooden handles
Collection of Chuck Kaplan

The kitchen, a wonderful space, also
contained furniture by Roberto Cuevas,
including the round cedar table (Pl. I-79).
The shell-shaped basin designed by Lois is
still intact with its hand-painted tile trim. The
charcoal stoves were used every day for
cooking and the large baking ovens were just
outside the kitchen.

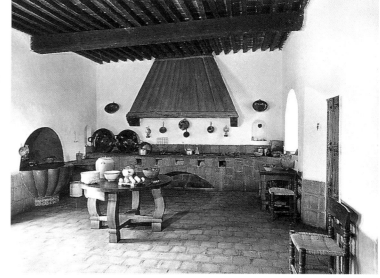

I-79 *The Shell Sink in the Kitchen Designed by Lois
Aguilar*
Photograph by Héctor Aguilar in the Collection of Rob
Cartwright

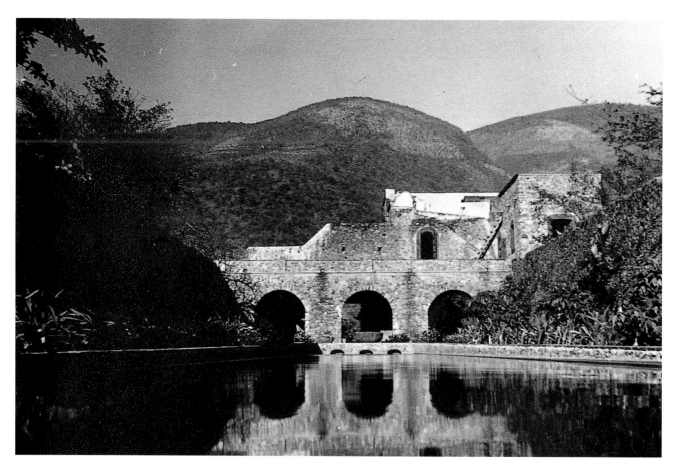

I-80 *The Reflecting Pool and Main Residence*
Photograph by Héctor Aguilar in the Collection of Rob Cartwright

The reflecting pool with its garden and the fountains along the wall had their origins in the Arabic gardens in Spain. The Aguilars stocked the pool, called an *espejo*, or mirror, with several hundred goldfish that swam beneath the lily pads (Pl. I-81). At either end were two large Pre-Columbian ceremonial bowls of basalt, which have not been removed. The wall of fountains stood between the garden patio and the large patio for refining. The swimming pool, located in the main patio, was the original tank where the silver amalgam was separated from the ore (Pl. I-82).

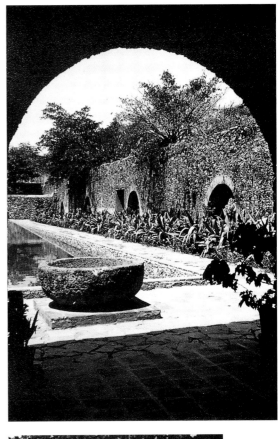

I-81 *A View of the Reflecting Pool from the Arched Veranda*
Photograph by Héctor Aguilar in the Collection of Rob Cartwright

I-82 *The Swimming Pool*
Photograph by Héctor Aguilar in the Collection of Rob Cartwright

The guest house was not restored, but was built by the Aguilars, using the rear wall and foundations of an original structure, possibly the hacienda's office (Pl. I-83). Called the Casa Chica, it was finished in 1954 and contained three bedrooms, a bath, a small kitchen, and a living room across the front. The porch was supported by heavy columns that gave strength to the facade. A charming addition to the Casa Chica and the main residence were copper downspouts in the shape of fish that were handwrought at the Taller Borda (Pls. I-85-86).

San Juan Bautista was not simply a house in the country; it was a working hacienda.

Héctor raised bees and made honey that was sold to Larín, a large chocolate company in Mexico City. Corn, vegetables, and sugar cane were grown on the property. Héctor had the cane rendered and cooked to brown sugar which was poured into half-moon shapes with the letters SJB (San Juan Bautista) in the bottom of the molds. All the sugar and corn were placed in storerooms by the lower vegetable garden. The animals' water trough, with its stone cross ornament, where the livestock were fed and watered during the colonial period, is still visible in the walled yard (Pl. I-87). This area was used by the Aguilars to keep guinea hens and chickens.

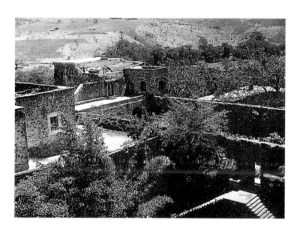

I-83 *The Patios, the Guest House Before the Roof was Put on, and the Main Residence*
Photograph by Héctor Aguilar in the Collection of Rob Cartwright

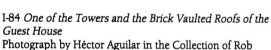

I-84 *One of the Towers and the Brick Vaulted Roofs of the Guest House*
Photograph by Héctor Aguilar in the Collection of Rob Cartwright

Lois befriended the Tlamacazapan Indians, who lived in the jungle on the other side of the mountain. They spoke no Spanish, but she was able to have them make rugs for the hacienda which were colored with natural dyes. She gave them jobs and sent them food. At one point she saved a young girl's life by getting medical help for her. A few days later, a group of Tlamacazapans arrived at the hacienda and asked to see Lois. After a flowery speech expressing their appreciation, they offered Lois the child, a gift she graciously declined.[47]

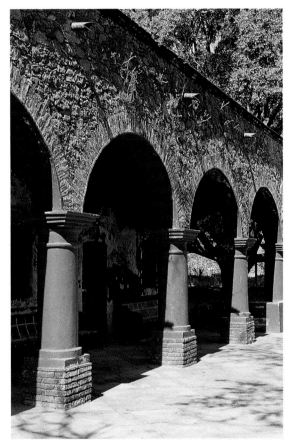

I-85 *The Columns and Copper Downspouts on the Guest House Facade*
Photograph in the Collection of Penny C. Morrill

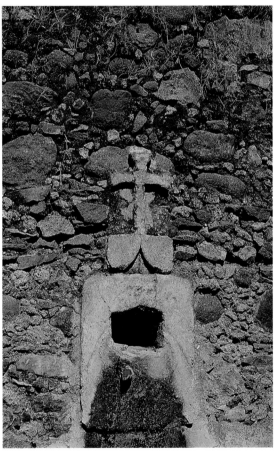

I-87 *The Cross over the Canal Opening that Fed the Animals' Fountain*
Photograph in the Collection of Penny C. Morrill

I-86 *Copper Downspouts Fashioned as Fish on the Main Residence*
Photograph in the Collection of Penny C. Morrill

Almost every Sunday, the Aguilars walked to the silver hacienda of Hueymatla (Pl. I-90). The hacienda was originally part of an *ejido*, owned jointly and farmed individually by the *ejidatarios* or villagers. The Indians, before and after the Conquest, had practiced this type of communal ownership of property until the mid-nineteenth century, when the *ejidos* were taken up by large landholders. The Constitution of 1917 reestablished the *ejidos* by breaking up the haciendas and redistributing the land.[48]

Sometime in the late 1930s, the *ejidatarios* of Hueymatla agreed to sell the hacienda's main house and gardens to William Spratling, whereupon he restored them (Pl. I-91). Spratling then sold the house to John Brahm, a director of B-films in Hollywood.[49] Brahm was quite taken with the hacienda and devoted himself to furnishing it with antiques of the period. When Brahm brought his new wife down to Mexico, she did not share his enthusiasm for the hacienda and refused to return. Brahm asked Héctor Aguilar to take care of the hacienda in his absence. According to David Read, who bought the house from Brahm, Héctor paid a local villager to watch the house and to do minor repairs.[50] This recollection is corroborated by Rob Cartwright and Luis Reyes, both of whom say that Héctor Aguilar never owned Hueymatla but paid the gardeners and other laborers who were working for an absentee owner. Héctor took on this responsibility for years, paying for the upkeep of the house out of his own pocket.[51]

David Read saw Hueymatla and was assisted by Héctor and Lois in his efforts to find John Brahm. He bought the hacienda in 1963, just as the Aguilars were leaving San Juan Bautista. The improvements made by Spratling, a brick vaulted roof over the dining room and the conversion of the tank into a swimming pool, are still in evidence. Fortunately, the ancient aqueduct, the tower for grinding ore, and the reflecting pool have also remained intact (Pls. I-89-90).

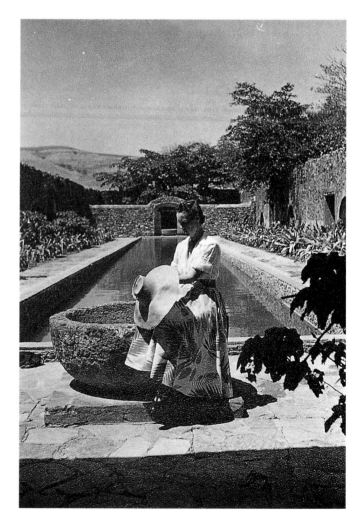

I-88 *Lois Aguilar Seated Before the Reflecting Pool*
Photograph by Héctor Aguilar in the Collection of Rob Cartwright

Spratling's ranch was right up the road from San Juan Bautista, and Spratling and the Aguilars enjoyed a long-time friendship. In 1951, Lois flew with Spratling to Zihuatanejo and she was enchanted by its beauty. She convinced Héctor to visit this lovely village on the Pacific coast and they decided to build a house there. Héctor enjoyed fishing and they traveled to Zihuatanejo often.

I-91 *Hueymatla's Swimming Pool, Once a Tank for Separating Ore from the Silver and Mercury Amalgam* Photograph in the Collection of Penny C. Morrill

I-89 *The Tower at the Hacienda de Hueymatla* Photograph in the Collection of Penny C. Morrill

I-90 *The Reflecting Pool at Hueymatla from Inside the Main Residence* Photograph in the Collection of Penny C. Morrill

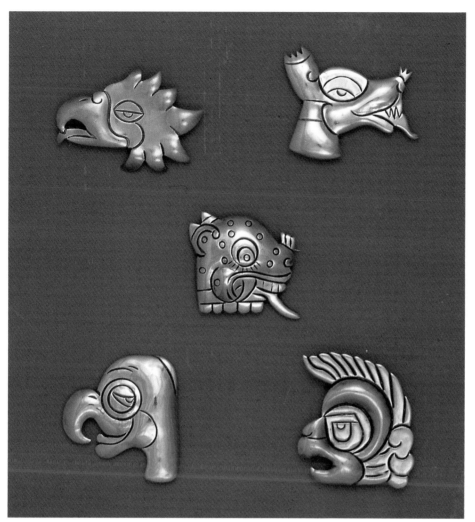

I-92 Héctor Aguilar *Jaguar, Monkey, Eagle, Buzzard, and Deer Head Pins* (B) c. 1940 940 or 990 silver
Collections of J. Crawford, and Gunther Cohn and Marc Navarro; Private Collection

I-93 *Calendar Name Symbol – Deer* from *The Codex Nuttall*

I-94 *Calendar Name Symbol – Rabbit* from *The Codex Nuttall*

I-95 *Calendar Name Symbol – Jaguar*
from *The Codex Nuttall*

I-98 *Calendar Name Symbol –
Crocodile*
from *The Codex Nuttall*

I-99 *Calendar Name Symbol – Dog*
from *The Codex Nuttall*

I-102 Héctor
Aguilar *Stylized
Serpent Head Pin*
(B) c. 1940 990
silver
Collection of
Jamie Snow
Photograph
Courtesy of Jamie
Snow

I-96 *Calendar Name Symbol – Eagle*
from *The Codex Nuttall*

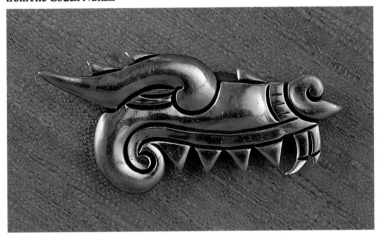

I-100 Héctor Aguilar *Crocodile Head
Pin* (B) c. 1940 990 silver
Collection of Dayle Kolbrenner

I-97 *Calendar Name Symbol –
Feathered Serpent*
from *The Codex Nuttall*

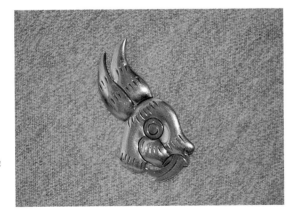

I-101 Héctor Aguilar *Rabbit Head Pin*
(B) c. 1940 990 silver
Collection of James D. Black Photo-
graph by James D. Black

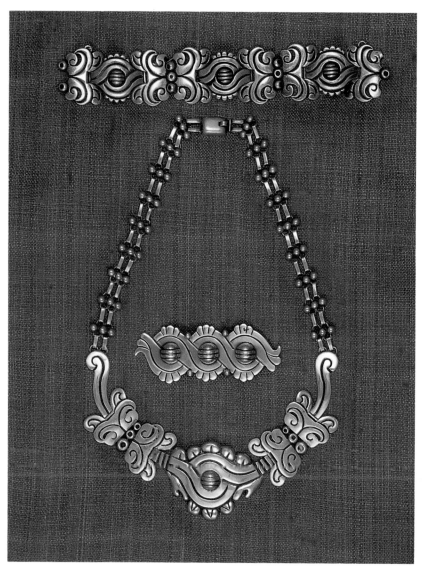

I-103 Héctor Aguilar *Maguey Necklace and Bracelet* (B)
c. 1940; *Three Domes Pin* (I) c. 1950 940 silver
Collection of Gunther Cohn and Marc Navarro

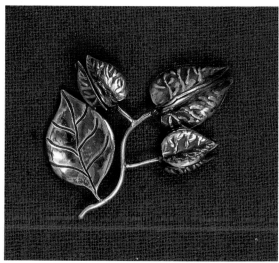

I-105 Héctor Aguilar *Acorn and Three Petals Pins* (B) c.
1940; *Poinsettia Pin* (C) c. 1945 925 or 940 silver
Collection of Gunther Cohn and Marc Navarro

I-106 Héctor Aguilar *Three-Dimensional Leaf Pin* (B) c.
1940 990 silver
Collection of Gunther Cohn and Marc Navarro

I-104 Héctor Aguilar *Double Repoussé Cuff; Six-ridged
Repoussé Cuff; and Double Repoussé with Amethyst Cuff*
(F) c. 1945-50 925 silver
Collection of Gunther Cohn and Marc Navarro

THE TALLER BORDA CLOSES AND THE AGUILARS LEAVE TAXCO

Over a period of about five years, a sequence of events set in motion the demise of the workshop system in Taxco. The first was the construction in 1954 of a new Acapulco highway that bypassed Taxco, taking away the tourist traffic that was essential for the survival of the talleres. In 1958, the Department of Social Security decided to build a hospital in Taxco, and the government demanded that the employees of the talleres be included in the program. The workshop owners were required to file the names of all employees and pay social security for them monthly.

Many of the talleres went into bankruptcy, and others cut their workforce by as much as fifty percent. In response to the impending loss of job security, the workers formed a union, the *sindicato*, and called a strike which lasted four months. The death knell was sounding for several of the large workshops, including the Taller Borda. Héctor Aguilar was opposed to the formation of a union among his workers. Facing unionization, coupled with the disastrous drop in tourism and sales, he chose to declare bankruptcy.[52]

Héctor and Lois sold San Juan Bautista for $100,000 and walked out, leaving everything behind. The new owners were two men from Garden Grove, California, who turned the hacienda into an inn. The Hacienda San Juan Bautista, with its twenty-six guest rooms, was recommended in a 1966 guidebook as "new, charming, with two meals."[53]

The Aguilars moved into the Casa Fuller in Taxco, which they rented for only a few years from a Professor Fuller who taught Greek philosophy at Pomona College in California. In the photograph of Héctor and Lois (Pl. I-113) taken at the Casa Fuller, they are seated in front of the painting by Guerrero Galván and a charcoal drawing of a

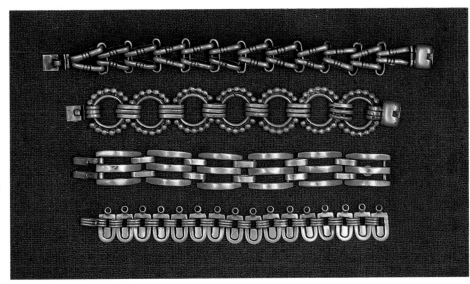

I-107 Héctor Aguilar *Linked Circles Bracelet* (C) c. 1945 925 silver; *Half-oval Linked Bracelet; V-chain, and Three Bands Bracelets* (B) c. 1940 940 or 980 silver
Private Collection

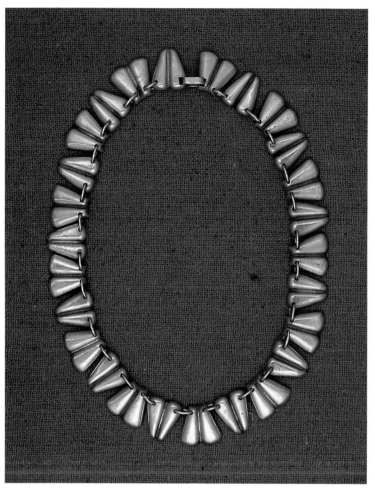

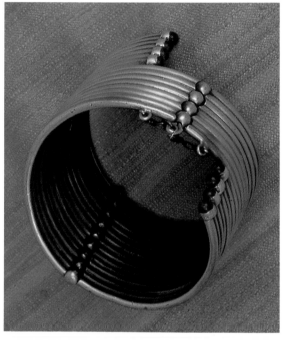

I-108 Héctor Aguilar *Solid Silver Drops Necklace* (C) c. 1945 sterling
Collection of Yona Bäcker; Courtesy of Throckmorton Fine Art, Inc.

I-109 Héctor Aguilar *Spiral Wire Cuff with Amethysts* (I)
c. 1955 940 silver/amethyst quartz
Collection of J. Crawford

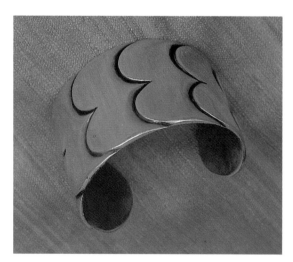

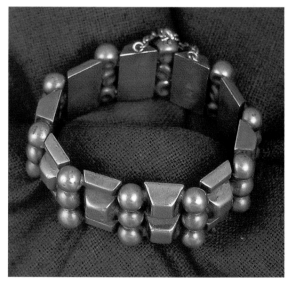

I-110 Héctor Aguilar *Scallop Cuff* (F) c. 1945-50 925
silver
Collection of J. Crawford

64

I-111 Héctor Aguilar *Pyramid and Three Beads Bracelet*
(O) c. 1955 940 silver
Collection of Gunther Cohn and Marc Navarro

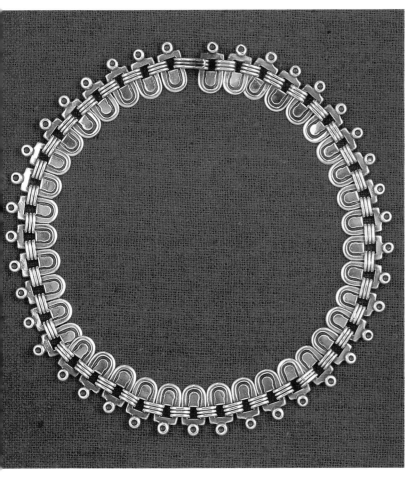

I-112 Héctor Aguilar *Half-oval Linked Necklace* (D) c. 1945 940 silver
Collection of Linda and Steve Nelson

nude by Diego Rivera. These were probably among the few possessions they took with them after the sale of the hacienda.[54]

After closing the taller and settling with the workers, Héctor and Lois moved permanently to Zihuatanejo. In 1966, the Aguilars sold the store to Benjamín Pérez, who was also responsible for sending the rents from the Casa Borda to Héctor. The Mexican government took possession in 1983, and the Casa Borda is today a cultural center for the state of Guerrero.[55]

The house Héctor and Lois designed and built at Zihuatanejo was terraced and open. The style was rustic, with flagstone floors and rough cedar furniture. In 1968, Héctor published his book *Artesanía de la Plata* on the silver industry and on techniques developed in the Taller Borda. Lois died in 1978. Not long after, Héctor sold the house they had built together and moved into a smaller place he had constructed down the beach. He died in 1986 on the day of the disastrous earthquake in Mexico City.[56]

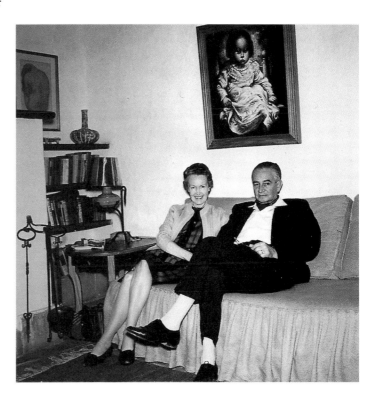

I-113 *Héctor and Lois Aguilar at the Casa Fuller* c. 1964
Photograph in the Collection of Rob Cartwright

When Héctor Aguilar wanted to describe something he felt was nearly perfect, he would say, "Le faltó un grado para ser niño." ["It only lacked a tiny bit in order to be a child"]. The kindly and gracious tone of this folk saying evinces the quality of Héctor's character and the life he chose to lead. In remembering his uncle, Robert Tarte has written: "He was a serious man, with a very masculine bearing and a calm, scholarly, often technical manner. Accompanying him in Taxco, I sensed that he was known to everyone, respected, perhaps considered wealthy and influential, certainly admired.

Socially, he was invariably, above all, gracious, hearty, on the warm side of aristocratic, with a confident sense of style that one almost never encounters in North America. I recall that one summer when I was in Taxco, Héctor was host to a group of American silversmiths participating in seminar/workshops there. I remember being struck by the respectful comments that I overheard among them and by the earnest, serious, and enthusiastic manner with which my uncle explained and demonstrated aspects of silversmithing and design."[57]

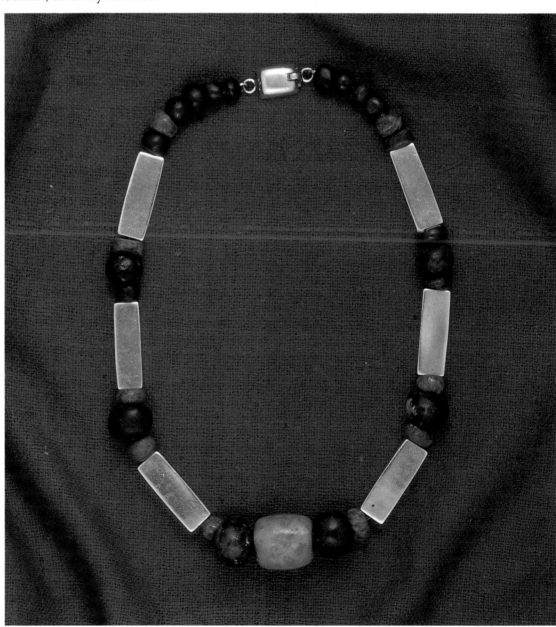

I-114 Héctor Aguilar *Pre-Columbian Bead and Silver Necklace* (B) c. 1940
Private Collection

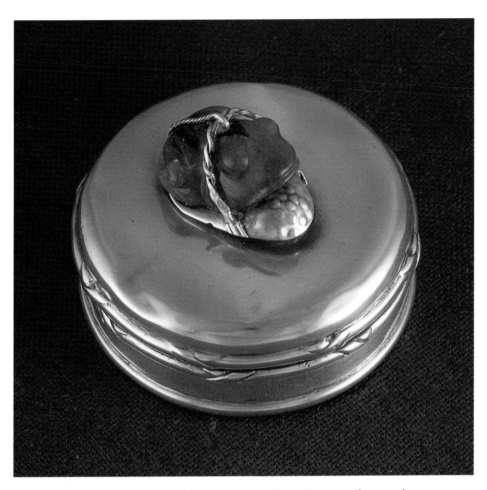

I-116 Héctor Aguilar *Circular Box with Amethyst Frog* (B) c. 1940 940 silver/amethyst quartz
Collection of Ronald A. Belkin

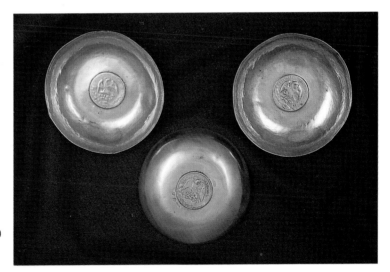

I-115 Héctor Aguilar *Three Candy
Dishes with Mexican Coins* (B) c. 1940
940 silver
Collection of Ronald A. Belkin

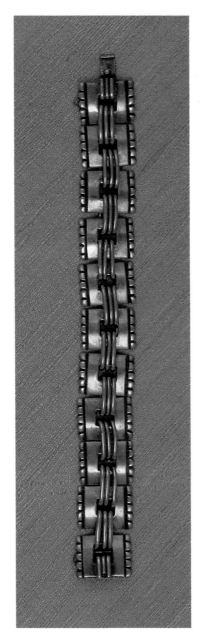

I-117 Héctor Aguilar *Ornamented Squares Bracelet* (I) c. 1950 940 silver
Collection of Gunther Cohn and Marc Navarro

[1] Information on Héctor Aguilar's early life is taken from interviews with his stepson Rob Cartwright and Blanca Flores Cartwright.

[2] Rolando Aguilar Ricketson was a movie director with 26 films to his credit. He co-directed several American films, one of which, "Tarzan and the Mermaids," was filmed in Acapulco in 1946. He was a founding member of the Sociedad de Directores. Born in San Miguel de Allende in 1903, he died Jan. 9, 1985 in Mexico City (*Variety Obituaries*).

[3] Hotel Taxqueño Guest Registers.

[4] In a letter on Hotel Rancho Telva stationery dated April 20, 1937, Natalie Scott refers to Héctor Aguilar as the manager of the workshop at the Taller Borda (*Natalie Scott Papers*, Box 3, Folder 4).

[5] William Spratling, "Modern Mexican Silversmithing."

[6] *Martha Robinson Papers*, Letter from Natalie Scott to Martha Robinson, Nov. 30, 1939. Kim Schee, an author, wrote *Cantina* while in Taxco. His wife Tamara was a ballerina, a protegé of Pavlova (Elizabeth Anderson and Gerald Kelly, *Miss Elizabeth: A Memoir*, 230).

[7] Rob Cartwright, interview.

[8] Luis Reyes, interview by Penny C. Morrill.

[9] Manuel Toussaint, *Tasco*, 203.

[10] Toussaint, *Tasco*, 205. In a 1929 article for the magazine *Travel*, William Spratling wrote: "The house of Monsieur de La Borda is now used in part as a barracks, also for a small cinema, and the cellars or halls far below, the same halls and patios which once graced the slopes of the lower mountain-side, are now quarters for burros and cattle" (Spratling, *"The Silver City of the Clouds,"* 23).

[11] In 1950, Leslie Figueroa wrote of the Casa Borda, "The present owner is doing a great deal to restore and preserve its beauty and it is a busy place with jewelry shops, silver factories, and private apartments" (Leslie Figueroa, *Taxco: The Enchanted City, 20*).

[12] Robert D. Tarte, Letter to Penny C. Morrill, March 7, 1995.

[13] Michael Day, "Mexico's City of Silver," *Popular Mechanics Magazine*: 120-2; Mary L. Davis, and Greta Pack, *Mexican Jewelry*, 199.

[14] Tarte, Letter, Feb. 9, 1995; Rob Cartwright, interview.

[15] Rob Cartwright, interview.

[16] Rob Cartwright, interview. *Blueberries for Sal* was published in 1948. In 1955, McCloskey spent two months painting in Mexico (Anne Commire, *Something About the Author*, 143). According to Leslie Figueroa, Wayman Adams, "the famous portrait painter," maintained a studio at the Casa Borda (Figueroa, *Stuffed Shirt in Taxco*, 78).

[17] Verna Cook and Warren Shipway, *Mexican Interiors*, 50; Rob Cartwright and Robert Tarte, interviews by Penny C. Morrill; Penny C. Morrill and Carole A. Berk *Mexican Silver*, 78-9 n. 19, V-12a, V-12b, V-10.

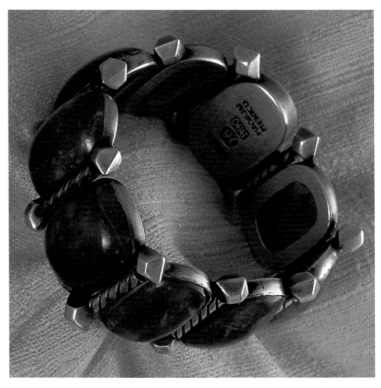

I-118 Héctor Aguilar *Amethyst Bracelet with Braid and Diamond-shaped Hinges* (C) c. 1940 990 silver
Collection of Linda and Steve Nelson

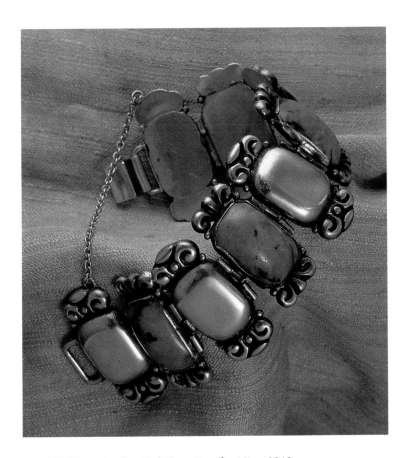

I-119 Héctor Aguilar *Pink Onyx Bracelet* (C) c. 1940
silver
Collection of Linda and Steve Nelson

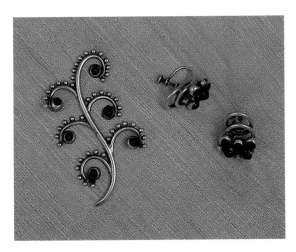

I-120 Héctor Aguilar *Flower Branch Pin and
Earrings* (I) c. 1950-55 940 silver/azurite
Collection of Gunther Cohn and Marc Navarro

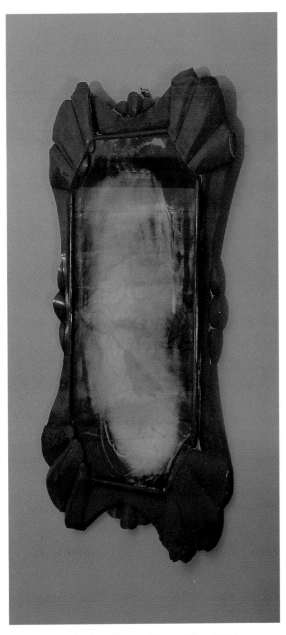

I-121 Héctor Aguilar *Copper Mirror* (R) c. 1945
copper
Collection of Gunther Cohn and Marc Navarro

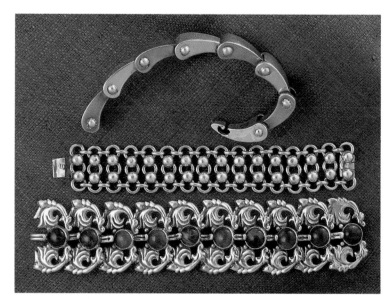

I-122 Héctor Aguilar *Copper and Silver Bracelet* (V) c. 1940 silver/copper; *Chain and Small Dome Bracelet* (F) c. 1945 925 silver; *Silver Flowers With Amethyst Cabachons Bracelet* (B) c. 1940 940 silver/amethyst quartz
Private Collection

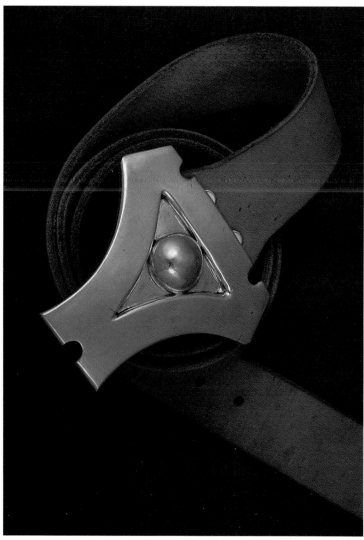

I-123 Héctor Aguilar *Massive Belt Buckle* (C) c. 1940-45 925 silver
Private Collection

[18] Sanborn's was the quintessential department store for tourists in Mexico City. North Americans gathered to eat in the patio restaurant or at the soda fountain; they found toiletries in the drug store; or they purchased tobacco products, perfumes, furs, or ladies' ready-to-wear imported from France and Italy in the various departments. After 1933 and up until his retirement in the mid-fifties, Fred Davis supervised the purchase and display of native crafts, handwrought silver, and Mexican antiques at Sanborn's.
[19] *Primer Directorio Industrial Nacional: 1947-48,* 924; Rob Cartwright, interview.
[20] Adriana Williams, *Covarrubias, 134.*
[21] Michael A. "Tony" Vaccaro, Interview by Penny C. Morrill.
[22] Shipways, *Mexican Interiors,* 50, 174, 178, 188; Shipways, *Mexican Homes of Today,* 37. The gold symbol bracelet with tiny bells is on p. 192 of the Shipways' *Decorative Design in Mexican Homes.* Davis and Pack published *Mexican Jewelry* in 1963; see 198-202. In June 1969, several bracelets were shown in *Mexico This Month* ("Mexico's Wonderful Metals," 22-26).
[23] Rob Cartwright, interview.
[24] Tarte, Letter, Dec. 18, 1995.
[25] Rob Cartwright; Blanca Cartwright, interviews.
[26]*Natalie Scott Papers,* Jennison to Scott, Feb. 24, 1944. According to Leslie Figueroa, Cole Porter wrote part of "Mexican Hayride" on the balcony of Paco's Bar (Leslie C. de Figueroa, *Stuffed Shirt in Taxco,* 80).
[27]Reyes, interview.
[28] Héctor Aguilar Ricketson, *Artesanía de la Plata,* "El Autor."
[29] Aguilar Ricketson, 82-3.
[30] Aguilar Ricketson, "El Autor."
[31] According to David Read, who owns the nearby Hacienda de Hueymatla, Elizabeth Anderson was also one of the owners of San Juan Bautista, with Valentín and the Aguilars (David Read, interview by Penny C. Morrill).
[32] Anderson and Kelly, 265-66; Rob Cartwright; Reyes, interviews. In a letter dated June 10, 1948, Natalie Scott mentions several parties, "The most impressive one was at the hacienda which Lois and Héctor Aguilar have restored" (*Martha Robinson Papers,* Letter from Natalie Scott to Martha Robinson, June 10, 1948).
[33] *Mexico: Splendors of Thirty Centuries,* 17-18.
[34]Tarte, Letter, Feb. 9, 1995.
[35] Modesto Bargalló, *La Minería y la Metalurgia en la América Durante la Epoca Colonial,* 30, 56-8.
[36]Bargalló, 57-58. *La Minería y la Metalurgía. . . ,* 57-8.
[37] Modesto Bargalló, *La Amalgamación de los Minerales de Plata en Hispanoamérica Colonial,* 116-17; Clement G. Motten, *Mexican Silver and the Enlightenment,* 21-22.
[38] Javier Ruiz Ocampo, interview by Penny C. Morrill; Motten, 22-3.
[39] Ruiz Ocampo, interview; Motten, 21.
[40] Salt for the haciendas of Taxco came from the lake of Ahuitzlán (Bargalló, *Amalgamación de los Minerales. . . ,* 382). A drawing of a patio for refining on p. 39 of Federico Hernández Serrano's "La Minería," shows the *tortas* and the teams of mules.
[41] Motten, 23-24; Richard L. Davies, interview by Penny C. Morrill.
[42] Don Federico Sonneschmid, *Tratado de la Amalgamación de Nueva España,* 20.
[43]The hacienda was supposedly haunted by the spirits of the hundreds of Indian slaves who suffered deformities or death from mercury poisoning. In the late sixteenth century, black slaves were brought in to work the mines. After a bloody uprising, many blacks escaped to the Pacific coast where their descendants live today (Ruiz Ocampo, interview; Jaime Castrejón Diez, "Una Ciudad Minera en sus Orígenes," 29-30).
[44]Davies; Ruiz Ocampo, interviews; Motten, 24.
[45] Tarte, Letter, Mar. 7, 1995; Rob Cartwright, interview.
[46] There is a short biography of Jesús Guerrero Galván in *Modern Mexican Artists.*
[47] *Blanca Cartwright; Rob Cartwright, interviews.*
[48]Helen Delpar, ed., *Encyclopedia of Latin America,* 215-16; Thomas E. Weil, *Area Handbook for Mexico,* 292-95.
[49] Brahm, a German, came to the U. S. in 1937 and worked for Columbia, Universal Studios, and 20th Century Fox, and was later one of the first directors to move into television. Brahm died on Oct. 27, 1982 (*Variety Obituaries,* Vol. 9, 10-27-88).
[50] Read, interview.
[51] Rob Cartwright, Reyes; Javier Ruiz Ocampo with Ciro Escorcio Ortega, interviews.
[52] Gail Stromberg, *El Juego del Coyote,* 54-7.
[53] John Wilhelm, *Guide To Mexico,* 257. According to Rob Cartwright, one of the men's names was Green.
[54] Rob Cartwright, interview. The fireplace tools in the photograph were undoubtedly produced at the Taller Borda.
[55] Virginia Redondo de Pérez, interview by Penny C. Morrill. The Aguilars may have left Taxco as late as 1965. In a letter dated July 19, 1964, the author describes being introduced by her grandmother to Héctor Aguilar at the Casa Borda.
[56] Rob Cartwright; Blanca Cartwright, interviews.
[57] Tarte, Letter, Mar. 7, 1995.

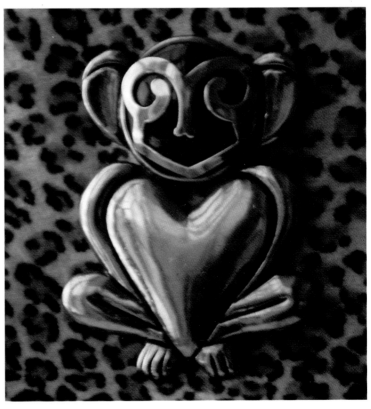

I-124 Héctor Aguilar *Monkey Pin* (B)
c. 1945 silver/onyx
Collection of James D. Black Photograph by James D. Black

Valentín Vidaurreta

II-1 Valentín Vidaurreta *Magnolia Blossoms and Orchids* 1942 Photograph in the Collection of Penny C. Morrill

II-2 Héctor Aguilar *Rectangular Flat Conch Pin* (P) c. 1945-50 940 silver Collection of Peregrine Galleries

CHAPTER II

Valentín Vidaurreta

Valentín Vidaurreta engaged in a lifelong pursuit of beauty. His approach to everyday life was with the mind and eye of an artist. He depicted what he saw around him in hammered silver, paint, or carved stone and enhanced his surroundings as a sculptor, painter, restoration architect, and as a horticulturalist.

Born in the year 1902 in northern Mexico, Valentín became an expatriate during the Revolution, living in Spain and France from the time he was seven until he was twenty-two years old. In 1920, he commenced his studies with the Spanish painter López Mezqueta. He was also influenced by the artist Joaquín Sorolla y Bastida's treatment of light, a soft luminosity which was to characterize his work.[1]

VALENTIN REACHES ARTISTIC MATURITY

Valentín Vidaurreta returned to Mexico in 1924 and entered the School of Painting at the former Convent of Churubusco which was under the directorship of Alfredo Ramos Martínez. The school had become the center

II-3 Valentín Vidaurreta *Chrysanthemum Pin* (F) c. 1945-50 925 silver
Collection of Gunther Cohn and Marc Navarro

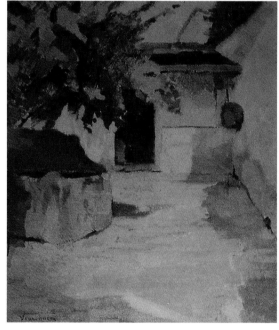

II-4 Valentín Vidaurreta *Colonial Court* January 1929
cover of *Mexican Life*
Courtesy of the Columbus Memorial Library

of Mexico's artistic revolution, the artists responding to political events and social changes by frescoes they painted on public walls. The influence of the muralists is evident in Valentín's fresco for the Chicago World's Fair "The Deer Dance," but his work more often reflected a synthesis of the Spanish academic style with the simplified and planar forms of cubism.[2] In 1928, Howard Phillips, the editor of *Mexican Life*, wrote of Valentín: "We see a trace of Spanish amber in Vidaurreta's Mexican sunlight. . . . There is, too, something reminiscent of the Roman and Moorish Toledo in the massive rounded contours, in the shades and outlines of native Mexican walls and patios."[3]

Dolores Olmedo Patiño, who was a participant in the artistic renaissance and who has bequeathed to the people of Mexico a museum filled with her art collection, remembers Valentín Vidaurreta as a close friend of her husband's and as a talented artist: "Yes I remember Valentín Vidaurreta.

Very good-looking. The first cousin of Emilio Azcarraga. He was a good, but not great, painter. He knew and worked for Fred Davis and was very close to my husband Howard Phillips. Valentín was very educated and often went to Europe. He also went to Taxco often."[4]

Valentín Vidaurreta found himself in the midst of an exhilarating, at times chaotic, storm of artistic and intellectual activity. He was talented enough to have his paintings featured on numerous covers of *Mexican Life*, beginning in 1928. In that year his "Patio in the Convent of Churubusco," a painting of the art school he had attended in Mexico City, was on the front of the November issue (Pl. II-5).[5] He had joined a circle that included the young author and architect William Spratling, artist Miguel Covarrubias, Carmen López Figueroa, and Fred Davis, the first to exhibit the work of Mexican artisans and painters in his gallery.[6] Valentín's main residence was probably in Mexico City, but it

II-6 Valentín Vidaurreta *Taxco* from Erna Fergusson's *Fiesta in Mexico*
Courtesy of the Columbus Memorial Library

II-5 Valentín Vidaurreta *Patio in the Convent of Churubusco* November 1928 cover of *Mexican Life*
Courtesy of the Columbus Memorial Library

seems that just before 1930, he was spending time in Cuernavaca and may even have had a house there. His choice of subjects and scenes during this period is indicative of his presence in Cuernavaca. A painting by Valentín that appeared on the December 1930 *Mexican Life* cover "A Cuernavaca Patio (Home of Alfred MacArthur)" can be compared to the photographs of the same arcaded patio taken by the Shipways in 1960 for their book *Mexican Houses Old and New* (Pl. I-1).[7]

Alma Reed, owner of Delphic Studios in New York, in collaboration with the Junior League in December 1931, organized a large exhibit of paintings by contemporary Mexican artists which included the work of Valentín Vidaurreta.[8] His most important commissions came three years later in 1934. His paintings were part of a "very successful exhibit" at a prominent art gallery in Chicago and were shown later in New York at Delphic Studios. The same year, Erna Fergusson's two books, *Mexican Cookbook* and *Fiesta in Mexico*, were published with illustrations by Valentín Vidaurreta. His use of tilted landscapes, heavily outlined and simplified shapes, and multiple viewpoints owed much to the cubists (Pl. II-6).

II-7 Valentín Vidaurreta *The Deer Dance* July 1935 *Mexican Life* – photograph of the mural in the Mexican Village at the Century of Progress Fair in Chicago Courtesy of the Columbus Memorial Library

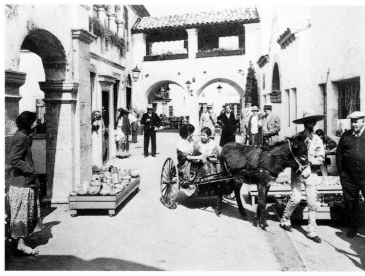

II-8 *Mexican Village at the Century of Progress World's Fair, Chicago* Prints and Photographs Division of the Library of Congress. *A Century of Progress International Exposition: Chicago 1933-1934.* Lot 12616: page 24 Photograph Courtesy of The Library of Congress

Valentín's real challenge came with the execution of a series of murals for the Mexican Village at the Century of Progress World's Fair in Chicago held in 1933-34 (Pl. II-7).[9] The pavilion was one of several "international villages" at the Chicago World's Fair where restaurants and shops were housed in replications of the particular country's distinctive architectural style and staffed by people in native costume (Pl. II-8). By 1934, when the Mexican village opened, the muralists had achieved recognition among North Americans so that part of what would have distinguished that country's pavilion would have been the presence of frescoed walls. Valentín's "The Deer Dance" was a village festival, an appropriate theme for the pavilion. The white-clad figures, crowded into the foreground, were arranged around the dancers, highlighting the significance of the performance. Valentín combined strong tropical colors with a stylized cubist approach to represent form as a series of simple interlocking shapes. The exaggerated foreshortening and diagonal lines contributed to the sense of movement and festivity.

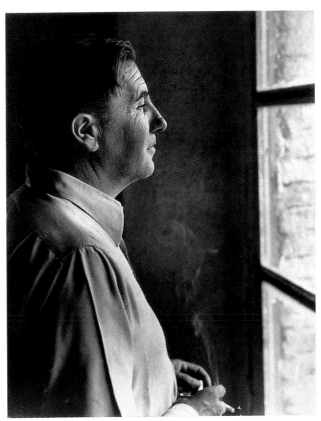

II-9 *Valentín Vidaurreta* photograph by Charles Kessler, III c. 1950
Collection of the Cartwright Family

In November 1935, the *New York Times* reviewed the exhibition at Delphic Studios which included paintings by Diego Rivera, David Alfaro Siqueiros, José Orozco, Carlos Mérida, Valentín Vidaurreta, and others.[10] At the same time, Valentín was painting his first mural in Mexico at the Papillon Club in the capital. In her 1935 travel guide, Anita Brenner described this popular bar near Sanborn's as "where you go to find people who go to find people who go to be found."[11] In a series of tableaux, Valentín used a rich and sensuous palette to depict the people and tropical landscapes of Tehuantepec in southern Mexico. Writing in *Mexican Life* magazine, what editor Howard Phillips found worthy of note were Valentín's balanced compositions and strong color sense and his successful adaptation to the club's architectural setting in the arrangement of the mural decorations.[12]

The last notice of Valentín's work as a painter appeared in the March 1938 issue of *Mexican Life:* "Something decidedly different in the way of stage-sets has been introduced here last month by the very gifted and versatile painter, Valentín Vidaurreta. These sets were used in connection with the annual ballet of the National School of Dance and present a radical departure from all the usual concepts of stage decoration. Reducing the actual sets to the minimum of silhouettes, Señor Vidaurreta has evolved a striking method of lighting that converts the stage into a weird and translucent abstract painting. So impressive, in fact, was the new stage decoration that in our opinion it actually dwarfed the rather amateurish ballet program."[13]

II-10 Valentín Vidaurreta *Siesta* watercolor in February 1936 *Mexican Life*
Courtesy of the Columbus Memorial Library

TURNING TO SILVER DESIGN

Perhaps it was the radical political climate that caused Valentín to quietly dissociate himself from the frenetic center of the Mexican art world, or perhaps it was his versatility as an artist that led him to take up silver designing. In March 1931, an advertisement in *Mexican Life* announced that unusual native arts and crafts which had formerly been sold at the Sonora News Company in the Hotel Iturbide, were now available at the gallery of F. W. Davis. At about that same time, Valentín began producing a line of silver jewelry for Fred Davis. All of this work was hallmarked *FD*. The necklace in Plate II-14 provides the link between Valentín's work for Davis and later for the Taller Borda, because the identical necklace can be found hallmarked either *FD* or *HA*. It is also possible that Valentín may have been the producer of one of the quintessential designs signed by Fred Davis (Pl. II-15). The necklaces with alternating carved onyx masks and flanges of silver resemble the necklace described above in the way that the simple geometric forms were embossed and hinged. Hèctor Aguilar, who knew Valentín well, described him as a designer and producer for Fred Davis in his book, *Artesanía de la Plata:* "In 1928, North American tourists were beginning to come to Mexico, and Fred Davis [sic] at Sanborn's, was the first to understand what they might want and offered a type of jewelry they liked, having it made at various workshops and using the best designers, like Valentín Vidaurreta."[14]

II-13 Valentín Vidaurreta *Arrow Pin* (F) c. 1945-50 925 silver/onyx
Collection of Penny C. Morrill

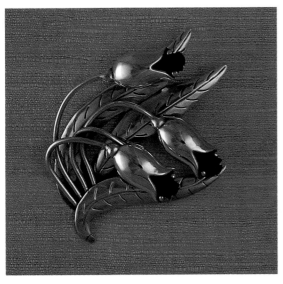

II-12 Valentín Vidaurreta *Onyx Flower Pin* c. 1950 silver/onyx
Collection of Penny C. Morrill

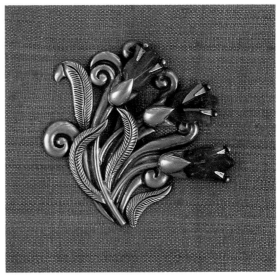

II-11 Valentín Vidaurreta *Large Amethyst Flower Pin* (F) c. 1945-50 925 silver/amethyst quartz/ goldwash
Collection of Gunther Cohn and Marc Navarro

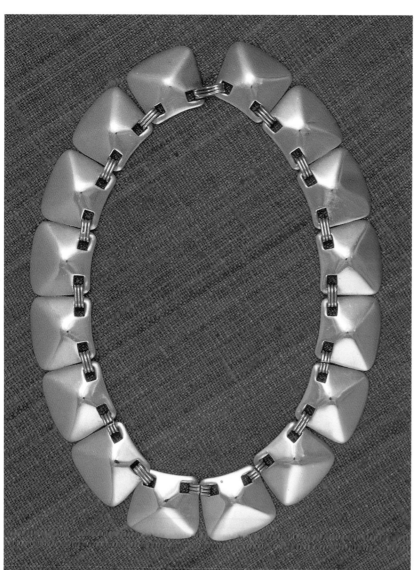

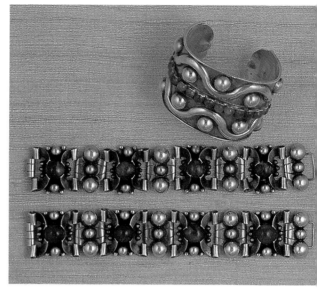

II-16 Frederick W. Davis *Amethyst Bracelets and Cuff* (Silver, Mexico. FD) c. 1930 sterling/amethyst quartz Collection of Carole A. Berk, Ltd.

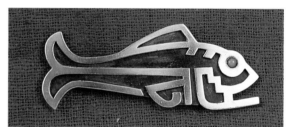

II-17 Frederick W. Davis *Fish Pin* (Silver, Mexico. FD) c. 1930 silver/ turquoise Collection of Leah Gordon

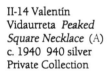

II-14 Valentín Vidaurreta *Peaked Square Necklace* (A) c. 1940 940 silver Private Collection

II-15 Frederick W. Davis *Black Mask Necklace and Ring* (FD) c. 1931 sterling/onyx Collection of Penny C. Morrill

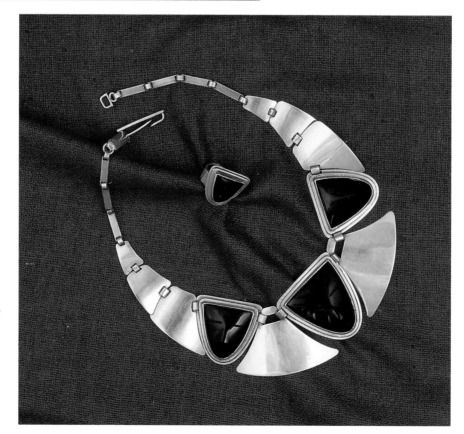

In 1935, Valentín was "making his home on his two-acre rancho at the edge of Taxco," referring to his purchase of the Hacienda San Juan Bautista in Taxco el Viejo.[15] Valentín's friendship with William Spratling and the beauty of the mountains probably influenced his move to the village which had become the destination for many Mexican and North American intellectuals and artists.

However, Valentín did not move permanently to Taxco. Instead he traveled frequently back and forth between Mexico City and Taxco, maintaining a taller in the capital on the corner of San Ignacio and Vizcaínas. Because of his prolonged absences, Valentín relied on a workshop administrator to supervise the production of his designs. Most of the brooches, bracelets, necklaces, and elaborate floral belt buckles were in *repoussé* and required the skills of a *maestro*. The ability of an expert silversmith was also necessary in assembling and finishing these complex pieces (Pl. II-18).[16]

All of Valentín's jewelry continued to be made for one important client, Fred Davis. Valentín's working relationship with Davis is borne out in the photographs of his jewelry that were taken in 1963 for the book *Mexican Jewelry* (Pls. II-19-20). In describing several pieces by Valentín, authors Mary Davis and Greta Pack wrote in 1963 that the work had been produced twenty-five years earlier. Thus, the date for the jewelry in the Davis and Pack photographs is c. 1938, long after Fred Davis had taken over Sanborn's arts and crafts division.[17]

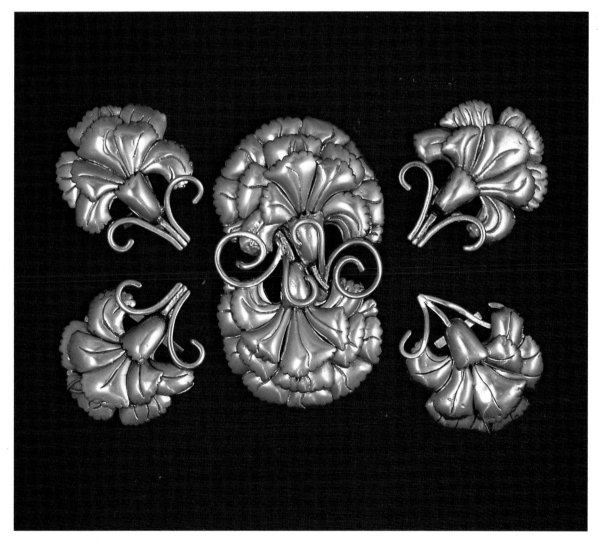

II-18 Valentín Vidaurreta *Floral Buckle and Ornaments* (VV. 930) c. 1935 Collection of Penny C. Morrill

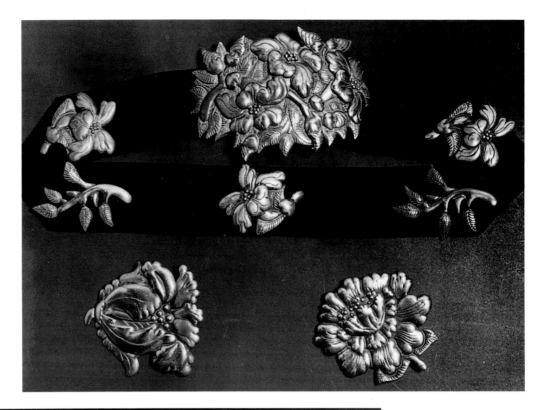

II-20 *Belt Ensemble and Pins Designed by Valentín Vidaurreta for Sanborn's* Photograph in the Collection of Federico and Ellen Jimenez

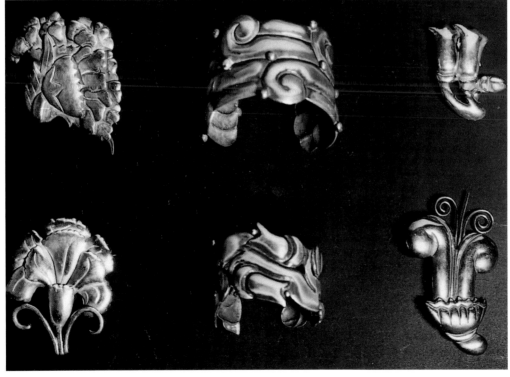

II-19 *Valentín Vidaurreta's Designs for Sanborn's* Photograph in the Collection of Federico and Ellen Jimenez

The importance of this connection through the photographs is that it will now be possible to identify as Valentín's some of the silver designs that were stamped with the Sanborn's hallmark. It is also likely that the large floral brooch in Plate II-21, which has no mark on the back other than its silver content (0.980), was made in Valentín's workshop. When compared to the pin in the Davis and Pack photograph (Pl. II-20), the differences between the two pieces are negligible, owing to the fact that these flower pins were handwrought and were probably in production over a number of years. The naturalistic rendering of the flower, its large size, the depth of the repoussé, and the vigorous overlapping of form were elements found in the silver designs of Valentín from this period, like the belt ensembles in Plates II-18-20.

Benjamín Santarriaga and his brother Odilón left the Taller de las Delicias in 1938 to work for Valentín in Mexico City. Antonio Pineda also worked for Valentín in the capital for several months, an experience which he believes had a powerful impact on his later work.[18]

The necklace in Plate IV-54 is hallmarked *AP* and can be considered the stylistic link between Antonio Pineda and Valentín Vidaurreta and between Valentín and Fred Davis. It is almost identical to the Fred Davis necklace in Plate II-15. The supposition can be made that the original necklace was produced in Valentín's Mexico City workshop and hallmarked FD. After Antonio Pineda left his apprenticeship with Valentín, he revived this early design and stamped it with his own hallmark.

Antonio Pineda remembers that Valentín was not very responsible financially and was often broke: "When there was not enough money to pay the workers on Saturday, Valentín always had that one fabulous piece of jewelry. He knew the most well-placed people of the highest society from Sonora and Mexico City. We would take this piece of jewelry to the house of one of these families to sell for the cash to make payroll."[19]

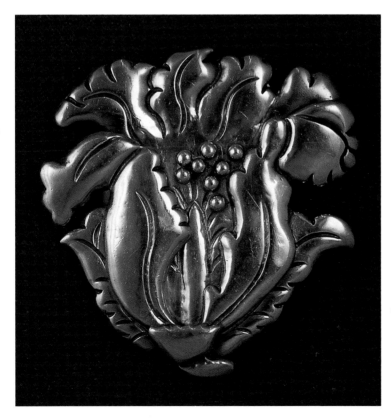

II-21 Valentín Vidaurreta *Large Flower Pin* (Sterling. 0.980) c. 1935
980 silver
Collection of Eric Salter

After 1935, even though Valentín was spending time in Mexico City, it is possible that he was also designing for William Spratling before he joined the Taller Borda in Taxco. In the late thirties, the Taller de las Delicias began producing a series of brooches, cuff bracelets, and necklaces depicting a woman's hand in silver holding a carved amethyst flower.[20] These pieces can be compared to the jewelry Valentín was designing for Fred Davis during that same period. They also closely resemble Valentín's amethyst flower designs which were later made and sold with the Taller Borda hallmark (Pls. II-22-25). Because the amethyst flower jewelry was so different from the Aztec bracelets and the parrots, owls, and jaguars which Spratling was fashioning in silver, these elegant hands with lace cuffs can be seen as more in keeping with Valentín's appreciation of the Mexican colonial period. Valentín may have worked with Spratling on other projects for he is said to have been asked by Spratling to design a chair for Leon Trotsky.[21]

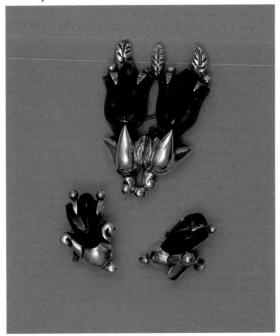

II-22 Valentín Vidaurreta *Amethyst Flower Pin* (C) *and Earrings* (Silver, Mexico) c. 1945 silver/true amethyst Collections of Carole A. Berk, Ltd., and Penny C. Morrill

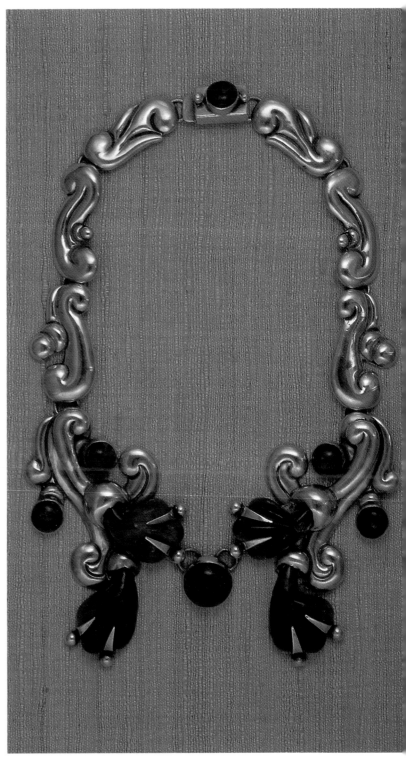

II-23 Valentín Vidaurreta *Actress/Singer Gale Robbins Acquired This Dramatic Necklace in Mexico While Filming the Movie "The Brigand" with Anthony Quinn and Anthony Dexter in the Late Forties* (F) c. 1945-50 925 silver/ amethyst quartz
Collection of Victoria Olson

THE BEAUTIFUL LIFE

According to Rob Cartwright, Valentín was in Taxco when the Aguilars arrived in 1936 and there developed between them a strong friendship and a relationship of interdependence and respect. When Héctor and Lois made the decision to strike out on their own, Valentín provided financial support.

Valentín's business relationship with Héctor Aguilar was not one-sided, for it allowed Valentín to supplement his inheritance. He was descended from two prominent families in the northern states of Sonora and Sinaloa, the Vidaurretas and the Verdugos.[22] He spoke five languages and his tastes were elegantly European. He came from wealth but had spent extravagantly, maintaining homes in Mexico City, Taxco, Cuernavaca, and Taxco el Viejo.[23] For Valentín, art was an intellectual response that became a way of life. He was remarkably talented and his wealth had allowed him the freedom to experiment in various media. Mexican artist Amador Lugo recalls, "Valentín was descended from a powerful family and was very wealthy. He was a gracious, lovely person and lived a bohemian life. Valentín painted because he loved to, not to become a great painter or to sell his work, and for this reason he is not well-known."[24]

Although Valentín had purchased an hacienda in Taxco el Viejo, he was living in a small house in Taxco before 1938.[25] In that year, he began construction on his house on the Calle de Las Estacas near the church of La Veracruz, now the Casa de la Cultura. This house probably took several years to finish because Natalie Scott writes in 1948,

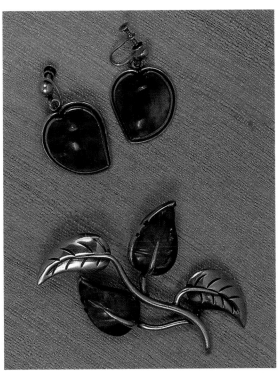

II-24 Valentín Vidaurreta *Carved Amethyst Pin* (B) *and Earrings* (I) c. 1945-50 940 silver/amethyst quartz
Collection of Lolly Commanday

II-25 Valentín Vidaurreta *Three Amethyst Flowers Necklace* (F) c. 1945-50 925 silver/amethyst quartz
Collection of Gunther Cohn and Marc Navarro

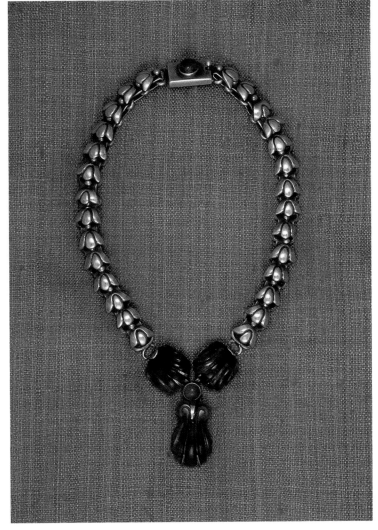

"Valentín has inherited another fortune of about half a million, and is busily spending it, as he has several previous ones. He has built a simply tremendous house in the lower section of town and has a really remarkable collection of handsome treasures, mostly of the Colonial epoch."[26] The house's stuccoed walls were enlivened with wooden balconies, circular windows, a cupola, and carved cornices and pilasters around the entrances (Pls. II-26-29). Valentín painted a mural over the fireplace and applied large *repoussé* copper shells in diamond shapes to the interior doors (Pls. II-30-31). The early photograph of Valentín's house (Pl. II-33) reveals the extent of his garden, filled with tropical trees and vines which flowered profusely. The garden no longer exists,

demolished to make way for a shopping mall, a block from the *zócalo*.

Valentín designed other houses in Taxco. In 1944, Ricardo Dueños and his wife bought part of the Schees's property and commissioned him to build a house for them. Sr. Dueños was a poet and his wife, a concert pianist, both having come to Taxco from San Salvador.[27] Valentín may also have collaborated with Hans-Joachim von Block in designing von Block's beautiful house in Cuernavaca.[28]

Left:
II-27 *View of the Rear of Valentín's House, Showing the Cupola*
Photograph in the Collection of Penny C. Morrill

Below:
II-28 *Stairway to the Entrance of Valentín Vidaurreta's House in Town*
Photograph in the Collection of Penny C. Morrill

II-26 *Carved Wood and Wrought Iron are Refinements to the Exterior of Valentín's House.*
Photograph in the Collection of Penny C. Morrill

86

II-31 *The Door Handle Resembles the Earrings in Plate II-32.*
Photograph in the Collection of Penny C. Morrill

II-29 *Carved Architrave and Pilasters at the Entrance of Valentín's Home*
Photograph in the Collection of Penny C. Morrill

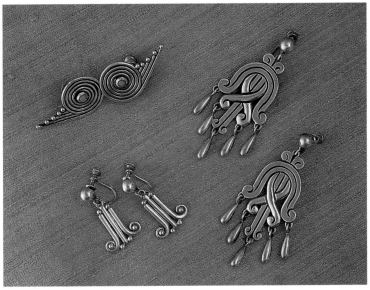

Left:
II-30 *Copper Shells Ornament the Interior Doors.*
Photograph in the Collection of Penny C. Morrill

Above:
II-32 Héctor Aguilar *Bell-shaped Earrings with Pendants* (D) c. 1945 940 silver; *Spiral Earrings* (D) c. 1945 940 silver/turquoise; Gabriel Flores *Wire Pendant Earrings* (K) c. 1945 940 silver
Collections of Penny C. Morrill, and Carole A. Berk, Ltd.

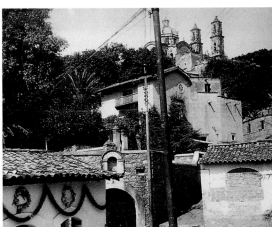

II-33 *Valentín Vidaurreta's House in Taxco* c. 1950 Photograph in the Collection of Luis Reyes Ramírez

87

Valentín had a small workshop in his house in Taxco, although he never registered as an independent taller. His jewelry designs were manufactured both at his workshop and at the Taller Borda. They were sold in the Borda showroom marked *HA* until the fifties, when the signatures of either Gabriel Flores, Valentín, or Héctor appeared in the rectangular hallmark.[29]

For a short period, during the early forties, Valentín formed a partnership with David Martinez Vázquez, son of the former owner of the Casa Borda, to establish a small workshop in the Borda. This short-lived venture, with Martinez Vázquez providing the capital, lasted only two years. In a business directory published in 1943, Héctor Aguilar was listed at Plaza Borda, No. 2 and Valentín Vidaurreta at Plaza Borda, No. 3.[30] Soon after, Valentín returned the taller to his house in town.

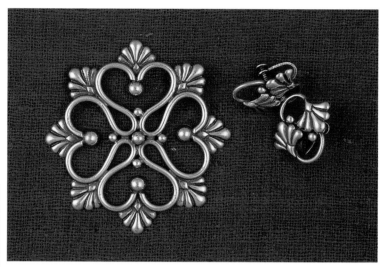

II-35 Héctor Aguilar *Fleur-de-lis Circle Pin and Earrings* (I) c. 1950 940 silver
Collection of Gunther Cohn and Marc Navarro

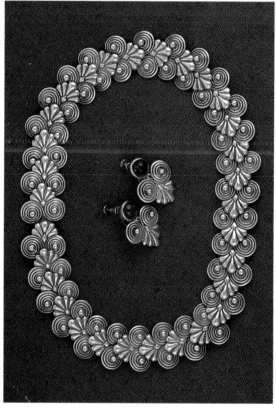

II-34 Valentín Vidaurreta *The Fleur-de-lis Necklace and Earrings, Designed by Valentín, Became the Inspiration for Other Pieces Produced at the Taller Borda.* (B) c. 1940 940 silver/amethyst quartz
Collection of Gunther Cohn and Marc Navarro

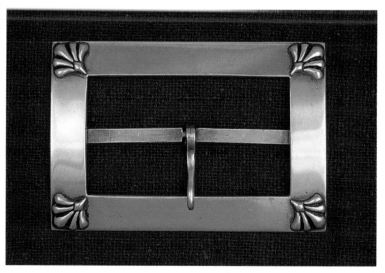

II-36 Héctor Aguilar *Large Rectangular Fleur-de-lis Buckle* (J) c. 1955 940 silver
Collection of J. Crawford

II-37 Héctor Aguilar *Fleur-de-lis Pendant/ Brooch* (J) c. 1955 940 silver/ copper Collection of Penny C. Morrill

From the beginning, Valentín contributed a distinctive style to the Taller Borda. The beautifully detailed flower pins and his other early designs were often in *repoussé*. His jewelry was displayed on a separate table in the showroom, with his nameplate in rosewood. His work was different from Héctor's, who had found inspiration in Pre-Columbian sculpture and painting for his boldly geometric jewelry and objects. There is no question, however, that the two men influenced each other in an artistic dialogue that lasted twenty years. The pectoral by Valentín and the many braided or woven designs by Héctor were both inspired by the Indian woven straw mats known as *petates* (Pls. II-38-39). Héctor's emphasis on abstract linear patterns and Valentín's elegant interpretation of natural form were divergent approaches that could only have been synthesized by an ongoing collaboration and mutual respect.

II-39 Héctor Aguilar *Braid Cuff with Three-ball Ends* (C) c. 1945; *Braid Cuff with Five-ball Ends* (B) c. 1940; *Small Braid Cuff with Three-ball Ends* (J) c. 1955 925 or 940 silver
Collection of Gunther Cohn and Marc Navarro

II-38 Valentín Vidaurreta *Petate Necklace* c. 1950 silver
Collection of Penny C. Morrill

In 1942, Valentín painted a mural for the School of Fine Arts in what is now a *tianguis,* or bazaar, filled with very ordinary silver jewelry (Pl. II-1). The school was inaugurated by the artist Fidel Figueroa. He and his wife Leslie had renovated the Casa de las Lágrimas [House of Tears] above the *zócalo,* which they renamed the Casa Figueroa and opened for tours. Fidel and another artist, Jaime Oates, taught classes in painting and sculpture to North American students who stayed in apartments provided by the school in the building next door.

Valentín was himself a sculptor, doing over-life-size portrait heads in marble. Artist Carl Pappe remembers seeing the large, one-meter square blocks of marble from Ixteopán in Valentín's garden. However, there is no evidence that Valentín ever taught painting or sculpture at the art school.[31]

Valentín was a friend of the Figueroas and offered to paint the mural at the school's entrance where the office was located. Vibrantly colored orchids are at the very center of the composition, set against the dense dark greens and creamy whites of the magnolia tree and its blossoms. The landscape is perfunctory, an undulating line of low hills, their stark appearance in contrast to the lush green in the foreground. The tree's color and line are exotic and sensuous, the growth so luxuriant that it seems to be pushing out of the picture's surface.

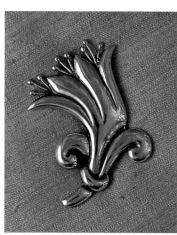

II-40 Valentín Vidaurreta *Coro Feathers, Floripondio, and Flower Pins* (E) c. 1943-50 silver
Collections of Gunther Cohn and Marc Navarro, and Frederick and Stella Krieger; Private Collection

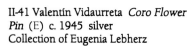

II-41 Valentín Vidaurreta *Coro Flower Pin* (E) c. 1945 silver
Collection of Eugenia Lebherz

II-42 Valentín Vidaurreta *Floral Pin* (VV. 930) c. 1945-50 930 silver
Collection of James D. Black
Photograph by James D. Black

II-43 *Valentín Vidaurreta's* hallmark
Photograph by James Black

Spratling's close friend Elizabeth Anderson, in her autobiography, recounted a description of a party Valentín gave in honor of Helena Rubenstein, the founder and owner of a large cosmetics company in the United States: "Helena Rubenstein visited Bill Spratling at his newly acquired house in Acapulco. . . . We spent a peaceful evening on the beach. . . . Helena Rubenstein kept us entertained with stories about her enormous business that she had built up from nothing. . . . We all went back to Taxco, where Valentín Vidaretta [sic] had arranged to give a party for Helena and the Prince in the huge old Hacienda San Juan de Batista [sic]. Everyone in town had been invited and we had pooled our servants to create a great and lavish *olla* of potted pigeons.

"The servants had been all over town, snaring and netting the pigeons, which were cleaned, plucked and plunked into a vast caldron. The ancient hacienda had been cleaned to perfection and the Olympic-size swimming pool with its Romanesque arches had been scrubbed down."[32]

Miss Anderson's reminiscences provide evidence that Valentín's ownership of San Juan Bautista predated Spratling's acquisition of his house in Acapulco in the late thirties. There is no indication that Valentín was living at the hacienda when he gave the party. Before he sold the hacienda to the Aguilars, he had done very little in the way of restoration other than to roof his bedroom in the main house. In 1945, his decision to share partial ownership with Héctor and Lois may have been predicated by an opportunity that was beckoning in Mexico City.

Right:
II-44 Héctor Aguilar *Two Flowers and Bud Pin* (C) c. 1945 925 silver; *Two Naive Flowers Pin* (B) c. 1940 silver
Private Collection

Below:
II-45 Valentín Vidaurreta *Large Tulip Flower and Three Flowers Pins* (B) c. 1940 940 or 990 silver
Private Collection

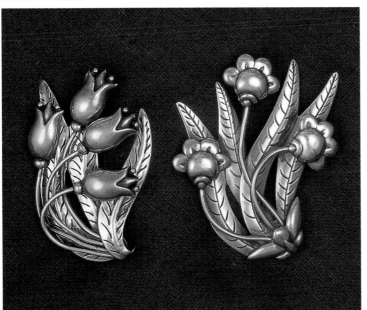

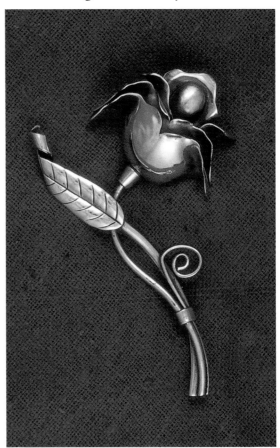

II-46 Héctor Aguilar *Large Rose Pin* (B) c. 1940 940 silver
Private Collection

Valentín was very much esteemed by Fred Davis and the Sanborns as a silver designer and they were anxious to have him back in the capital. The Sanborns urged him to return to Mexico City and whatever was produced in his newly reorganized workshop would be sold in the Casa de Azulejos [House of Tiles], the building which housed Sanborn's on Madero. Valentín took about eight young Taxqueñians with him and set up a taller in a building on the corner of the Calle de Aldaco.[33]

Valentín's designs for large, elaborate *repoussé* buckles with matching belt ornaments, and dramatic jewelry all had their origins in the flowers which he lovingly grew in his gardens and often reproduced in paint or silver (Pls. II-18-22). The pieces were beautifully crafted orchids, chrysanthemums, and pomegranate blossoms, reproducing the complex forms of the flowers as they appeared in nature, but with a stylization and creative arrangement of line and shapes that revealed the hand of the artist.

Valentín's stay in Mexico City lasted three years during which time he produced hundreds of pieces for Sanborn's. Upon his return to Taxco in 1948, he sold his part in the ownership of San Juan Bautista to the Aguilars. In the forties, Valentín and Robert Griffith had purchased the Hacienda Santa Rosa from Manuel Castrejón. Bob Griffith was manager and vice-president of Wells Fargo, the travel company that had commissioned Spratling's architectural design for the Hotel Rancho Telva in Taxco. When Griffith died, he left his portion of the hacienda to Valentín.[34] Sr. Castrejón recalled the dramatic changes made by Valentín: "His idea. . . was to live in tranquility in the countryside; he dedicated himself to the cultivation of orchids and got to the point where he had many varieties of the flower. His collection was famous, but, unfortunately, was lost when Sr. Vidaurreta died."[35]

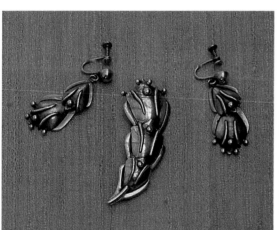

Left:
II-47 Héctor Aguilar *Triple Flower Pin and Earrings* (J) c. 1950 940 silver Collection of the Cartwright Family

Left:
II-49 Valentín Vidaurreta *Hummingbird Pin* (K) c. 1950 940 silver Collection of Penny C. Morrill

II-50 Valentín Vidaurreta *Bells Earrings* c. 1950 silver Collection of Penny C. Morrill

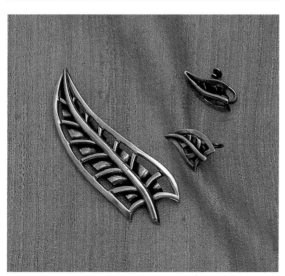

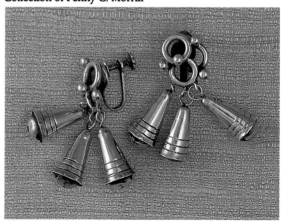

Left:
II-48 Valentín Vidaurreta *Leaf Pin and Earrings* (M) c. 1955 940 silver/goldwash Collection of the Cartwright Family

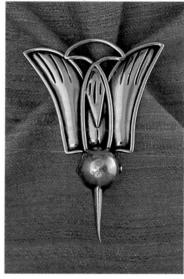

The village of Santa Rosa was so remote that Blanca Cartwright remembers the trip from Taxco had to be made in a jeep.[36] In spite of the isolation, the setting must have appealed to Valentín for its beauty. The village had grown up along a river that meandered through a deep and distant valley. Today in Santa Rosa, in the smallest gardens, flowers bloom in colorful profusion.

The entrance to Santa Rosa is difficult to find and all that is left of the hacienda are crumbling stone structures and an aqueduct that is completely covered by tropical growth (Pls. II-52). Under Valentín's guidance, the Hacienda Santa Rosa was restored to an aristocratic elegance, the interiors ornamented with angels in polychromed wood, and with Spanish paintings on the walls. Valentín designed the furniture for the house in the colonial style, reflecting his desire to interpret the hacienda authentically.[37]

The approach to the main house from the river was a multi-level patio which still exists but in poor condition. The public spaces, including a living room with a large fireplace, occupied the main residence, and Valentín's living quarters were in another part of the complex. What was most memorable about Santa Rosa were Valentín's gardens, which were planted in tiers down the slope to the river. His collection of orchids was renowned. He had hundreds of varieties, many of which were quite rare, including one called "la Negra." Valentín had a kiosk built in the garden where he could sit with his paints and canvases.[38]

Valentín kept the houses in Taxco and Santa Rosa after his return from Mexico City. He was well-known as a gracious host. According to Antonio Pineda, "Valentín was a fabulous cook. He trained a number of young men who later went to Acapulco as chefs. We would be invited for dinner Saturday and would spend the night. He could cook anything."[39]

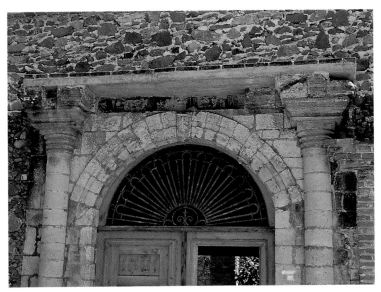

II-51 *Gate into the Courtyard at Hacienda Santa Rosa*
Photograph in the Collection of Penny C. Morrill

II-52 *Vegetation Overtakes the Aqueduct at Hacienda Santa Rosa.*
Photograph in the Collection of Penny C. Morrill

In the forties and fifties, Valentín contributed a number of designs that were produced in the Taller Borda.[40] In the last few years of his life, he spent most of his time at the hacienda and may have been less active as a designer.

Valentín's death came suddenly in 1959. He had gone into town to have lunch with the Aguilars. They were at the Casa Borda when he had a massive heart attack and died in Rob Cartwright's arms. Unfortunately he died intestate and the government stepped in to take possession of his property. Luis Reyes was instrumental in having Valentín's house in town converted into a center for children. It is now the Centro Cultural for Taxco where classes are given. Government functionaries stole all the furniture and works of art out of the Santa Rosa. One official's wife took the orchid collection.[41] What is left of Valentín's magnificent garden are the tiered steps set off by low stone walls. Tending the flowers, which still bloom, and the tall corn plants that grow there now are gardeners who worked for Valentín Vidaurreta forty years ago (Pl. II-53).

II-53 *Corn Now Grows at Santa Rosa, Tended by the Gardener who Worked for Valentín.*
Photograph in the Collection of Penny C. Morrill

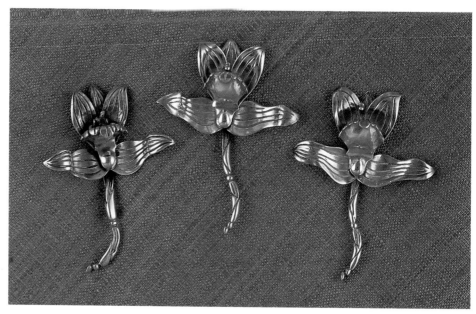

II-54 Héctor Aguilar *Three Orchid Pins* (B/C/E) c. 1945 925 or 990 silver
Collection of Gunther Cohn and Marc Navarro

[1] Guillermo Rivas, "The Art of Valentín Vidaurreta," 28.
[2] Guillermo Rivas, "Valentín Vidaurreta," 29. See *Modern Mexican Artists* for a brief history of this art school.
[3] Rivas, "The Art of Valentín Vidaurreta," 28. According to his daughter Irene Phillips Olmedo de José, Howard Phillips wrote occasionally under the pseudonym, Guillermo Rivas.
[4] Dolores Olmedo Patiño, interview by Penny C. Morrill. Don Emilio Azcarraga's mother was a Vidaurreta. According to Adán Alvarado, Valentín was *primo hermano*, or cousin, to Don Emilio, the founder of Mexico's first radio and television stations (Adán Alvarado, interview by Penny C. Morrill).
[5] Valentín's paintings appeared on the covers of *Mexican Life* in: April, June, and Nov. 1928; Jan. 1929; May 1934; and March 1936.
[6] Reyes, interview; see Williams, *Covarrubias,* 97 for more on Carmen López Figueroa.
[7] Shipways, *Mexican Houses Old and New*, 36-7. This house is mentioned in *New Designs for Old Mexico* by Henry A. Phillips, 107.
[8] *Mexican Life*, Vol. 7, No. 12, Dec. 1931: 53.
[9] *Mexican Life*, Vol. 11, No. 3, March 1935: 41.
[10] *Mexican Life*, Vol. 11, No. 11, Nov. 1935: 43.
[11] Anita Brenner, *Your Mexican Holiday*, 342. By 1940, the Papillon Club had moved to the Avenida Madero (Frances Toor, *Guide to Mexico*, 24). The original site of the club has been replaced by government buildings.
[12] *Mexican Life*, Vol. 12, No. 1, Jan. 1936: 41.
[13] *Mexican Life*, Vol. 14, No. 3, Mar. 1938: 42.
[14] Aguilar Ricketson, 70.
[15] *Mexican Life*, Vol. 11, No. 5, May 1935: 43.
[16] Reyes, interview.
[17] Davis and Pack, 197-8; Pl. 126.
[18] Morrill and Berk, 114, 142. Luis Reyes was a student in Mexico City in 1938-39 and remembers going to Valentín's workshop to sell several pieces he had made.
[19] Antonio Pineda, interview by Penny C. Morrill.
[20] These pieces were later featured in the 1943 Montgomery Ward catalogue (*Montgomery Ward Catalogue*, Christmas 1943; Morrill and Berk, 45-6, Pl. III-21).
[21] Alvarado, interview. Amador Lugo also remembers that Valentín had designed for Spratling (Amador Lugo, interview by Penny C. Morrill). Leon Trotsky was in exile in Mexico, living with Diego Rivera and Frieda Kahlo, and was assassinated in 1940.

[22] According to Blanca Cartwright, Valentín's grandmother's name was Carmen Verdugo de Verdad. Antonio Pineda has indicated that Valentín was from a prominent family in northern Mexico, possibly Sonora (Blanca Cartwright; Pineda, interviews). In the Mormons' *International Geneological Index*, Ramón Vidaurreta Verdugo, who might have been Valentín's father, was christened in 1864 in Culiacan, Sinaloa, and is listed with his parents, Valentin Vidaurreta and Guadalupe Verdugo.
[23] Carl Pappe; Alvarado; Amador Lugo, interviews by Penny C. Morrill.
[24] Amador Lugo, interview.
[25] According to Adriana Williams, Valentín's address in Rosa Covarrubias's address book was Callejón de la Luz No. 2, Taxco (Williams, Letter to Penny C. Morrill). An artist of merit, Rosa was the wife of artist and author, Miguel Covarrubias.
[26] *Martha Robinson Papers,* Letter from Natalie Scott to Martha Robinson, June 10, 1948. Reyes; Rob Cartwright, interviews.
[27] *Natalie Scott Papers*, letter from Freddie Jennison to Natalie Scott, Feb. 24, 1944. According to Adán Alvarado and Antonio Pineda, Valentín designed several houses in Taxco (Alvarado; Pineda, interviews).
[28] Pineda, interview. This house is covered extensively in the Shipways' *Mexican Homes of Today.*
[29] José Asención; Alvarado; Luis Flores, interviews. See the introductory description of hallmarks.
[30] *Directorio General de Socios de las Cámaras Nacionales del Comercio,* 388.
[31] Gloria Ireno; Carl Pappe; Roberto Cuevas Bárcenas, interviews by Penny C. Morrill. Frances Toor, in her 1957 *New Guide to Mexico* (p. 87), mentions the Taxco Art School with classes in all the fine arts. There are photographs of the art school in Leslie Figueroa's 1965 edition of *Taxco: The Enchanted Town.*
[32] Anderson and Kelly, 265-66.
[33] Alvarado; Reyes; Pineda, interviews.
[34] Reyes, interview. Rancho Telva was named for the opera singer Madame Marion Telva who had "married the Head of Wells Fargo" (Figueroa, *Stuffed Shirt in Taxco*, 80). In a 1942 *Who's Who and Buyers' Guide*, Robert E. Griffith was listed as Vice-President of Wells Fargo (p. 52).
[35] Manuel Castrejón Gómez, *Setenta Años en la Industria Embotelladora*, 93; Morrill and Berk, 114.
[36] Blanca Cartwright, interview.
[37] Blanca Cartwright, inteview.
[38] Rob Cartwright; Cuevas Bárcenas; Jesús Bustos Guardarama with Javier Ruiz Ocampo, interviews by Penny C. Morrill.
[39] Pineda, interview.
[40] José Asención remembers that Valentín had a small workshop and that some of his designs were made there, others at the Taller Borda. All were sold at the Borda shop.
[41] Henrik Shlubach Carr, Letter to Penny C. Morrill, May 20, 1995. Jesús Bustos Guardarama, interview by Ruiz Ocampo.

II-55 Valentín Vidaurreta *Orchids* 1950 charcoal pencil
Collection of the Cartwright Family

CHAPTER III

The Workshops

III-1 Valentín Vidaurreta *An Old Portal* June 1928 cover of *Mexican Life* Courtesy of the Columbus Memorial Library

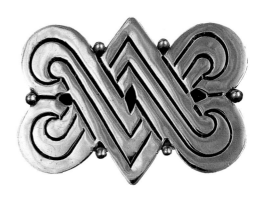

III-2 Héctor Aguilar *Double-V Rectangular Pin with Curved Edge* (C) c. 1945 925 silver Collection of Gunther Cohn and Marc Navarro

CHAPTER III

The Workshops

The object embodies the mind of the creator and allows the creative act to live on. When Héctor Aguilar established the Taller Borda, he provided a setting for artistic activity on a grand scale. As designer, teacher, and manager, Héctor inspired an aesthetic dialogue that included artisans, other designers, and the customers who bought the carefully crafted jewelry and objects from the Taller Borda.

Creativity engenders creativity, drawing the best out of everyone involved in the process. The workshop was an open and flexible environment. The structure itself

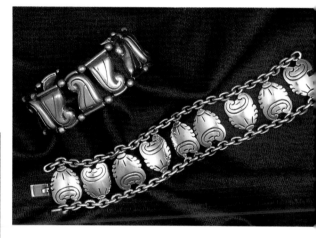

III-4 Héctor Aguilar *Pre-Columbian Style Bracelets* (C/I) c. 1945-50 925 or 940 silver
Private Collection

III-3 Héctor Aguilar *Knot Necklace, Bracelet, and Earrings* (D) c. 1940-45 940 silver
Collection of Frederick and Stella Krieger

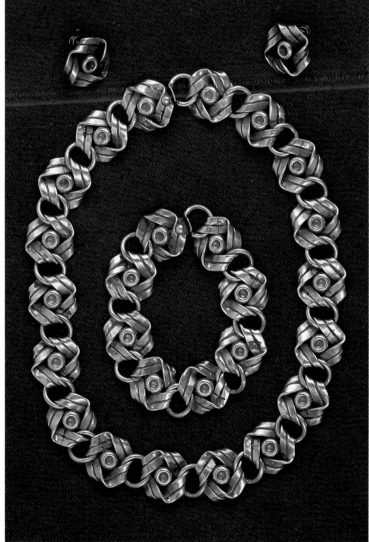

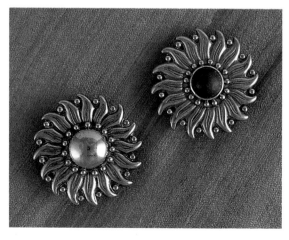

III-5 Héctor Aguilar *Malachite and Silver Sun Pins* (D) c. 1945 940 silver/malachite
Collection of Gunther Cohn and Marc Navarro; Private Collection

allowed for the expression of individuality among the workers. A handwrought industry, by its very nature, places an emphasis on the craftsman. At the Taller Borda, Héctor Aguilar was often a catalyst, providing an opportunity for the silversmiths, whom he trusted, to participate in the act of creating.

Héctor Aguilar arrived at his own design vocabulary, borrowing for the most part from the stylistic approach to form and the images of Pre-Columbian art (Pls. III-4-5). The use of clay stamp imprints, Mixtec manuscripts, and sculpture off the sides of the pyramids at nearby Xochicalco all had precedence in the vision of men like Diego Rivera and William Spratling. This choice of motifs was a philosophical one, confirming that Mexico's past was worthy of elevation to the same level of appreciation as European art. Pre-Columbian painting and sculpture also represented everything that was unique and exotic about Mexico. When travelers bought beautifully made silver jewelry that depicted Aztec

masks or birds and flowers in the style of the Mixtecs, they took away with them a worthy *recuerdo* of their stay in Taxco.

Héctor was the designer of most of the jewelry and objects produced by the Taller Borda, although Valentín Vidaurreta's contribution was important, particularly in the designing of silver jewelry. Pre-Columbian art was a significant presence in their work; however, both men found inspiration in the baroque splendor of the Church of Santa Prisca and were aware of international design

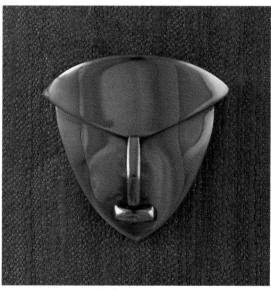

III-6 Héctor Aguilar *Abstract Face Pin* (B) c. 1940 940 silver
Collection of Gunther Cohn and Marc Navarro

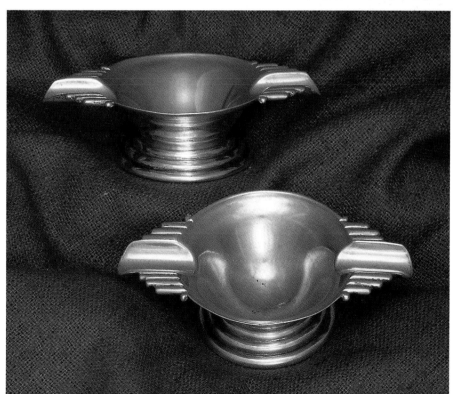

III-7 Héctor Aguilar *Two Art Deco Ashtrays* (B) c. 1940 940 silver
Collection of J. Crawford

trends (Pls. III-6-7). Their individual approaches were unique, but there is an identifiable style to the silver designs of the Taller Borda that indicates an ongoing dialogue. The soft whorls of the conch shells that wrap sensuously around the wrist in Plate III-8 exemplify the dramatic simplification of natural form that characterizes this artistic collaboration. The sophisticated elegance of the necklace and bracelet ensemble in Plate III-9 points to a mutual insistence on technical perfection and a devotion on the part of the two designers to the purity of geometric abstract form.

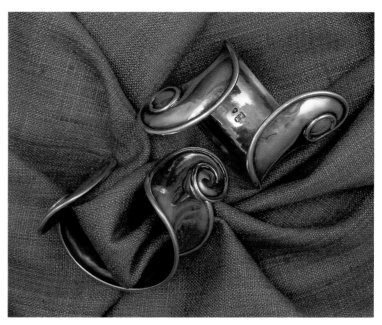

III-8 Héctor Aguilar *Pair Scrolled Cuffs* (D) c. 1945 940 silver
Private Collection

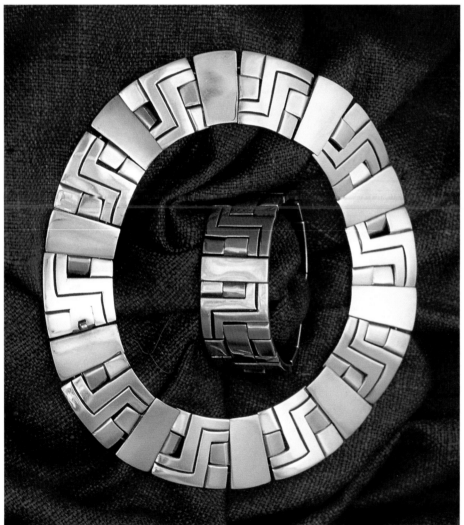

III-9 Héctor Aguilar *Puzzle Necklace and Bracelet* (J) c. 1955 940 silver
Collection of Carole A. Berk

A talented draftsman, Héctor took out his drawing pad in the evening and worked on perhaps five designs at a time, which he then shared with Lois. According to Rob Cartwright, "My father would always come up with something that my mother thought was a real stunner." The drawings were frontal views, incorporating technical aspects, for instance, using shading to indicate convexity and concavity for *repoussé*.[1]

The drawing was only the beginning of the design process. Héctor discussed with Julio Carbajal or Fuljencio Castillo where the soldering joints were to be or what type of hinges to use and where they were to be placed. Julio then made up the necklace or bracelet and final changes were incorporated after consultation with Héctor. The need for dialogue was particularly important when the piece was to be done in *repoussé*. A prototype and a master were made because so many aspects of the design could not be set forth on paper, but had to be communicated verbally or with the actual piece in hand.[2]

The original design for silver jewelry was produced in copper and attached to a wooden base. These masters were kept in a safe in the office. The designs for copper objects were made up as models by Fuljencio after Héctor had provided general instructions along with his drawing.[3] This design approach defined the character of the workshop. Aesthetic and technical solutions were found and integrated into the design and these were critical to the successful execution and the appeal of the finished piece. In acknowledgment of this effort, the Taller Borda won several Silver Prizes over the years at the annual Silver Fair in Taxco, always in competition with Spratling or Los Castillo.[4]

Robert Tarte's recollections of the working relationship between his uncle Héctor Aguilar and the *maestros* and artisans at the Taller Borda provide insight into Héctor's

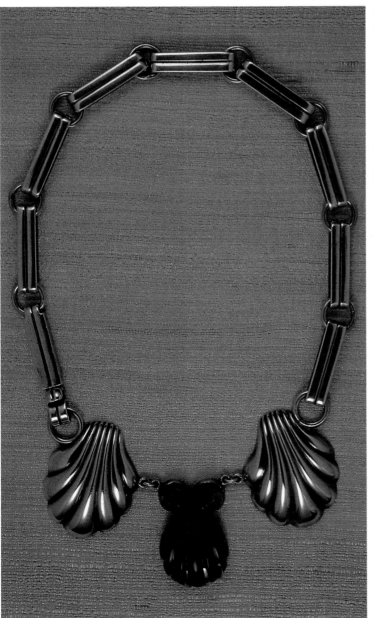

III-10 Héctor Aguilar *Silver and Amethyst Shell Necklace* (I) c. 1950 940 silver/amethyst quartz
Collection of Penny C. Morrill

gentlemanly demeanor and his respect for the talented men who worked for him: "I observed that Uncle Héctor's relationship with his employees was one of close collaboration and mutual respect; I never saw a trace of an overbearing manner. . . . An interesting process that took place regularly throughout each day was that of the craftsmen bringing pieces to Héctor (or to Benjamín or Luis) for inspection after final polishing. Each piece, handled with tissue paper in a manner that approached reverence, was studied carefully, and details were discussed and often complimented; occasionally, suggestions were made for touch-up. When accepted, the item was carefully wrapped in tissue and placed in one of two large safes, while the silversmith, with a smile and a clear bounce to his step, went back through the heavy door to the workshop, obviously proud and a little relieved that his piece had passed the test, had pleased Señor Aguilar."[5]

III-11 Héctor Aguilar *Tortoise, Silver, and Onyx Comb* (F) c. 1945-50 925 silver/tortoise/onyx
Collection of J. Crawford

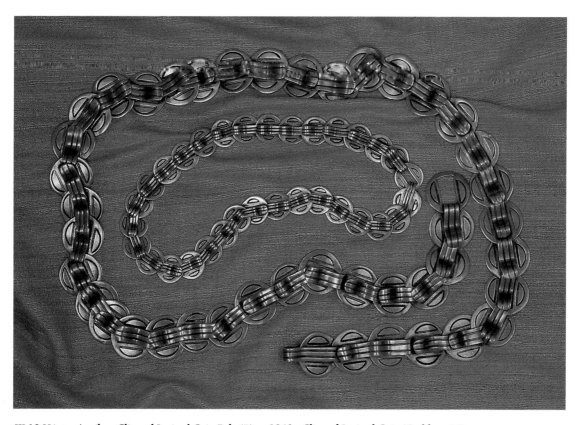

III-12 Héctor Aguilar *Clipped Incised Coin Belt* (B) c. 1940; *Clipped Incised Coin Necklace* (C)
c. 1940-45 925 or 940 silver
Private Collection

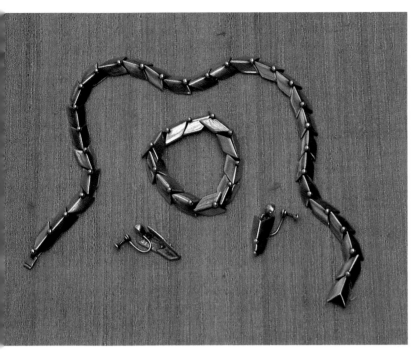

III-13 Héctor Aguilar *Arrow Point Necklace, Bracelet, and Earrings* (N) c. 1950 940 silver
Collection of the Cartwright Family

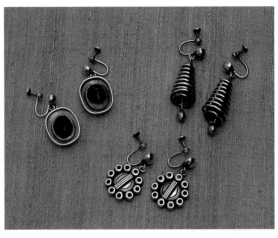

III-16 Héctor Aguilar *Amethyst Earrings* (J) c. 1950 940 silver/true amethyst; *Circle Earrings* (O) c. 1955; *Spiral Earrings* (J) c. 1950 940 silver
Collection of the Cartwright Family

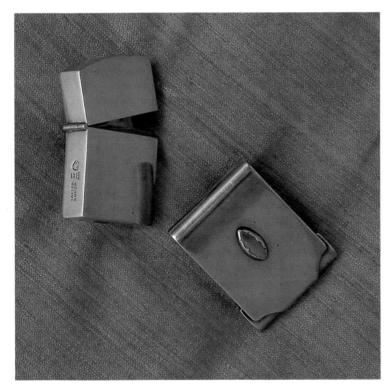

III-15 Héctor Aguilar *Cigarette Lighter* (L) c. 1955 940 silver; *Matchbook Cover* (B) c. 1940 940 silver/turquoise
Collection of J. Crawford

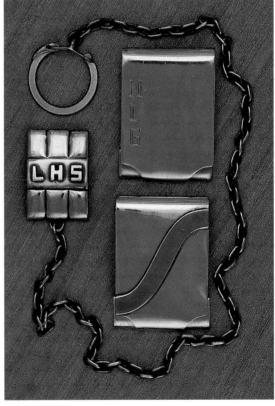

III-14 Héctor Aguilar *Matchbook Covers* (B) c. 1940-45 940 or 990 silver/copper
Collection of Gunther Cohn and Marc Navarro

THE ORGANIZATION OF THE TALLER

In 1947, Héctor Aguilar "of the prestigious Talleres Borda" provided information on the workings of the silver industry for a study on the state's economy conducted by the state of Guerrero. The typical workshop was said to be made up of the principal *maestro* [*maestro en jefe*], accomplished silversmiths [*plateros de 1a*], craftsmen [*oficiales*], and apprentices [*zorritas*].[6] The silversmiths were paid by the piece. The amount was assigned according to the intricacy of the work, *repoussé* being of the highest value. At the Taller Borda, when a new piece went into production, the value was set by Héctor in agreement with the silversmiths. A daily salary was paid when work was done that had no fixed value, such as special orders, models made for the first time, or repairs.

The principal *maestro* had responsibility for the general supervision of the work of the taller, and gave special attention to the training of the apprentices. The accomplished silversmiths were given the most delicate and difficult work, and those who excelled and could pass on their expertise were considered *maestros*. The craftsmen performed simple tasks, mostly finishing work. The apprentices ran errands and

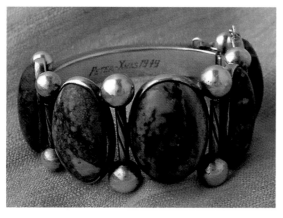

III-17 Héctor Aguilar *Malachite ID Bracelet* (D) c. 1949
940 silver/malachite
Collection of Carole A. Berk, Ltd.

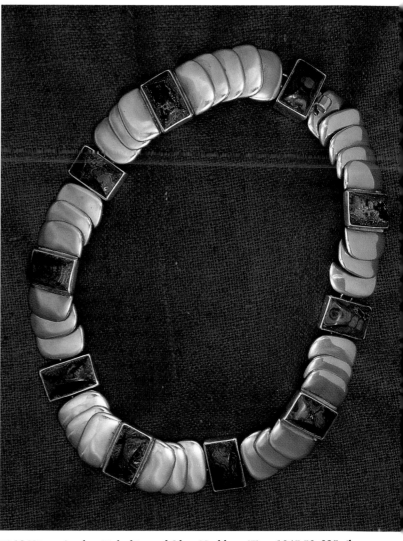

III-18 Héctor Aguilar *Malachite and Silver Necklace* (F) c. 1945-50 925 silver
Collection of Gunther Cohn and Marc Navarro

polished the finished pieces. After a *zorrita* entered the workshop, it took approximately six months to become an *oficial* and a minimum of three years to be a *platero*.

A silversmith hoped to produce an average of eight embossed bracelets or fifteen pins a week. If paid a salary, he received 10 pesos a day, and if by the piece, approximately 10-20 pesos each, the amount dependent on the complexity of the pin, bracelet, or necklace. A silversmith with an apprentice could work more efficiently. Ten silversmiths with one apprentice might produce work with a net value of four or five thousand pesos weekly. In 1947, a silver bracelet of secondary quality weighing fifty grams cost 35 pesos; a pin of twenty-five grams was 18 pesos; and a necklace weighing eighty grams had an average price of 55 pesos. However, a necklace with more elaborate detailing might cost 160 pesos; and if there were stones, the price could climb as high as 460 pesos.[7]

III-19 Héctor Aguilar *Square Malachite Cufflinks* (D) c. 1945 940 silver/malachite; Julio Carbajal *Onyx Cufflinks* c. 1945 silver/onyx
Collections of Jackson F. Morrill, and James A. Morrill

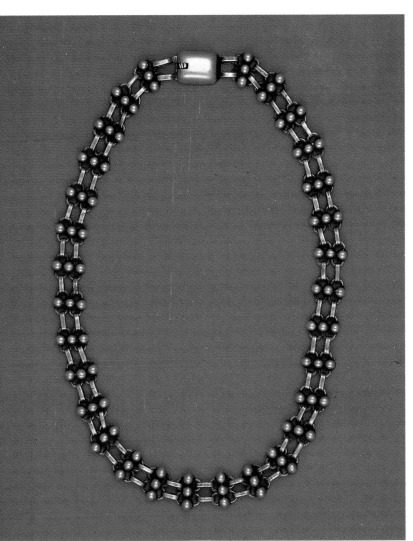

III-20 Héctor Aguilar *Chain with Three Beads Necklace* (B) c. 1940 990 silver
Private Collection

The Taller Borda store and the workshops were arranged around the courtyard on the east in the Casa Borda. The store faced south onto the *zócalo* with two entrances on either side of the wrought iron sign for the Taller Borda (Pl. I-19). A swinging door on the right of the salesroom led into three workshops along the eastern side of the courtyard (Pl. III-22).

LEATHER

The first room housed the leather workshop, overseen by Severo Estrada. Early in the history of the Taller Borda, this taller produced decorated leather belts and purses (Pl. III-23). The stitching was done in *pita*, taken from the maguey plant. *Pita* is a tough cream-colored thread, which was sometimes dyed pink or pale blue. The belts which came in two widths were decorated with stitched scrollwork, flat silver ornaments, and had silver buckles (Pl. I-22). The mark *HA* was burned into the leather or stitched in *pita*. Once the war had begun to have an impact on Taxco's silver industry, these belts and purses were no longer made. The leather workers turned to the production of the simple leather strips that were used for the X-belts (Pls. III-24-27).[8]

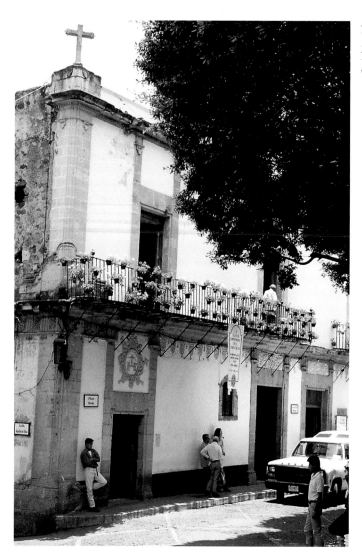

III-21 *The Facade of the Casa Borda in 1995*
Photograph in the Collection of Penny C. Morrill

III-22 *Small Doorway from the Showroom into the Workshops*
c. 1950
Photograph in the Collection of Robert D. Tarte

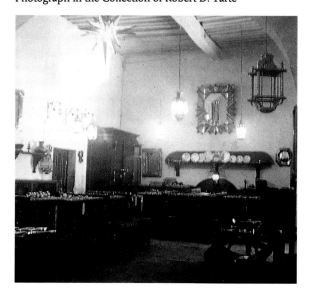

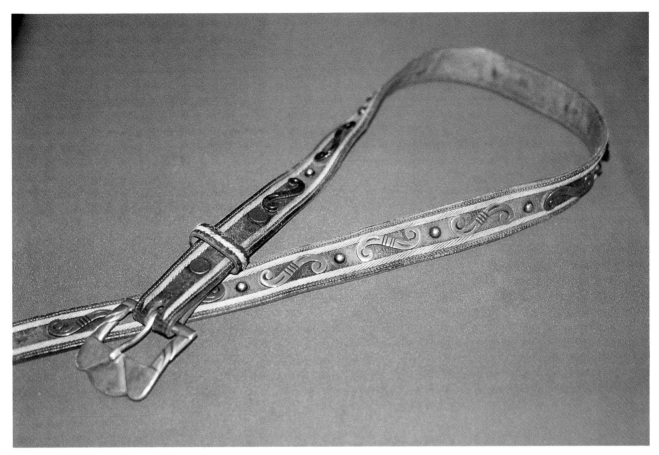

III-23 Héctor Aguilar *Leather Belt with Silver Detailing and Buckle* c. 1940-45 silver/leather/pita
Collection of Luis Reyes Ramírez

III-24 Héctor Aguilar *Seven Large X's, and Large X's with One Button Belts*
(B) c. 1940; *Arrow Point Belt* (J) c. 1955; *Narrow X's with Three Buttons Belt*
(C) c. 1940 925, 940, or 990 silver/black leather
Collections of J. Crawford, Frederick and Stella Krieger, Ronald A. Belkin, and
Gunther Cohn and Marc Navarro

III-25 Héctor Aguilar *X-bracelet* (B) *and X with dots belt*
(C) c. 1940 925 or 990 silver/black leather
Collection of Gunther Cohn and Marc Navarro

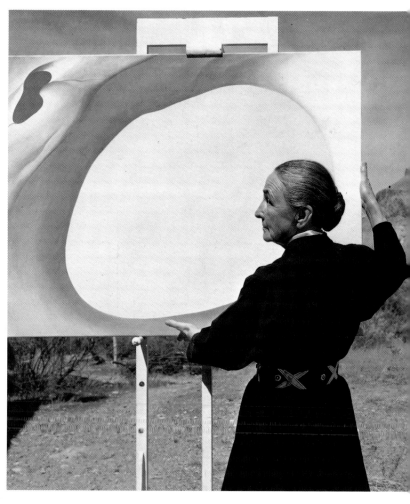

III-26 *Georgia O'Keeffe with "Pelvis Series — Red with Yellow" Abiquiu, New Mexico, April 8, 1960 Georgia O'Keeffe is Wearing an X-belt by Héctor Aguilar which She May Have Purchased or Received as a Gift When She Visited Rosa Covarrubias in 1951.* Photograph by Tony Vaccaro, Courtesy of Tony Vaccaro

III-27 Héctor Aguilar *Figure 8 Embossed Belt* (O) c. 1955 940 silver/black leather
Collection of Gunther Cohn and Marc Navarro

CARPENTRY

Roberto Cuevas and his half-brother Genaro Juarez were the *maestros* for the carpentry workshop. Cuevas was trained by Maestro Flores and is still considered one of the finest craftsmen in Taxco. The carpentry shop, with its lathes, vises, and large saws, was located in the courtyard. The shop was moved upstairs when all the machinery was put in place during the war. Cuevas and the other carpenters then shared the room which faced north onto the Plazuela de Bernal with Fuljencio Castillo and the coppersmiths.

The carpenters made jewelry boxes that were turned over to the silver workshop where peacocks or flowers in silver were attached with brads that fitted into three holes drilled in the top of the box (Pls. III-28, IV-7). The carpenters also provided wooden handles for silver or copper pitchers and tea sets and made the wooden bases for the jewelry models. These models, when inked, were used to create patterns for cutting the jewelry out of silver.[9]

Furniture designed by Héctor Aguilar was produced in quantity but was always a secondary operation. Large tables, chairs, some case pieces, and coffee tables were made in a variety of woods, most often in pine or juniper (Pl. III-29). Among the woods used at the Taller Borda were soft woods like cypress or sabine, and extremely hard woods like ironwood, vera, ebony, and two types of mahogany, caoba and zopilote. Other woods included ashwood, walnut, rosewood, cedar, brazilwood and guayacan. The ebony was brought from Zihuatanejo and mahogany from Mexico City. Amaranth or purple heart, called rosewood in Mexico, was often used at the Taller Borda. This wood is naturally purple and when oiled, becomes a deep purple-brown. Héctor ordered the amaranth, ebony, and some mahogany from Indians who mostly came from the coastal area. The wood was dragged into town by burros and the large trunks were cut up in the courtyard with a big circular saw.[10]

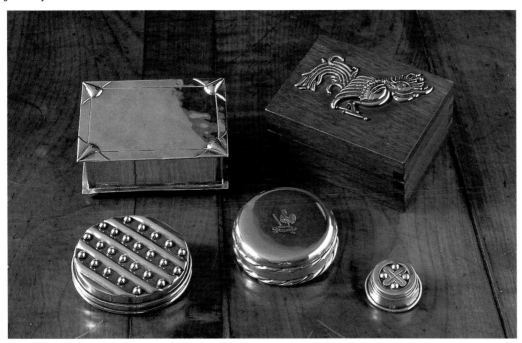

III-28 Héctor Aguilar *Wooden Box with Silver Rooster* c. 1940; *Oval Silver Box, Raised Lines* (F) c. 1945-50; *Small Circular Box with Gold Symbol; Lidded Box with Ball Feet, and Circular Box with Engraved Rooster* (B) c. 1940 925 or 940 silver
Collection of Gunther Cohn and Marc Navarro

Roberto Cuevas calls himself "Santa María de todo el mundo," a jack of all trades. At the Taller Borda, Cuevas was responsible for everything wooden, the objects either turned, carved, or formed by combining both techniques. He was involved in the production of holloware as a silversmith and as a carpenter. To make the "onion" coffee pot or any of the pieces that had large round bases and narrow necks, Cuevas placed a disc of silver on a turning lathe and hammered it around a form composed of several pieces of wood (Pl. III-30). As the silver was hammered or chased with a burin, it hardened and had to be heated or annealed several times during the process. When the container was finished, the wood was removed through the narrow neck in small pieces so that it could be reassembled and used again. Cuevas designed and created the wooden form and occasionally made the pitcher or pot himself.

III-29 Héctor Aguilar *Chair in Leather and Wood* c. 1945-50
Collection of Virginia Redondo de Pérez
Photograph by Penny C. Morrill

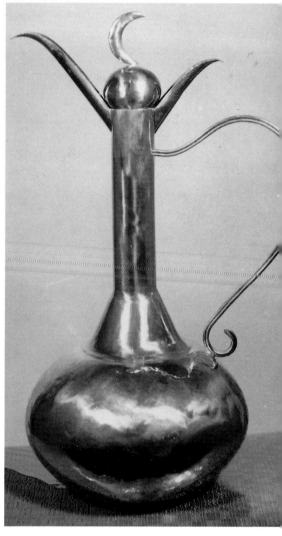

III-30 Héctor Aguilar *Middle Eastern Style Copper Carafe*
Photograph in the Collection of Fuljencio Castillo

Cuevas had his own hallmark, an *RC* with a *B* to the side. He made all his own tools, gravers and burins, and produced dies for silver jewelry in steel or antimony. He and Dámaso Gallegos also were gunsmiths, a technical expertise that some silversmiths acquired. In the late fifties, Roberto Cuevas made many of the tables for the chess sets designed by Héctor Aguilar and his son-in-law Gabriel Flores (Pls. III-42-43). The sets in silver and copper or copper and brass were expensive, priced at about three thousand pesos, and were even higher in price if in silver and vermeil. For example, the "*panzón*" set designed by Héctor was in copper and silver and the Medieval chess pieces, Gabriel Flores's design, were in silver and vermeil (Pls. IV-10-12).[11]

The design impact of the tray, shoehorn, and salad set in Plates III-31-33 is impressive, but what distinguishes these pieces above all is the beauty of the craftsmanship. The wooden fork and spoon handles bend gently downward to allow the silver bases to rest on the table. The curved lines of the carved volutes flow outward to encompass the bowls of the fork and spoon. The repeated motif in softly carved wood and in the etched bright surface of silver contribute to a balanced and elegant composition.

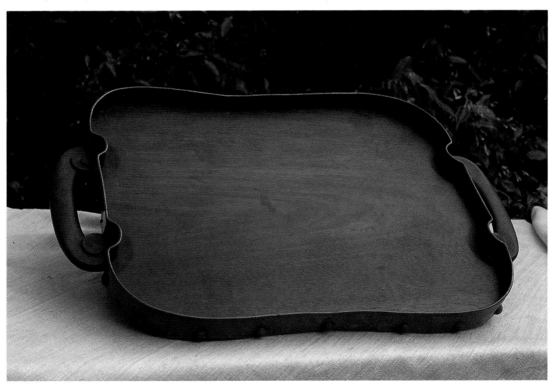

III-31 Héctor Aguilar *Large Mahogany and Copper Tray* (S) c. 1940-45 copper/ mahogany
Collection of Gunther Cohn and Marc Navarro

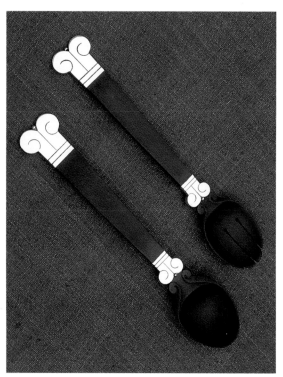

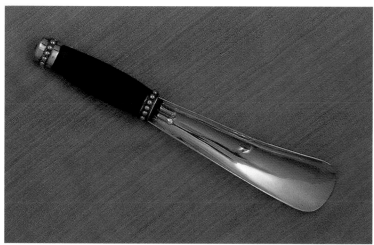

III-33 Héctor Aguilar *Shoe Horn* (P) c. 1955 925 silver/rosewood
Collection of J. Crawford

III-32 Héctor Aguilar *Salad Set* (L) c. 1955 940 silver/
rosewood
Collection of Gunther Cohn and Marc Navarro

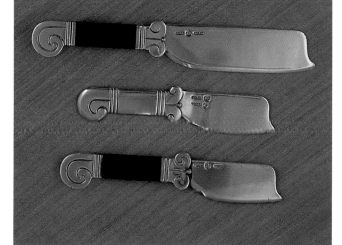

III-34 Héctor Aguilar *Cheese Spreaders with
Wooden Handles* (D) c. 1945 925 silver/
rosewood; *Silver Cheese Spreader* (P) c. 1950
925 silver
Collections of Gunther Cohn and Marc Navarro,
and Frederick and Stella Krieger

III-35 Héctor Aguilar *Four
Square Onyx and Silver
Buttons* (O) c. 1955; *Bar Pin*
(F) c. 1945-50 925 or 940
silver/onyx
Collection of the Cartwright
Family

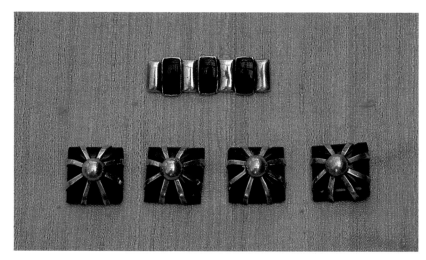

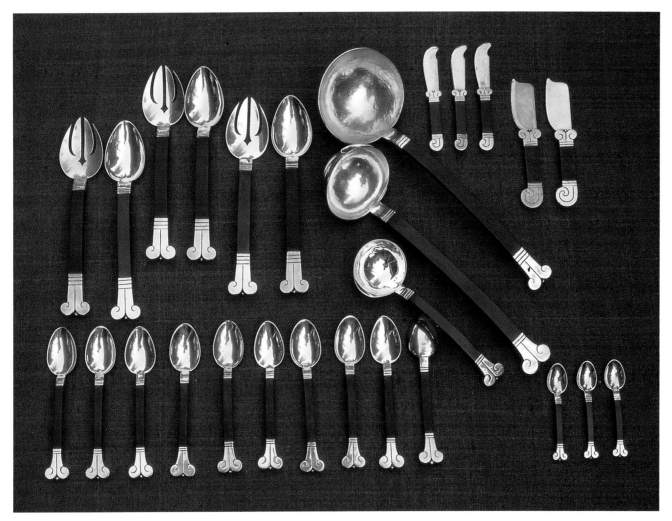

III-36 Héctor Aguilar *Three Varying Size Ladles* (L) c. 1950; *Seven Spoons and Butter Knife* (B) c. 1940; *Three Spoons, Three Demitasse Spoons, and Salad Set* (I) c. 1950; *Two Salad Sets and Butter Knife* (P) c. 1950; *Butter Knife* (N) c. 1950; *Two Cheese Knives* (Q) c. 1948 925 or 940 silver/rosewood
Collection of Gunther Cohn and Marc Navarro

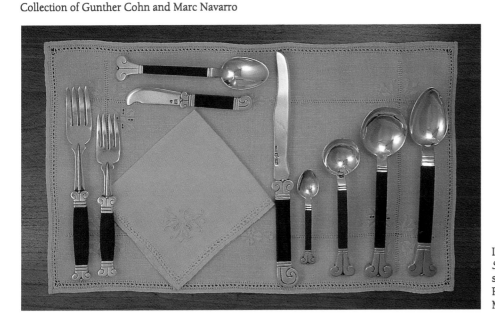

III-37 Héctor Aguilar *Place Setting in Silver and Rosewood* c. 1950 925 silver/rosewood
Private Collection – Santa Fe, New Mexico

Although Roberto Cuevas was primarily employed by Héctor Aguilar, his ability as a craftsman placed him in demand. He was "lent" to Spratling to do trophies and other specialty pieces. After the Taller Borda closed, he worked for Los Castillo and Antonio Pineda and has been with Ezequiel Tapia for sixteen years. The silver and gold box in Plates III-38-39 is the exceptional result of a collaboration that involved both the designer and craftsman. Cuevas has received a number of important commissions, recently producing a domino set in rosewood and silver that was presented to the Mexican President Ernesto Zedillo.[12]

Left:
III-38 *Ezequiel Tapia and Roberto Cuevas with their Beautiful Box* 1994
Photograph in the Collection of Penny C. Morrill

Below:
III-39 Ezequiel Tapia *Box in Silver and Vermeil and Etched Rock Crystal* (Exel) 1994
Photograph Courtesy of Ezequiel Tapia Bahena

IRON

Gabriel and his brother Daniel Embriz were the *maestros* in the ironworks, located in the courtyard. What was produced in wrought iron included fireplace equipment, holders for lanterns, and stands for large planters (Pl. III-40). Most of the work was of heavy twisted iron ornamented with bands of copper. These large-scale heavy pieces were sold in quantity, even to the casual tourist. The Taller Borda had a contract with Villarreal y Guerrero, international shippers in Mexico City, to crate and send to the purchaser's home anything from a set of silver flatware to a set of fireplace tools.[13]

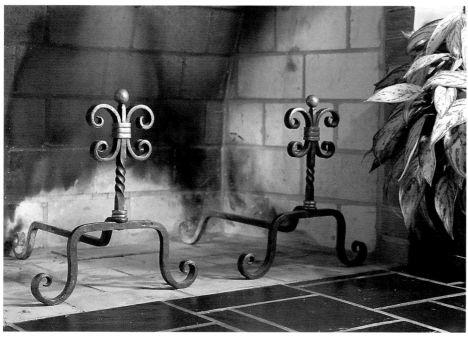

III-40 Héctor Aguilar *Andirons* (R) c. 1940 wrought iron/copper
Collection of Carole A. Berk, Ltd.

Right:
III-41 Héctor Aguilar *Copper and Iron Pot* (R) c. 1940 copper/wrought iron
Collection of the Cartwright Family

COPPER

The artisans in the Taller Borda never worked in tin, but copper rivaled silver in importance. Fuljencio Castillo, the *maestro* of the copper division, was with Héctor Aguilar for twenty years. As a young man, he appeared in the June 1952 issue of *Popular Mechanics Magazine* at his work table, intent on the construction of a faceted mirror.[14]

Before a lamp or copper tea set went into production, Héctor provided an original concept on paper and Fuljencio made the model, giving each of the designs a name by which it could be identified. Fuljencio made or oversaw the production of lamps, sets for beer, bowls, trays, mirrors, the scroll candelabra, small cabinets, coffee and tea sets. Roberto Cuevas made the wooden handles for the pitchers and tea or coffee sets and these were brought to the coppersmiths for final assembling.

The lamps and mirrors were made up of glass; copper or silver strips; and copper, brass, or silver discs. The discs served to cover joints, but were also decorative and part of the design. The strips were cut according to the size of the piece of mirror or glass and bent around a thick wire to create a tube. The tubes were mitred to match the angles of the mirror facets. The coppersmith then ran an icepick through the tube to open it just enough so that the tube would fit tightly onto the edge of the glass.

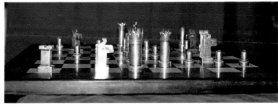

III-43 Héctor Aguilar *Silver Chess Set with Board* c. 1955 silver/ebony Private Collection

III-42 Héctor Aguilar *Panzón Chess Piece* c. 1950 copper Collection of Luis Flores

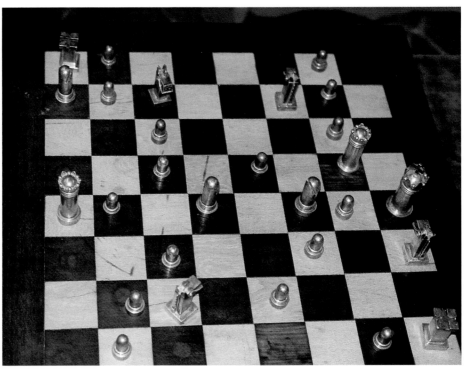

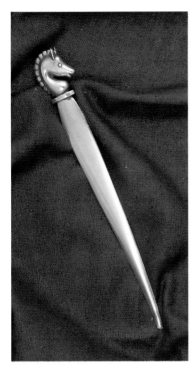

III-44 Héctor Aguilar *Copper Letter Opener* (R) c. 1950 copper/eyes are tiny brilliants
Private Collection

III-46 Héctor Aguilar *Copper Mirror* (R) c. 1940 copper/glass
Collection of Gunther Cohn and Marc Navarro

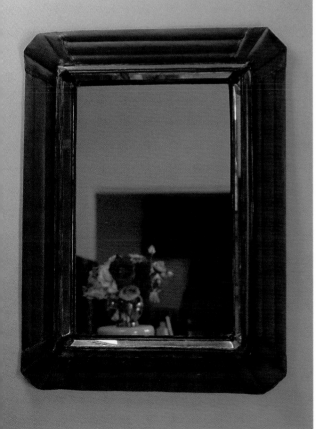

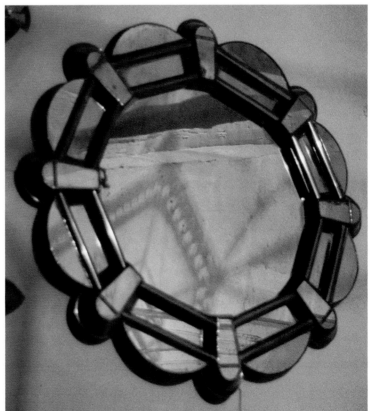

III-45 Héctor Aguilar This *Copper Mirror Box Originally had Mirrors on the Sides.* (R) c. 1945 copper/mirror
Collection of J. Crawford

III-47 Héctor Aguilar *Circular Mirror* c. 1940 copper/glass
Collection of Virginia Redondo de Pérez
Photograph by Penny C. Morrill

The discs were cut, then shaped into a wooden mold with an iron mallet. Rob Cartwright remembers that Fuljencio had a half-log of hard wood with numerous carved out spaces for making the different discs and shapes for the lamps and other decorative objects. Before soldering the discs onto the lamp, the surfaces were prepared with muriatic acid, although to clean mirrors, the acid was cut with water and zinc. The tin/ lead solder was applied with a soldering iron that had either a point or an angled tip. The surfaces were cleaned with a triangular-shaped file so that only a line of soldering remained in the joint.

III-50 Héctor Aguilar *Four Copper and Brass Beer Mugs* (R) c. 1940 copper/ brass
Collection of Gunther Cohn and Marc Navarro

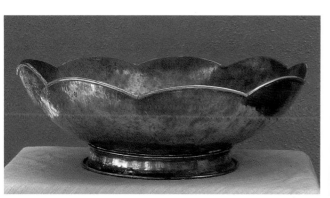

III-48 Héctor Aguilar *Large Scalloped-edge Bowl* (R) c. 1940 copper/brass
Collection of Frederick and Stella Krieger

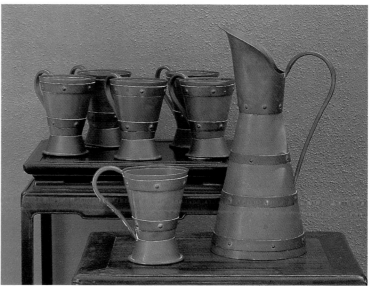

III-51 Héctor Aguilar *Inverted Cone Pitcher and Six Cups* (R) c. 1940 994 copper/brass
Collection of Gunther Cohn and Marc Navarro

III-52 Héctor Aguilar *Shallow Brass and Copper Bowl* (R) c. 1940 copper/ brass
Collection of Gunther Cohn and Marc Navarro

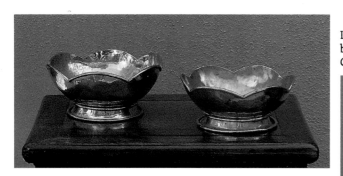

III-49 Héctor Aguilar *Two Scalloped-edge Copper and Brass Bowls* (R) c. 1940-45 copper/brass
Collections of Frederick and Stella Krieger, and Gunther Cohn and Marc Navarro

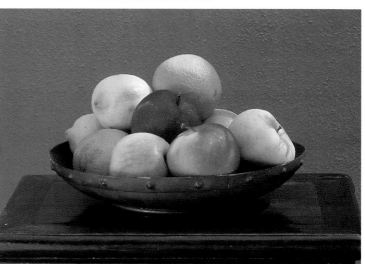

118

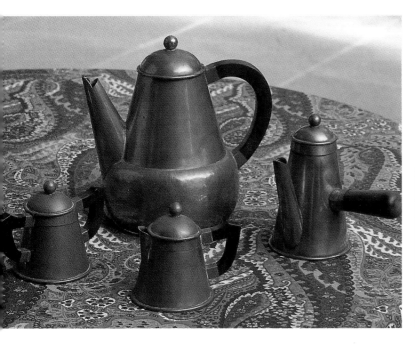

III-53 Héctor Aguilar *Copper Teapot; Sugar and Creamer; Demitasse Pot* (R)
c. 1940 copper/wooden handles
Collection of Gunther Cohn and Marc Navarro

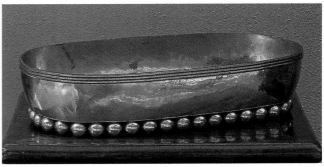

III-55 Héctor Aguilar *Large Oval Copper Bowl with Ball
Base* (R) c. 1940 copper
Collection of Gunther Cohn and Marc Navarro

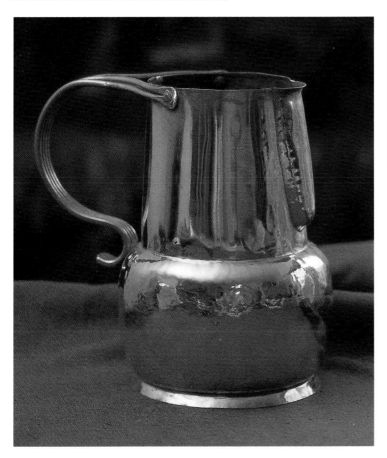

III-54 Héctor Aguilar *Copper Pitcher* (R) c. 1950
Collection of Carole A. Berk, Ltd.

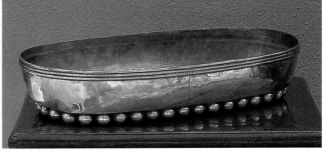

III-56 Héctor Aguilar *Large Oval Brass Bowl with Ball Base*
(R) c. 1940 brass
Collection of Gunther Cohn and Marc Navarro

Among the many designs in copper produced by the taller, the scroll candelabra were among the most successful (Pl. III-58). The eye follows the tumbling spirals as though they were lines in relief. Balance and movement coexist as the spirals push upward toward the light of the candles. The candelabra were made in silver only two or three times, but were produced in copper over all the years that the workshop was active (Pl. III-59).[15]

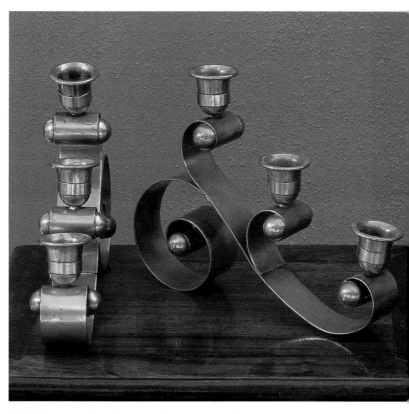

III-58 Héctor Aguilar *Copper and Brass Candelabra* (R) c. 1940 copper/brass Collection of Frederick and Stella Krieger

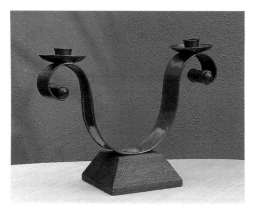

III-57 Héctor Aguilar *U-shaped Candelabrum* (S) c. 1940-45 copper/wooden base
Collection of J. Crawford

III-59 Héctor Aguilar *Silver Candelabra* (l) c. 1955 925 silver Collection of Federico and Ellen Jimenez

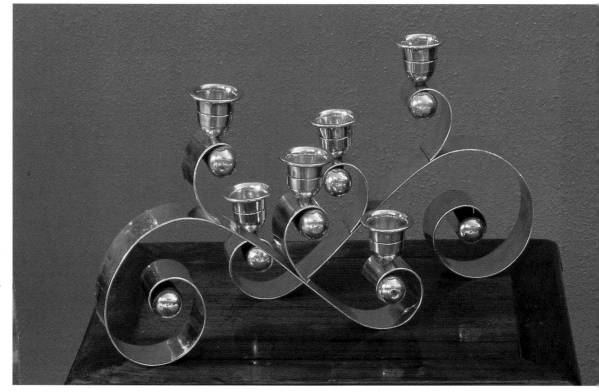

After the Taller Borda went bankrupt, Fuljencio worked for two years in Antonio Pineda's workshop. He then put together a taller in his own home where he continued to make copper lamps and other decorative objects. One of his most remarkable achievements was the copper model of the Church of Santa Prisca, for which he received an award in 1952 (Pl. III-73). The detailed model, one meter high and a meter in length, was displayed for many years in Taxco's City Hall.[16]

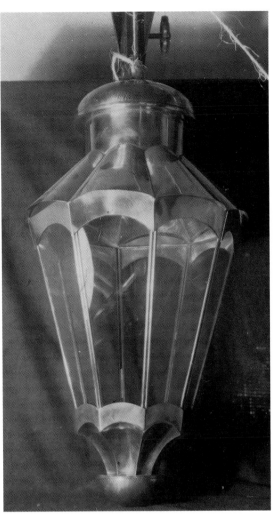

Below:
III-60 Héctor Aguilar *Copper Lantern* (R) c. 1940 copper/glass
Collection of Susan McCloskey Photograph by Thomas McCloskey

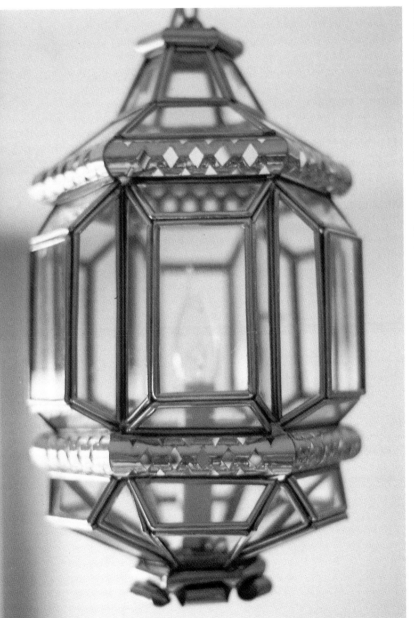

Above:
III-61 Héctor Aguilar *"The Spool" Copper Lantern*
Photograph in the Collection of Fuljencio Castillo

121

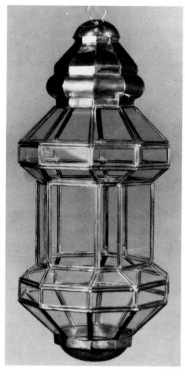

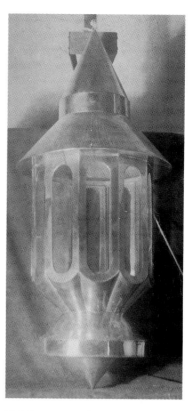

III-62 Héctor Aguilar *Copper Lantern*
Photograph in the Collection of
Fuljencio Castillo

III-64 Héctor Aguilar *"The Para-
chute" Copper Lantern*
Photograph in the Collection of
Fuljencio Castillo

III-66 Héctor Aguilar *"The Rocket"
Copper Lantern*
Photograph in the Collection of
Fuljencio Castillo

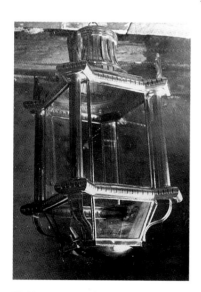

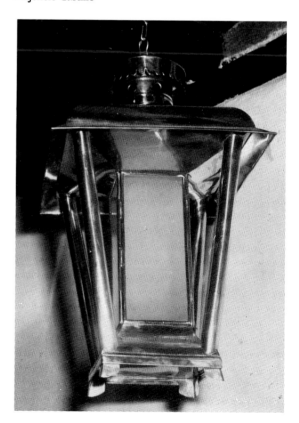

III-63 Héctor Aguilar *"Four Columns"
Copper Lantern*
Photograph in the Collection of
Fuljencio Castillo

III-65 Héctor Aguilar *"Modern Four
Columns" Copper Lantern*
Photograph in the Collection of
Fuljencio Castillo

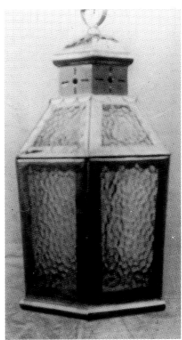

III-69 Héctor
Aguilar *Copper
Lantern for a Boat*
Photograph in the
Collection of
Fuljencio Castillo

III-67 Héctor Aguilar *"The Star" Copper Lantern*
Photograph in the Collection of Fuljencio Castillo

III-68 Héctor Aguilar *Copper Lantern*
Photograph in the Collection of Fuljencio Castillo

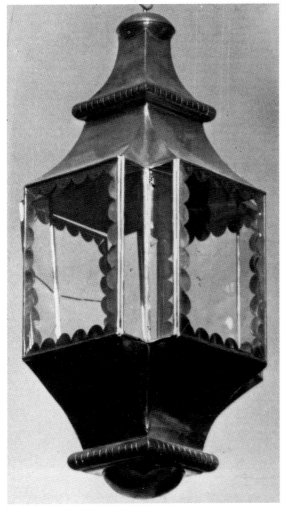

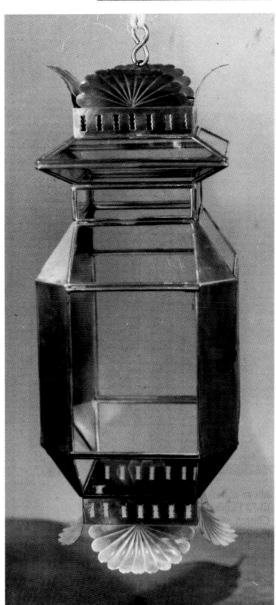

III-70 Héctor
Aguilar *Copper
Lantern with
Shell*
Photograph in the
Collection of
Fuljencio Castillo

123

III-71 Fuljencio Castillo *Four of These Lanterns Were Carried Atop Wooden Poles in a Procession in San Luis Potosí for the Festival of the Virgen de los Dolores.* Photograph in the Collection of Fuljencio Castillo

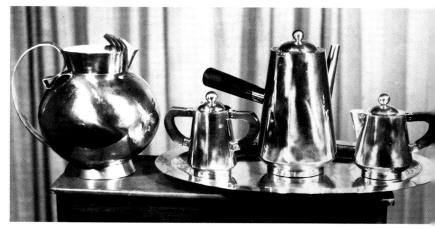

III-72 Héctor Aguilar *Copper Tea Set with Tray, and Copper Pitcher*
Photograph in the Collection of Fuljencio Castillo

Above and right:
III-73 Fuljencio Castillo *Copper Model of the Church of Santa Prisca*
Photograph in the Collection of Fuljencio Castillo

SILVER

In January 1995, Luis Reyes brought together a group of silversmiths at Luis Flores's taller to demonstrate the process of taking silver from its purest state to the production of a piece of jewelry. What was significant about this event was that these twenty or so silversmiths had not been together since the closing of the Taller Borda thirty-five years before. The descriptions given by the participants and the contemporary photographs help record a process that has not changed in all that time.

The silver division was by far the largest at the Borda, with most of the employees involved in silversmithing or related activities. The Bank of Mexico controlled all sales of silver, and only those silversmiths who were registered could purchase the ingots of 0.999 silver. Luis Reyes recalls going to Mexico City to buy silver with his brother Benito Reyes. The ingots were placed in the back of the car under a blanket and a large ferocious-looking dog sat on top of the silver all the way home. Even the driver was kept in ignorance, believing that what was under the blanket was lead.[17]

Benito Reyes was in charge of the storeroom where all the silver was kept. It was his responsibility to weigh the silver before it went out to the workshop, and afterwards, when the finished pieces were returned to the safe. He kept track of all the dies, tools, and design models. Benito also acted as Héctor Aguilar's chauffeur, once driving the children all the way to Augusta, Kansas and back to Taxco.[18]

In his book *Artesanía de la Plata*, Héctor Aguilar stipulated in his preface that he wanted to provide a practical guide that would serve the amateur silversmith as well as the *maestro*. The book is a transcription of the many techniques developed at the Taller Borda and for this reason it is invaluable in its description of the workshop, particularly when coupled with the reminiscences of the silversmiths.

III-74 *Luis Flores Smelts Silver with Copper.*
Photograph in the Collection of Penny C. Morrill

III-75 *The Silver Ingot is Removed from the Mold.*
Photograph in the Collection of Penny C. Morrill

In explaining his choice of 0.940 silver, Héctor wrote: "For several years, I made my jewelry with 0.990 silver (less than one percent copper alloy), and my clients marveled that their jewelry never tarnished. . . . However, I came to the conclusion, a few years later, that the silver was so soft, that the surfaces were wearing down and the delicate embossing and lightly engraved lines were being lost. At that point, I changed to 0.940, which results in a better alloy that does not tarnish like sterling and stands up better to use."[19]

According to Héctor Aguilar, the silver was melted in a graphite crucible with copper and cadmium as alloys. The addition of seven grams of cadmium to the 53 grams of copper and 940 grams of silver provided better malleability and decreased the amount of oxidation when the metals were melted together. At the foundry on the first level, the silver and alloys were melted at over a thousand degrees centigrade and poured into molds (Pls. III-74-75). The resulting silver ingot, one inch in width and a foot in length, was forged at an anvil with a heavy mallet. The silver was reheated or annealed to give it greater maleability and then plunged into sulphuric acid. The reason for the acid bath was that, when heated, the metal's surface would oxidize and discolor. The sulphuric acid dissolved the oxide, cleaning and whitening the silver. After the silver was cleaned, the ingot was passed through a rolling mill until it was the desired gauge or thickness (Pl. III-77).[20]

III-76 *Luis Flores Trims the Ingot so that it will Move Smoothly Through the Rolling Mill.*
Photograph in the Collection of Penny C. Morrill

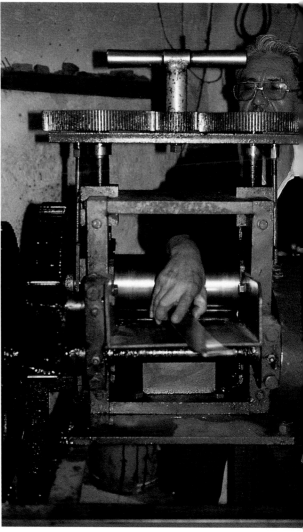

III-77 *After the Silver Ingot Has Been Cleaned with Sulfuric Acid, it is Put Through the Rolling Mill.*
Photograph in the Collection of Penny C. Morrill

Héctor's designs had been made up as copper models attached to wooden bases and these were secured in the office safe. The models were used to replicate Héctor's design but, because the pieces were made by hand, they were never exact duplicates of the original. After inking the copper model, the silversmith made several impressions onto tissue paper and glued it onto the plaque of silver (Pls. III-79-80). The lines indicated on the paper were engraved onto the silver plaque with a tap of the hammer on variously shaped engraving tools. The paper was removed and the silversmith cut out the engraved pattern with a coping saw, being careful to always keep the saw perpendicular to the silver plaque (Pl. III-81).

After the basic shape had been cut out, the simpler pieces were embossed with the design details. If the design called for work in *repoussé*, the piece was turned over to a *maestro*. For this technique, the silversmith used a box about one foot square filled with brea, or pitch, which had been heated to softness. The silver plaque was clipped at the four corners with heavy scissors and these tips were bent down at right angles. When the plaque was placed into the box, the tips sank into the brea while it was warm and soft. After cooling, the hardened brea held the tips and kept the plaque from sliding around while it was being worked on.

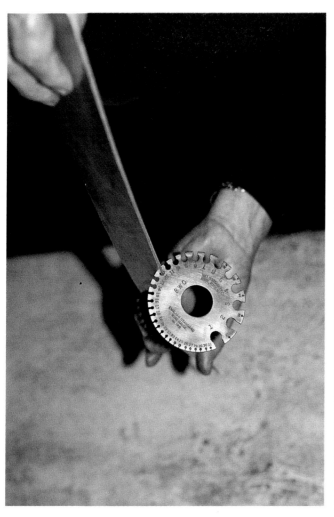

III-78 *Luis Flores Measures the Silver Plaque's Gauge.*
Photograph in the Collection of Penny C. Morrill

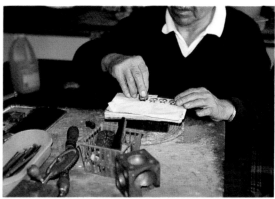

III-79 *Luis Flores Stamps the Design onto Transparent Paper.*
Photograph in the Collection of Penny C. Morrill

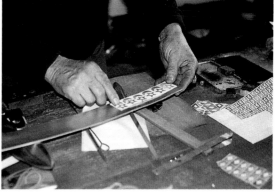

III-80 *The Paper is Glued onto the Silver Plaque.*
Photograph in the Collection of Penny C. Morrill

The design, which had been transferred from the tissue paper with engraving tools, was hammered onto the back side of the plaque. The silversmith used a rosewood mallet and several cylindrical tools, each having a differently formed rounded end. When the silver was struck with one of the tools, the metal became increasingly hardened and had to be annealed or heated several times so that the plaque would remain malleable. What made the brea the perfect medium for *repoussé* was that the hammered design in silver was held in place against a surface that did not offer too much resistance.

After the work had been completed, a flat piece of silver the same size as the design was soldered onto the back to protect the *repoussé*. This backing, called a *sochapa*, held whatever fastener was to be added and was where the hallmark was stamped after

the silversmith had received final approval of his work in *repoussé*.

For all the silver jewelry produced at the Taller Borda, the finishing work began with the filing and polishing required to remove any roughness. In his chapter on silversmithing, Héctor indicated that this work had to be done with extreme caution in order to protect the integrity of the design.[21] Once the surfaces were smooth, the silversmith could solder together the various parts that made up the piece of jewelry. He placed the two points which were to be joined side by side on an asbestos sheet (Pl. III-87). With a tiny brush, he applied a flux paste made of borax dissolved in water. At high heat, the borax liquefied and protected the surface of the silver, keeping it clean so that the solder would adhere. The borax hardened like glass after cooling, and was removed from the newly soldered joint with sulfuric acid.

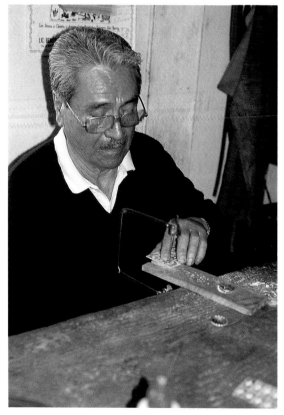

III-81 *Using a Coping Saw, Luis Flores Cuts Out Stars and Moons.*
Photograph in the Collection of Penny C. Morrill

III-82 *The Stamp, the Silver Plaque, and a Star and Moon*
Photograph in the Collection of Penny C. Morrill

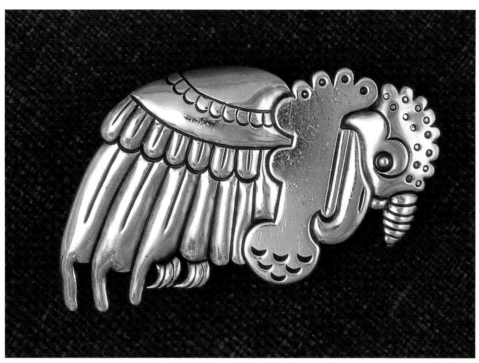

III-83 Héctor Aguilar *Turkey Pin*
(B) c. 1940 990 silver
Collection of Carole A. Berk, Ltd.

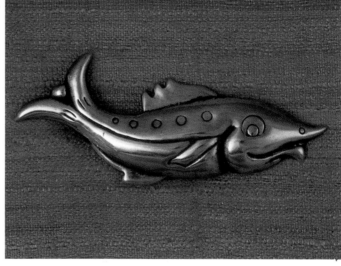

III-85 Héctor Aguilar *Fish Pin* (B) c. 1940 940 silver
Collection of Gunther Cohn and Marc Navarro

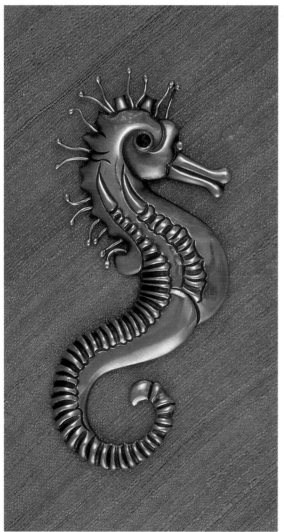

III-84 Héctor Aguilar *Seahorse Pin* (O) c. 1955 940 silver
Collection of Gunther Cohn and Marc Navarro

129

The silver solder was made at the Taller Borda and was a thin sheet of silver cut into tiny pieces. If the object to be soldered were of 0.925 silver, the solder was seventy percent silver to thirty percent tin, and if it were of finer silver, the percentage of silver in the soldering material was seventy-five to twenty-five of tin. These tiny bits of silver were placed at the joint and heat applied with an acetylene torch only long enough to melt the silver solder, so as not to overheat and thus distort the piece of jewelry itself. The silver solder, when liquified, was directed in its flow by the silversmith using a thin iron wire. When there were several points to solder, the silversmith used a paste made up of jeweler's rouge and a small amount of oil to protect previously soldered joints.[22]

III-86 *The Artisan Polishes a Star.*
Photograph in the Collection of Penny C. Morrill

III-87 *Carefully Soldering a Bracelet*
Photograph in the Collection of Penny C. Morrill

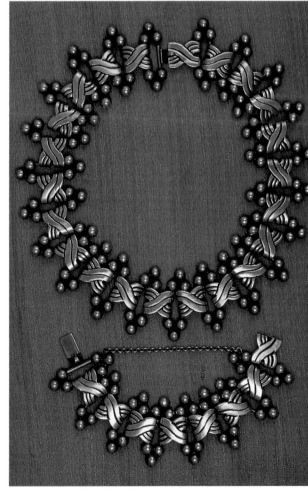

III-88 Héctor Aguilar *Six Spheres Necklace and Bracelet*
(B) c. 1940 940 silver
Collection of Gunther Cohn and Marc Navarro

The Taller Borda was the first workshop in Mexico to use generators that produced acetylene gas. Héctor had seen acetylene torches used in Providence, Rhode Island, to heat silver for soldering, and he believed it was the perfect flame for silver production.[23]

Any fasteners, clasps, or pins were soldered onto the backs of the jewelry before final polishing. Héctor recommended that these be purchased rather than made at the taller for greater accuracy. The Taller Borda bought fasteners in Mexico City from a jewelry supplier. If there were stones added to the jewelry, they had to be set after soldering. Hector only infrequently incorporated stones into his silver designs, among them,

onyx, obsidian, amethyst quartz, azurite, and opals (Pls. III-89-91, 93-94). All of the lapidary work was done by Daniel and Saul Martinez, who were not part of the taller but worked for Héctor Aguilar on a contract basis.[24]

The taller manufactured its own polishing wheels, a task that was required of the apprentices. The *zorrita* piled up a large stack of cotton squares and cut a hole down the center of the stack. The cotton squares were slipped onto a shaft and bolted down. The machine was turned on and, as the stack of cotton spun on the shaft, the *zorrita* used a file to shape it into a polishing wheel. This was messy work, and the *zorritas* were

III-89 Héctor Aguilar *Reversible Three Spheres Onyx Bracelet* (O. no eagle) c. 1945-50 940 silver/onyx Private Collection

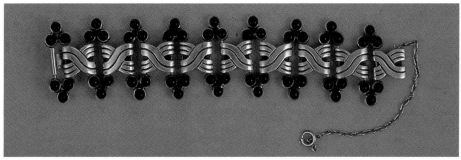

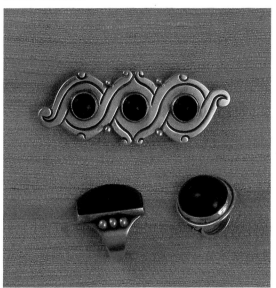

III-90 Héctor Aguilar *Onyx Three Domes Pin* (C) c. 1945; *Large Rectangular Onyx Ring* (B) c. 1940; *Circular Onyx Ring* (O) c. 1955 925, 940, or 990 silver/onyx
Collection of Gunther Cohn and Marc Navarro

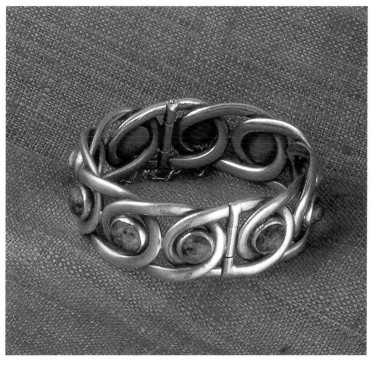

III-91 Héctor Aguilar *Interlocked Azurite Ovals Bracelet* (O) c. 1955 940 silver
Collection of Federico and Ellen Jimenez

usually covered in tiny bits of white cloth when it was over.[25]

The polishing wheels were in the basement and were separated into two functions, to smooth away marks made during filing, and secondly, to shine the silver to brightness. The polishers applied a mild abrasive paste to the silver. Héctor recommended that the piece be held at a forty-five degree angle from the wheel (Pl. III-86). The silver was cleaned off with gasoline to remove any greasy residue and polished with jewelers' rouge. Finally, the silver was cleaned once again with gasoline and washed with soap and sodium bicarbonate.[26]

The lint that was created during the process of polishing the silver was gathered up and put into barrels. These were taken to a plant in Mexico City which rendered the lint and made up silver bars or granules from what was extracted. The silver that fell away when pieces were die-cast, machine-cut, or filed was also saved and made into granules and could be purchased at independent shops or at the bank.[27]

Oxidizing darkened the lines and details so that there would be greater contrast to the surfaces of the piece. This technique was critical to the enhancement of the Taller Borda designs, considering Héctor Aguilar's

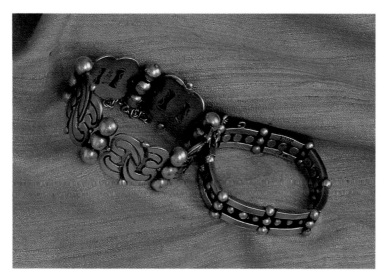

III-92 Héctor Aguilar *Knot and Three Beads Bracelet* (O) c. 1955; *Slim Bands and Beads Bracelet* (N) c. 1955 940 silver
Private Collection

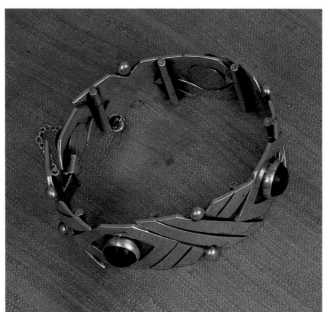

III-93 Héctor Aguilar *Pelican Pin* (B) c. 1940 940 silver/onyx; *Swan Pin* (J) c. 1955 940 silver/malachite
Collections of Gunther Cohn and Marc Navarro, and J. Crawford

III-94 Héctor Aguilar *Malachite Bracelet* (J) c. 1955 940 silver/malachite
Collection of J. Crawford

focus on line and contour. One of the methods was to immerse the silver quickly into tinture of iodine. The second method, which provided greater contrast, involved the use of potassium sulfate dissolved in hot water. In both cases, the oxidant was polished off the surfaces with bicarbonate.[28]

The Taller Borda was one of three workshops in Taxco that produced holloware by hand. Jesús Pérez, Enrique Ledesma, and José Asención were among the silversmiths involved in making large pieces, hammering silver into trays, bowls, or pitchers. After 1942, there was very little of this work done once the machine had made its appearance. For the most part, the bases of teapots or pitchers were made as half-spheres on a turning wheel. The silver was shaped around a model of hard wood or metal with a tool called a "spoon." Since the half-sphere was sitting on the turning wheel, it was already flattened on the bottom so that it could be placed later on a table. The upper portions of the pitchers or teapots, the pouring spouts and decorative detail were soldered on, and the pieces were finished and polished. A special white solder was developed that was invisible and durable when applied to holloware.

Trays were made in metal forms with hydraulic pressure and special presses so that the detailing was more accurate and the surfaces mirror-like, without the marks of the hammer

(Pl. III-131). Despite the fact that, after the war, much of the holloware was produced by machine, Héctor Aguilar made the point in his chapter on silversmithing, that these pieces still required handwork in the application of ornamentation and in the finishing work.[29]

Once the decision was made to put a silver design into production, Lois was responsible for pricing it for the shop. She had arrived at a formula for determining price based on the initial cost of the silver, the presence of gold or stones, and the

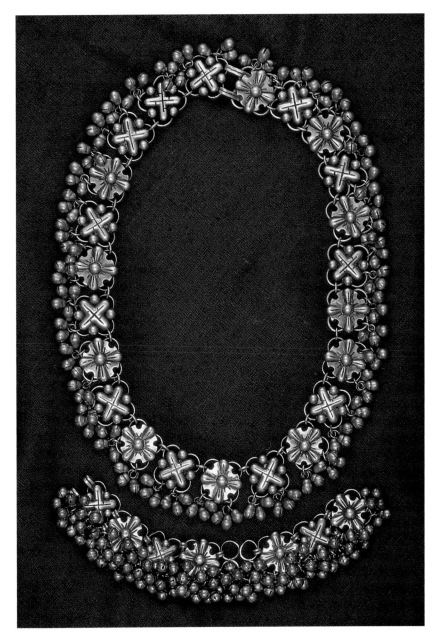

III-95 Héctor Aguilar *The Pre-Columbian Gold Symbol and Tiny Bells Necklace and Bracelet* (B) c. 1940 990 silver
Collection of Gunther Cohn and Marc Navarro

III-96 Héctor Aguilar *Two Salts* (B) *with Spoons* (N) c. 1945-50 940 silver
Collection of Gunther Cohn and Marc Navarro

number of hours required in production. Jewelry that involved *repoussé* was always more expensive because of the higher level of difficulty and time spent in making it.[30]

The many different floral and animal pins and the elaborate jewelry ensembles like the "gold symbol with tiny bells" set (Pl. III-95), all exemplify the quality of the *repoussé* done at the Taller Borda. Luis Flores, Pancho Galindo, Julio Carbajal, and Adán Alvarado were among the gifted silversmiths who worked in *repoussé*. There were also a few silversmiths, Julio Carbajal and Dámaso Gallegos, who were designated as *joyeros*, or jewelers. They were called upon whenever there was a special commission in gold, particularly if it involved the lost wax method.[31]

III-97 Héctor Aguilar *European Style Sugar and Creamer* (T/ J) c. 1950 925 silver
Collection of Gunther Cohn and Marc Navarro

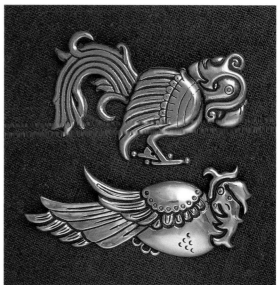

III-99 Héctor Aguilar *Macaw and Rooster Pins* (C) c. 1940-45 925 silver
Collection of Gunther Cohn and Marc Navarro

III-98 Héctor Aguilar *Carving Set* (fork– B, knife – C); *Silver Candlesticks, Bread and Butter Plate, and Large Silver Plate* (B) c. 1940; *Placecard Holder and Large Salad Set* (L); *Salt Shaker and Pepper Grinder, Pie Server* (J); *Ladle* (T/P); *Gravy Boat* (J) *with Tray* (T); *Forks, Knife, and Spoon* (I); *Salad Set, Candle Snuffer, Two Serving Spoons, and a Butter Knife* (P) c. 1945-55 925 or 940 silver
Collections of Gunther Cohn and Marc Navarro, and Frederick and Stella Krieger

CORO

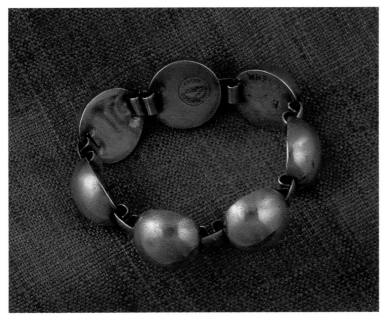

III-100 Héctor Aguilar *Coro Dome Bracelet* (E) c. 1943 silver
Collection of J. Crawford

The Second World War brought about an overwhelming increase in production for the silver business in Mexico. When U. S. companies with government contracts came to Taxco, the demands for standardization of the product and the magnitude of the orders brought about a change from an arts and crafts industry to one based on large-scale mechanized production. A number of the silver designers turned to the machine, including the Castillos, William Spratling, Dámaso Gallegos, and Héctor Aguilar.[32]

For the Taller Borda, the impetus for mechanization came from Gerald Rosenberger, owner of Coro, a costume jewelry company. Rosenberger brought a much-needed cash infusion to the Taller

III-101 Héctor Aguilar *Coro Four Hollow Square Bracelets* (E) c. 1940-45 silver
Collection of Gunther Cohn and Marc Navarro

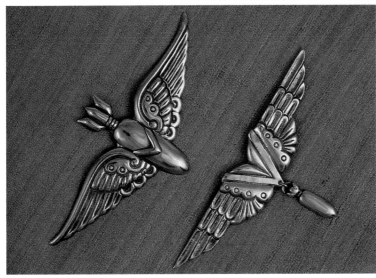

III-102 Héctor Aguilar *Wings with Pendant Bomb* (H) c. 1945; *Bomb with Wings Pin* (G) c. 1943 925 silver
Collections of Gunther Cohn and Marc Navarro, and J. Crawford

135

Borda when he and Héctor Aguilar formed a financial partnership. Rosenberger bought half of the Casa Borda in 1943 and installed the machinery to produce silver Army aviation badges for bombardiers (Pl. III-102).[33]

During the war, when the United States government prohibited the use of silver in the production of jewelry, Mexican silver was imported by North American companies on a large scale. William Spratling sold over a million pesos' worth of silver jewelry and decorative objects to Montgomery Ward.[34] The Taller Borda produced silver jewelry for Coro in great volume. Dies were made of jewelry designs by Héctor Aguilar which originally had been handwrought. These dies and others that were manufactured and imported by Coro were used to press out hundreds of pins, barrettes, and other jewelry with the "Coro, Made in Mexico" hallmark. Some of the work was unexceptional, like the bracelets in Plates III-100-101. However, when the Taller Borda made its own designs, the difference in the style and energy of the pieces was notable (Pls. II-40, 54).

The Coro jewelry made at the Taller Borda was all silver and was hand-finished by a workforce that grew to number close to three hundred artisans. These numbers caused an expansion into a building down the street from the Hotel Los Arcos near the Church of the Veracruz. Among the silversmiths hired were about half a dozen women. According to María Pineda, who was part of this small group, the women had routine responsibilities, making beads and small bells that were later added to bracelets and necklaces. The women did not stay on in the talleres after the war.[35]

There were other changes that were made in the way the workshop functioned. Héctor designated thirty men as *contratistas*, or contractors, to manage the workforce in the mechanized division. Each *contratista* oversaw the work of ten to twenty silversmiths in his designated area either on the ground floor of the Casa Borda or in the buildings near the Church of the Veracruz. When the *contratista* received large orders to make hundreds of pieces of silver jewelry, he was

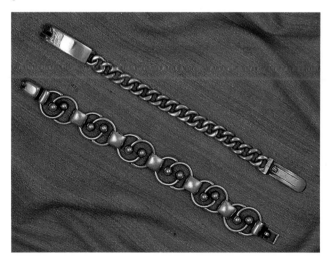

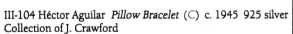

III-104 Héctor Aguilar *Pillow Bracelet* (C) c. 1945 925 silver Collection of J. Crawford

III-103 Héctor Aguilar *Bead and Band Bracelet* (O) c. 1955; *ID Bracelet* (B) c. 1940 45 940 silver Collection of Gunther Cohn and Marc Navarro

III-105 Héctor Aguilar *Copper Sconces and Display Shelf* c. 1940 copper/glass
Collection of Dorothy S. Chittim

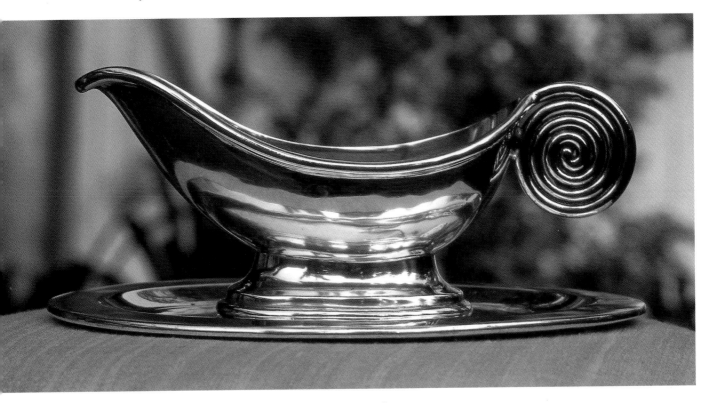

III-106 Héctor Aguilar *Gravy Boat* (J) *with Tray* (T) c. 1950-55 925 silver
Collection of Gunther Cohn and Marc Navarro

given the die-cut pieces that had to be filed, soldered, and finished. It was in the interests of the *contratistas* to move quickly on these orders. Once an order was filled, the workers were paid a rate by the piece; whatever was left, the *contratista* kept. Among the *contratistas* at the Taller Borda were Luis Flores, Reveriano Castillo, and Ignacio Castillo who was unique in that he had over fifty workers assigned to him.[36]

Héctor's business relationship with Rosenberger lasted about six years. When Héctor bought him out in around 1950, the workshop returned to a predominantly

handcraft industry. However, like most of his peers, Héctor relied on the machine for certain tasks because of the hours of labor that were saved. The talleres continued to use rolling mills, turning lathes, various presses, and the bar mills that made wire. Héctor bought his machines in Mexico City. The dies were made in Mexico City by a specialist, and in Taxco, by Julio Carbajal and the Embriz brothers, Daniel and Gabriel. Julio recalls making the die for the "feathers" pin (on the left in Pl. II-40). This pin, originally a *repoussé* design by Valentín Vidaurreta, was produced in the forties under the Coro hallmark.[37]

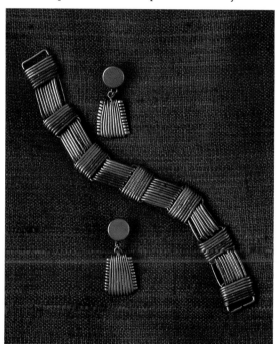

III-107 Héctor Aguilar *Watch Band* c. 1945 silver/copper;
Rectangular Wire Earrings (D) c. 1945 940 silver
Collection of Penny C. Morrill

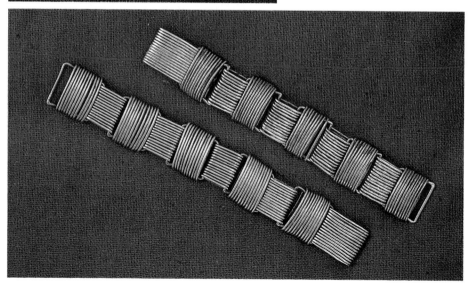

III-108 Héctor Aguilar *Wire Copper and Silver Bracelet* (D) c. 1945 940 silver/copper; *Silver Wire Bracelet* (J) c. 1950-55 940 silver
Collection of Gunther Cohn and Marc Navarro; Private Collection

THE FIFTIES

Héctor described the changes to the silver industry after the great surge of activity brought on by the war: "After this period came a calm, and we, the silver designers, had time, peace, primary materials, and buyers from all over the world."[38] During the fifties, Héctor Aguilar was able to increase production of holloware and flatware, undoubtedly because of his new reliance on the machine. Many of these pieces reflect Héctor Aguilar's maturity as a designer. The coiled handle and the strongly formed contours of the gravy boat (Pl. III-106) hark back to early design concepts and motifs, many of which were used in the copper pieces. The gravy boat's handle can be compared to the coils applied to the copper sconces in Plate III-105. They appear again in the remarkable silver goblets made about the same time as the gravy boat (Pl. IV-13). The silver stems seem to stream downward like water, pooling in spirals to form the base.

The Taller Borda became a corporation sometime in the late forties.[39] Héctor Aguilar made this decision so that he could reduce the taxes he was having to pay to the

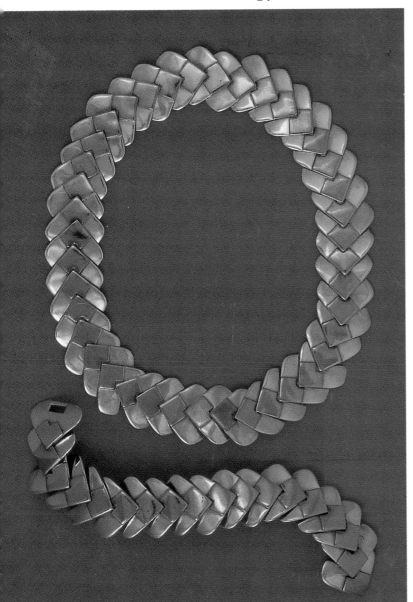

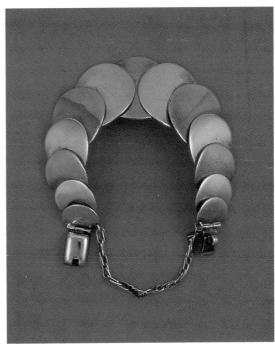

III-109 Héctor Aguilar *Silver Heart and Copper Square Necklace and Bracelet* (O) c. 1955 940 silver/copper Private Collection

III-110 Héctor Aguilar *Graduated Copper and Silver Discs Bracelet* (J) c. 1950 940 silver/copper Collection of J. Crawford

Secretaría de Hacienda. Rob Cartwright recalls that his father had the stock certificates printed up in Mexico City and had them made out to "Bearer." After picking up the certificates, Héctor caught a cab and left them on the back seat. After a period of intense anxiety for Héctor and Lois, the taxi driver returned with the certificates. This man did not realize it, but he could have owned a majority of the stock in the Taller Borda.[40]

Héctor Aguilar participated with other silver designers to reinstitute the colonial *quinto* or eagle stamp. The larger talleres paid a fee to register their hallmarks and to

receive their own eagle stamps with a number. In the case of the Taller Borda, the number was nine. An inspector was assigned to monitor the purity of the silver in jewelry or objects produced in the workshops. Srta. Dominguez was the director of the Assayer's Office and had a reputation as a stickler for strict compliance to the law.

The independent silversmith, on the other hand, finished his silver jewelry or objects and took them to the Assayer's Office. The pieces were checked for silver content and were marked with an eagle stamp without a number. The system broke down because silversmiths who had registered for a number began lend-

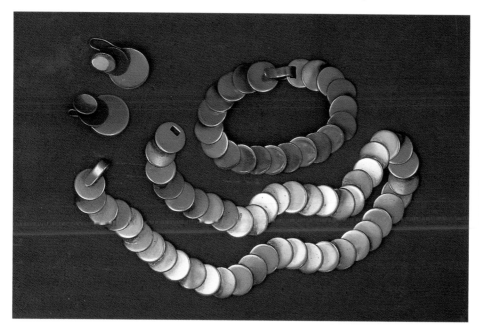

III-111 Héctor Aguilar *Silver and Copper Dot Necklace, Bracelet, and Earrings* (L) c. 1955 940 silver/copper
Collection of Gunther Cohn and Marc Navarro

III-112 Héctor Aguilar *Brass Candlesticks* (R) c. 1950 brass
Collection of William and Pauline Roed

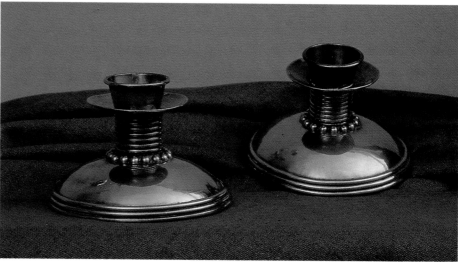

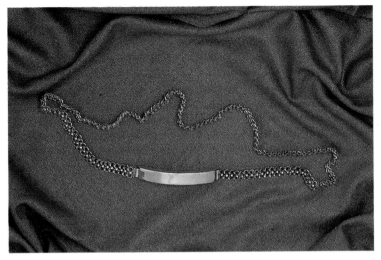

III-113 Héctor Aguilar *ID belt with Chain* (F) c. 1945
925 silver
Collection of Gunther Cohn and Marc Navarro

III-114 Héctor Aguilar *Bangles* (B/H) c. 1940-50 925 or
990 silver
Collections of Gunther Cohn and Marc Navarro; Private
Collection

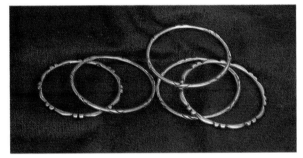

III-115 Héctor Aguilar *Six Tall Silver Tumblers* (B) c. 1940; *Pitcher* (L. 1987) c. 1950-55
Large Oval Tray with Winged Handles (J. 3625) c. 1955 925 or 940 silver
Collection of Gunther Cohn and Marc Navarro

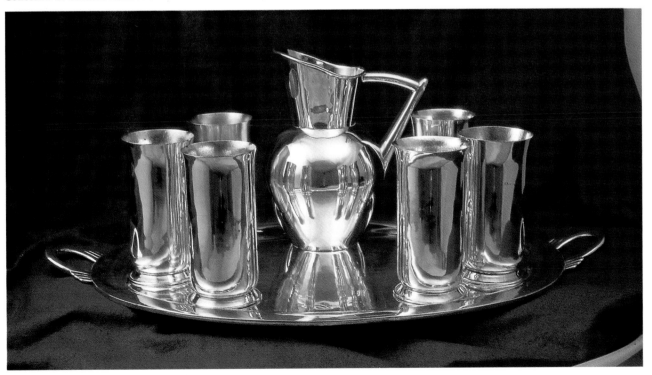

ing out their eagle stamps to friends. The use of the eagle stamp as a method of controlling silver content was discontinued in about 1970.[41]

Héctor Aguilar was a good friend of Horacio de la Parra, the original owner of Conquistador, the largest silver factory in Mexico. During the war, a Swedish industrialist Axel Leonard Wenner-Gren purchased Conquistador, along with three other silver factories and a magazine about silver called *Arte y Plata*. Wenner-Gren had begun investing heavily in Mexican companies after the United States blacklisted him in 1942 for his position of appeasement towards the Nazi government. In around 1950, Horacio de la Parra, who had stayed on as manager of Conquistador, had signed a contract with William Spratling to produce his jewelry designs. Parra had this same agreement with the Taller Borda, manufacturing Héctor Aguilar's holloware designs (Pls. III-115, 117-119). The Taller Borda store was selling the Aguilar/Conquistador holloware (Pl. I-20), the Spratling/Conquistador jewelry, and Conquistador's own silver holloware, ornamented with popular motifs. Neither Spratling nor Héctor Aguilar continued to do business with Conquistador for more than a few years.[42]

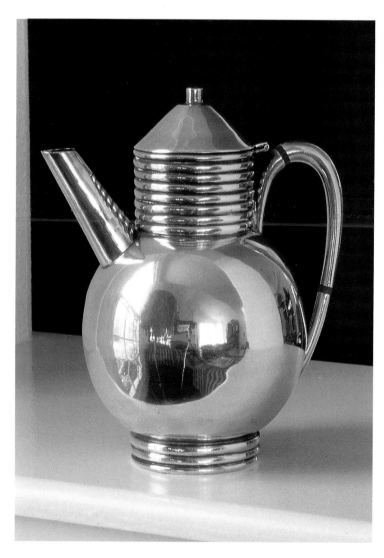

III-116 Héctor Aguilar *Tin Woodman Silver Pitcher* (T/J. 931) c. 1950-55 925 silver
Collection of the Cartwright Family

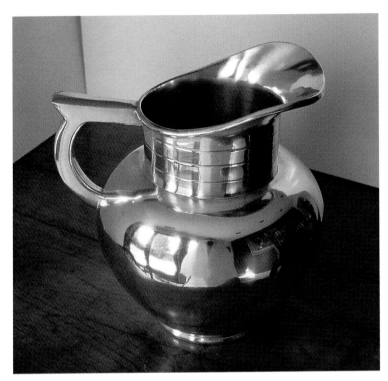

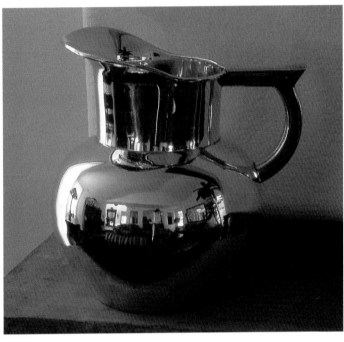

III-117 Héctor Aguilar *Pitcher with Squared-off Handle* (N/T) c. 1950
925 silver
Collection of J. Crawford

III-118 Héctor Aguilar *Pitcher with Squared-off Handle* (J.
1990) c. 1950-55 925 silver
Collection of the Cartwright Family

III-119 Héctor Aguilar *Tea and Coffee Set with Tray* (N/
T. 401-4) c. 1950-55 925 silver/wooden handles on tea
and coffee pots
Collection of J. Crawford

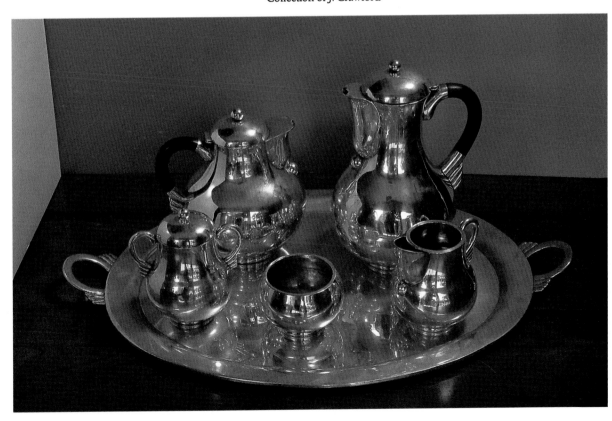

III-120 Héctor Aguilar *Baby Dish* (J.
1908) c. 1950-55 925 silver
Collection of the Cartwright Family

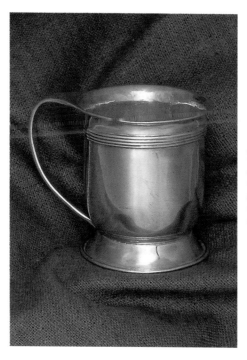

III-121 Héctor
Aguilar *Baby Cup*
(B) c. 1940 940
silver
Collection of J.
Crawford

III-122 Héctor Aguilar *Baby Spoon with Openwork
Handle* (B) c. 1940 940 silver
Collection of Gunther Cohn and Marc Navarro

144

The Taller Borda dealt directly with Horacio de la Parra in the purchase of silver. Wenner-Gren, it seems, refrained from being a visible participant in his business ventures in Mexico. According to a report written in 1947, "If you stepped into any of these companies' offices and asked for Mr. Wenner-Gren you would be answered by blank looks; for the man who controls them all is unknown to most of his employees, working from behind an intricate maze of directorates and holding companies."[43]

For the silversmiths who worked at the Taller Borda, Héctor was a serious and demanding administrator, but convivial and never superior. He treated all his workers with gentlemanly respect. Whenever anyone needed help with a family emergency, that person was never turned down and was allowed to pay back the loan on his own time. The men who were part of the Taller Borda recall that whenever a worker had his saint's day, the others got together and organized a party. Héctor was invited and always came to celebrate.[44] Héctor Aguilar's nephew Robert Tarte experienced the taller as a young teenager and has written: "Wondrous places to me as a growing boy, the workshop rooms of the Taller Borda were filled with good-natured men who seemed proud of their crafts and happy to display and share their skills amid the incessant

III-123 Héctor Aguilar *Ice Breaker* (N) c. 1955 940 silver
Collection of J. Crawford

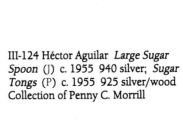

III-125 Héctor Aguilar *Four Rope Design Demitasse Spoons* (J) c. 1950-55 940 silver
Collection of Gunther Cohn and Marc Navarro

III-124 Héctor Aguilar *Large Sugar Spoon* (J) c. 1955 940 silver; *Sugar Tongs* (P) c. 1955 925 silver/wood
Collection of Penny C. Morrill

banter, the tapping of small hammers, the hiss of fine-toothed saws and files, and the smells of acetylene, fluxes, and buffing compounds."[45]

Rob Cartwright has described a charming custom that may be unique to Taxco. Members of the taller each had a distinctive whistle which consisted of about five or six notes. When a person saw a friend across the *zócalo*, he gave his friend's whistle in greeting.[46] This custom lives on, for the whistles can still be heard occasionally above the roar of the miniature taxis that zoom round the town square.

One of the more active organizations within the workshop was the Taller Borda Alpine Club. A number of silversmiths participated in hikes and mountain climbs in the region, organized by a small group that included Luis Reyes. A memorable accomplishment for the club members were their two climbs of the volcanoes, Popocatepetl and Ixtaccíhuatl.[47]

There were occasional events that involved the entire workshop. Once a year, everyone was invited down to the Hacienda San Juan Bautista on a Sunday for barbeque and a swim. The party was always festive and well-attended.[48]

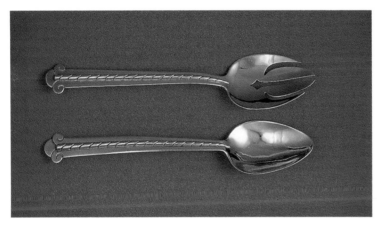

III-126 Héctor Aguilar *Salad Set* (D) c. 1945 925 silver
Collection of Carole A. Berk, Ltd.

III-127 Héctor Aguilar *Wood and Silver Salad Set* (B) c. 1940-45 940 silver
Collection of Nancy Elby

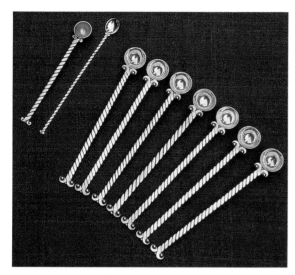

III-128 Héctor Aguilar *Six Teaspoons Braided Handles*
(D) c. 1940-45; *Shallow Teaspoon Braided Handle* (L)
c. 1955 925 silver; *Two Different Size Teaspoons Braided
Handles* (B) c. 1940 990 silver
Collection of Gunther Cohn and Marc Navarro

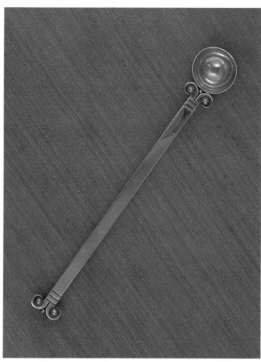

III-129 Héctor
Aguilar *Long
Teaspoon* (P) c.
1950 925 silver
Collection of
Frederick and Stella
Krieger

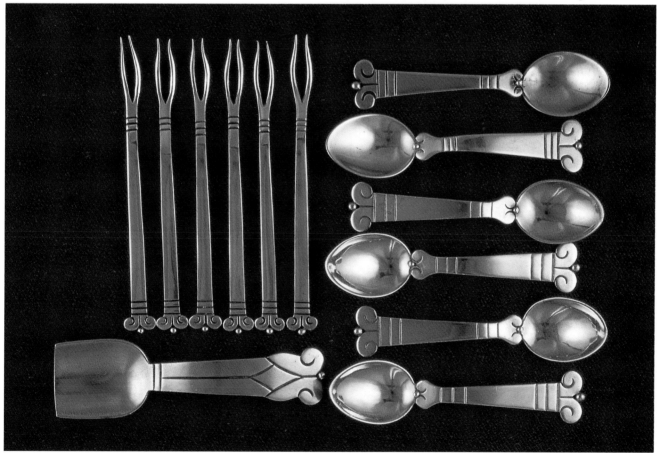

III-130 Héctor Aguilar *Small Shovel Sugar Spoon* (O) c. 1955; *Six Demitasse Spoons* (A) c. 1940; *Six Hors d'ouevres
Forks* (L) c. 1955 925 or 940 silver
Collection of Gunther Cohn and Marc Navarro

THE TALLER BORDA CLOSES ITS DOORS

On December 24, 1962, the workers of the Taller Borda arrived to find the doors of the Casa Borda closed. One silversmith recalls the sad scene: "The twenty-fourth of December, we arrived at eight in the morning for work at the Taller Borda and our surprise was overwhelming when we found at the door, Miguel Savedra, President of the Council for Conciliation and Arbitration, and three other lawyers. They explained to us that we could not enter, that the taller was closed because there was no longer any work for us. It was the day before Christmas."[49]

Héctor Aguilar had been forced into bankruptcy through an increase in costs and a loss of tourism and sales. He had requested loans from the bank and from his friends Doña Berta Estrada, Doctor Alberto Curiel de los Ríos, and others, but had finally reached a point where he could no longer sustain the workshop.

The thirty or forty workers formed a union and hired lawyers to represent them. They received the support of the state's Department of Labor and other government agencies in their efforts to receive indemnification. In April 1963, the workers attempted to reopen the Taller Borda. They felt they could keep the workshop functioning, but

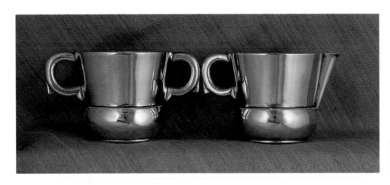

III-132 Héctor Aguilar *Sugar and Creamer* (B) c. 1940
940 silver
Collection of Gunther Cohn and Marc Navarro

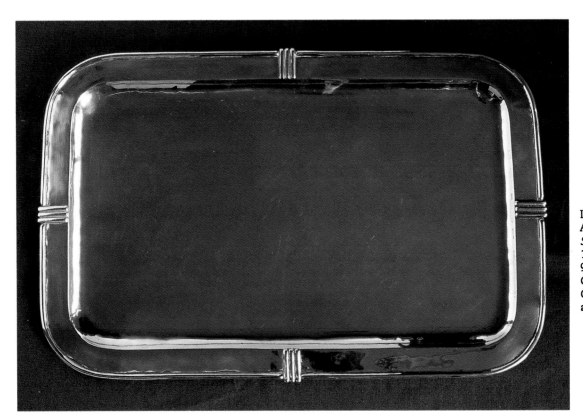

III-131 Héctor Aguilar *Large Silver Rectangular Tray* (C) c. 1942
925 silver
Collection of Gunther Cohn and Marc Navarro

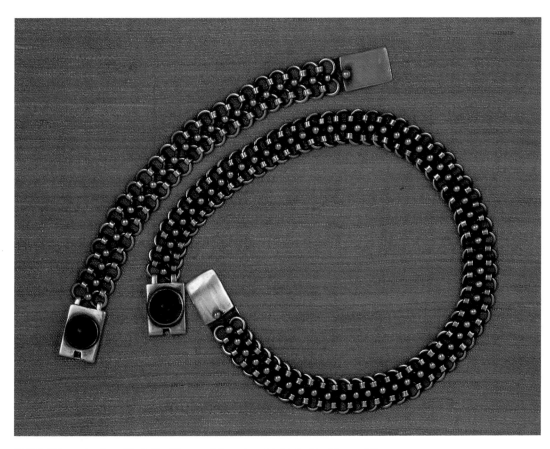

III-133 Héctor Aguilar *Chain Necklace and Bracelet with Malachite Clasps* (F)
c. 1945 925 silver/malachite
Private Collection

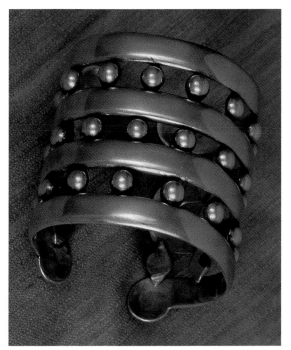

III-134 Héctor Aguilar *Wide Four Bands Bracelet* (F) c.
1945-50 925 silver
Collection of J. Crawford

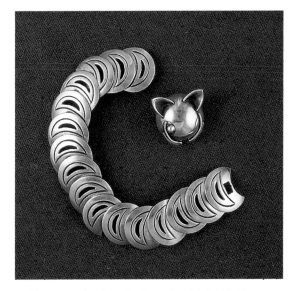

III-135 Héctor Aguilar *Cat Pin* (B) c. 1940; *Half-moon
Incised Bracelet* (N) c. 1950 940 silver
Collection of J. Crawford

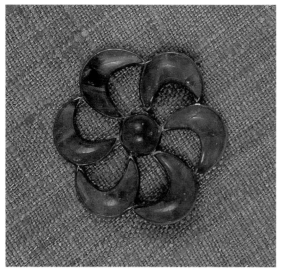

III-136 Héctor Aguilar *Spiral Amethyst Flower Pin* (B) c.
1940 940 silver/amethyst quartz
Collection of Federico and Ellen Jimenez

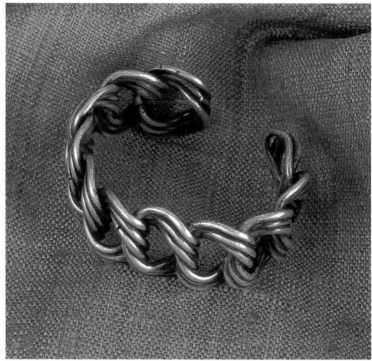

III-137 Héctor Aguilar *Heavy Flexible Chain Cuff* (C) c. 1940-45 925 silver
Private Collection

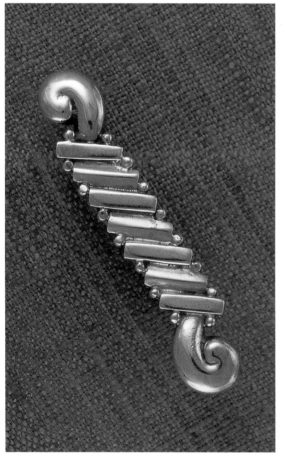

III-138 Héctor Aguilar *Bar Braid Pin* (B) c. 1940 940
silver
Collection of Gunther Cohn and Marc Navarro

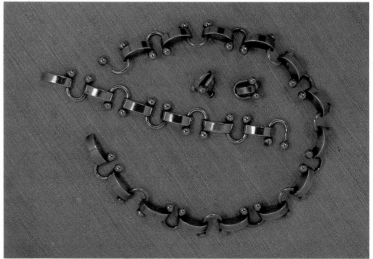

III-139 Héctor Aguilar *Heavy Necklace, Bracelet, and Earrings* (B) c. 1940-45
940 silver
Collection of Gunther Cohn and Marc Navarro

the request was turned down by Héctor Aguilar's lawyers.

Before the Council of Conciliation and Arbitration, the two sides came to an understanding. Héctor Aguilar agreed to pay 120,000 pesos to his former employees. Luis Reyes collected the forty-two thousand pesos from the workers to pay for their own legal fees. Most of the machinery was sold to pay for the indemnification, but the dies and tools and a few machines from the Taller Borda were distributed so that the silversmiths could continue to work at their trade.[50] The person responsible for this distribution was Benjamín Pérez, who had been a salesman and administrator in the Taller Borda's store.

After the Taller Borda closed and the Aguilars had sold the hacienda, they moved into the Casa Fuller which they rented for a short time. Héctor kept the store open until 1966 when he sold it to Benjamín Pérez and moved permanently to Zihuatanejo. Benjamín sold what was left of the pieces marked *HA*, then began buying and selling the work of independent silversmiths, a few of whom had originally been silversmiths at the Taller Borda. Benjamín also collected rents from the stores in the Casa Borda and sent the money to Héctor.

An era had ended. In 1983 the government took over and remodeled the Casa Borda, then offered the spaces back to the stores which had occupied them. Most of the merchants, including Benjamín Pérez, found it too difficult to do business with the government so they moved out. For a short period, the Casa Borda became the municipal building for Taxco, and more recently, has been reborn as a cultural center for the state of Guerrero.[51]

III-140 *Héctor Aguilar's Passport Photo*
Photograph in the Collection of Rob Cartwright

III-141 *Lois Cartwright Aguilar*
Photograph in the Collection of Rob Cartwright

Right:
III-142 Héctor Aguilar *Cufflinks* (L/N) c. 1950 940 silver
Collection of Gunther Cohn and Marc Navarro

III-144 Héctor Aguilar *Repeating V's Tie Clip* (I) c. 1950
940 silver
Private Collection

III-143 Héctor Aguilar *Tongues of the Sun Pin* (I) c. 1950
940 silver
Collection of Peregrine Galleries

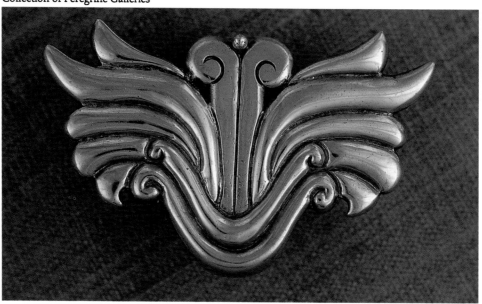

III-145 Héctor
Aguilar *Large
Repoussé Maguey
Pin* (C) c. 1940-
45 925 silver
Collection of
Gunther Cohn
and Marc Navarro

[1] Rob Cartwright, interview.
[2] Rob Cartwright, interview.
[3] Fuljencio Castillo; Rob Cartwright, interviews.
[4] Rob Cartwright, interview.
[5] Tarte, Letter, Mar. 7, 1995. The quote refers to Benjamín Pérez and Luis Reyes.
[6] Gobi Stromberg describes this same hierarchy, but with some differences. At the top was the owner or *patrón*. Below him were the *maestros contratistas* [the master contractors in the wholesale division during the war]; the *maestros especializados* [silver masters with a specialty]; and the designers. At the next level were the master silversmiths; then the silversmiths; and at the bottom of the hierarchy, the *zorritas* (Stromberg, 40-45).
[7] Moises T. de la Peña, *Guerrero Economico*, 430-3.
[8] Rob Cartwright, interview.
[9] Cuevas Bárcenas; Rob Cartwright; Fuljencio Castillo; Tarte, interviews.
[10] Rob Cartwright; Tarte; Cuevas Bárcenas, interviews.
[11] Reyes, interview. "Panzón" refers to someone with a protruding stomach.
[12] Cuevas Bárcenas, interview.
[13] Rob Cartwright, interview.
[14] Fuljencio Castillo, interview; Day, 121.
[15] Reyes, interview.
[16] Fuljencio Castillo, interview. Moises de la Peña mentions the copper production at the Borda (de la Peña, 432).
[17] Reyes, interview.
[18] Rob Cartwright; Reyes, interviews.
[19] Aguilar Ricketson, 88.
[20] Aguilar Ricketson, 86-94. Tarte, Letter, Dec. 18, 1995.
[21] Aguilar Ricketson, 98-9.
[22] Aguilar Ricketson, 99-105.
[23] Aguilar Ricketson, 103. Fortunately, there was never an accident involving acetylene gas at the Taller Borda.
[24] Aguilar Ricketson, 104; Luis Flores; Rob Cartwright, interviews.
[25] Rob Cartwright, interview.
[26] Aguilar Ricketson, 106-7.
[27] Rob Cartwright; Reyes, interviews.
[28] Aguilar Ricketson, 108.
[29] Aguilar Ricketson, 105, 108-10.
[30] Rob Cartwright, interview.
[31] Antonio Gallegos; Julio Carbajal; Rob Cartwright, interviews.
[32] Spratling, "25 Years of Mexican Silverware;" Morrill and Berk, 46, 89-90. 102,156.
[33] Gilbert Grosvenor, "Insignia of the United States Armed Forces," 693-4.
[34] Aguilar Ricketson, 70; de la Peña, 426.
[35] María Pineda; Julio Carbajal, interviews by Penny C. Morrill.
[36] Luis Flores, interview.
[37] Rob Cartwright; Reyes; Gallegos; Julio Carbajal, interviews.
[38] Aguilar Ricketson, 70.
[39] In a 1947-48 industrial directory for Mexico, there were two listings for the Taller Borda: the Taller Borda on the Plaza Borda (No. 2) in Taxco, and the Taller Borda, S. A. (incorporated) on the Avenida F. L. Madero No. 29, in Mexico City. This incorporation may have also resulted from the partnership that developed between the Aguilars and Héctor's sister Beatriz (*Primer Directorio Industrial*, 924).
[40] Rob Cartwright, interview.
[41] José Asención, interview; Morrill and Berk, xi.
[42] Stanley Ross, *Axel Wenner-Gren: The Sphinx of Sweden*, 17-8; Morrill and Berk, 71-2; Reyes; Rob Cartwright; Carbajal López, interviews. The Spratling "Aztec duck" spoon purchased at the Taller Borda by the Tarte family in 1953 bears the Conquistador hallmark. According to Nieves Orozco, who was living in Taxco after 1946, "I believe that when Spratling moved to Taxco-el-Viejo, Aguilar even sold Spratling items at his shop" (Edwin J. Schwartz, interview of Nieves Orozco, 1994).
[43] Ross, 18-9.
[44] Alvarado; Reyes; Carbajal, interviews.
[45] Tarte, Letter, Mar. 7, 1995.
[46] Rob Cartwright, interview.
[47] Reyes, interview.
[48] Rob Cartwright, interview.
[49] Reyes, interview.
[50] Reyes, interview; Stromberg, 56.
[51] Virginia Redondo Pérez, interview.

III-146 Héctor Aguilar *Incised Cross and Rosary* (B) c. 1940 940 silver
Collection of Gunther Cohn and Marc Navarro

CHAPTER IV

Silversmiths and Designers

IV-1 Valentín Vidaurreta
Corner in Cuernavaca April
1928 cover of *Mexican Life*
Courtesy of the Columbus
Memorial Library

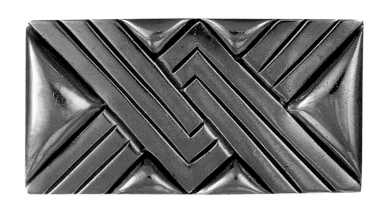

IV-2 Héctor Aguilar *Double-V
Rectangular Pin* (B) c. 1940
940 silver
Collection of Gunther Cohn
and Marc Navarro

Silver-smiths and De-signers

Talented people were nurtured and given the opportunity to develop at the Taller Borda. Héctor Aguilar considered Roberto Cuevas invaluable as an exceptional carpenter and mechanic. Héctor once said, "Cuevas could make me a locomotive if I asked him to."[1] The execution of a design concept in a handwrought industry requires a high level of experience and expertise. Among the artisans in the Taller Borda, the term "*maestro*" had great meaning and was not used lightly. It was applied to those men who had attained the respect of their peers for their leadership and technical skill. Julio Carbajal was a gifted silversmith in *repoussé* and had mastered the lost wax method and for this reason was highly regarded by Héctor Aguilar and by his fellow artisans.

The men in this chapter were connected to the Taller Borda in a variety of ways. Several were talented designers who had practiced their skills under the tutelage of *maestros* like Julio Carbajal. Many were artisans who made substantial contributions at the Taller Borda and then went on to establish their own workshops. Others, like Pedro Pérez, provided opportunity for the silversmiths when they could no longer work for Héctor Aguilar.

IV-3 *Luis Reyes Ramírez as a Young Silversmith*
Photograph in the Collection of Luis Reyes Ramírez

Gabriel "Chato" Flores was born with the imagination of an artist. The few pieces which can be attributed to him are well-designed, distinguished by a tendency toward sculpted

GABRIEL FLORES

forms taken from nature. The bull's head in the taurus bracelet (Pl. IV-5) is a masterful combination of stylization, strength of detail, and even humor.

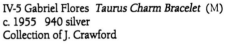

IV-5 Gabriel Flores *Taurus Charm Bracelet* (M) c. 1955 940 silver
Collection of J. Crawford

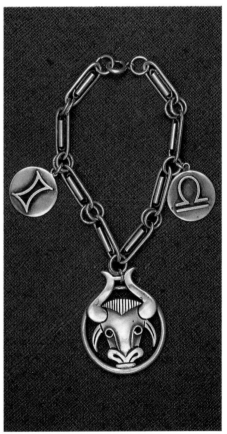

IV-4 *Gabriel Flores in Front of the Taller Borda Store* c. 1954
Photograph in the Collection of Robert D. Tarte

Gabriel Flores married Bunny Cartwright and became Héctor Aguilar's son-in-law. They lived in the Casa de las Palomas [the House of the Doves], a house with large columns near the Ex-Convento. Gabriel worked for Héctor for over a decade. He designed in copper and brass, creating decorative wall-hangings, like the fish in Plate IV-6. His concepts were applied to other pieces produced by the taller, like the wooden box with the silver fish that obviously had its match in the copper and brass wall-hanging (Pl. IV-7).

Héctor Aguilar loved to play chess, which may have prompted his decision after 1950 to design and produce chess sets.[2] Many of the sets were composed of simple silver chess pieces in small wooden cases, appropriate for a traveler, especially for the tourist who needed to take away something small in an already bulging suitcase.[3]

IV-6 Gabriel Flores *Whale Wallhanging* c. 1950 copper/brass Collection of the Cartwright Family

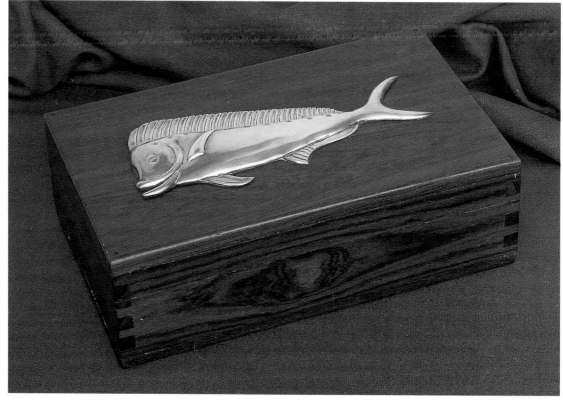

IV-7 Héctor Aguilar *Wooden Box with Silver Whale* Collection of the Cartwright Family

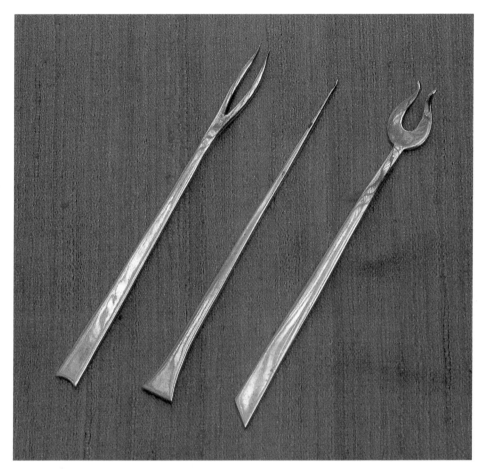

IV-8 Gabriel Flores *Cocktail Picks*
(M) c. 1955 940 silver
Collection of the Cartwright Family

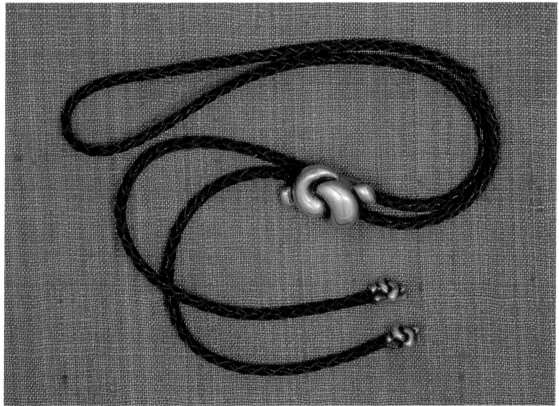

IV-9 Gabriel
Flores *Silver
Knot Bolo* (M) c.
1950 silver/
braided leather
Private Collection

The Medieval chess set designed by Flores, to which the knight in Plate IV-12 belonged, was in silver with vermeil. Each chess piece had movable parts and intricate detailing. The knights' swords could be removed from their scabards and the queens wore rings on their fingers. The horse had over one hundred parts. José Asención and Adán Alvarado remember fashioning these chess pieces, each one a miniature masterpiece. The entire chess set took over two years to produce.[4] This particular knight was hallmarked *GF* and *Taller Borda*.

Chess sets were made in copper, silver, and different colored woods in various combinations. The tables were of either rosewood or ebony, with silver inlay and were produced in the carpentry shop by Roberto Cuevas. The sets were displayed on low tables just inside the door of the shop and they sold well. According to Robert Tarte, "At the times that I visited Taxco, there were no chess sets for sale at the Taller Borda. Then, in the late '50s, I recall that in letters to my parents, Héctor and Lois referred to the success of the new chess sets that they had begun to produce."[5]

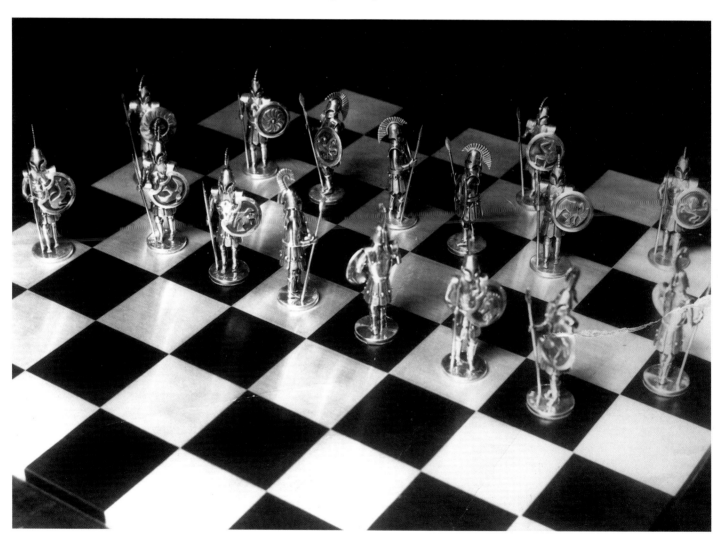

IV-10 Gabriel Flores *Trojan Chess Set* c. 1955
Photograph in the Collection of Robert D. Tarte

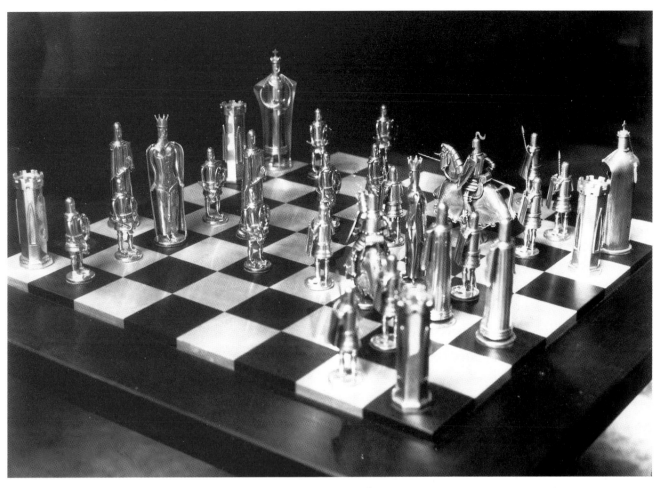

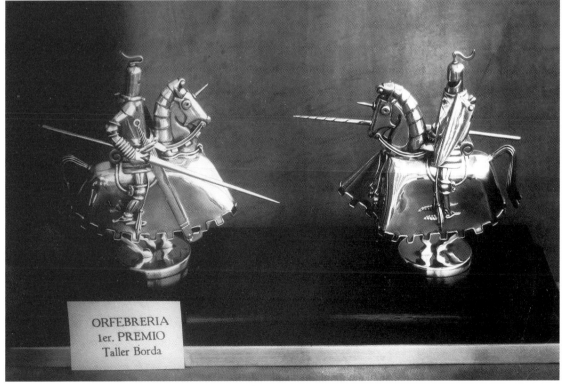

Above:
IV-11 Gabriel
Flores *Medieval
Chess Set* c. 1955
Photograph in the
Collection of
Robert D. Tarte

Left:
IV-12 Gabriel
Flores *Knight
from the Medieval
Chess Set – A
First Prize* (M)
c. 1960 940
silver
Photograph in the
Collection of
Robert D. Tarte

Gabriel Flores seemed to have been interested in history and the art of the past. The designs for the Medieval chess set indicate that he had studied the painting and sculpture of the period to arrive at authentic details in costume and style. In the mid-1950s, he was painting a mural on the interior walls of his house, depicting "the history of the Aztecs" in the style of Diego Rivera. The initial concept was sketched out, but Gabriel never brought the mural to completion.[6]

There is no question that Gabriel was innately talented. The chess sets in Plates IV-10-11 exhibit an extraordinary creativity, but what is unfortunate is that the flame only burned intermittently. Whether as a painter or silver designer, the impulses which swayed him were never tempered with discipline. Sadly for us, many of his ideas never became more than dreams.

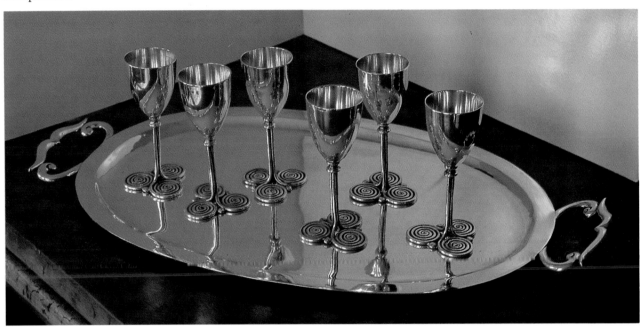

IV-13 Héctor Aguilar *Six Aperitif Glasses* (J) c. 1955; Gabriel Flores *Oval Silver Tray with Eyebrow Handles* (M) c. 1955 925 silver Collection of Gunther Cohn and Marc Navarro

IV-14 *Gabriel Flores's Signature and Hallmark*
Courtesy of Robert D. Tarte

Pedro Castillo was twelve years old when he started as a helper at the Taller de Las Delicias right after its founding. In 1939 he was the first to leave with Héctor Aguilar. He and his brother Carlos and his cousins Reveriano and Eduardo Castillo and later his uncle Dámaso Gallegos all anticipated greater opportunity. The newly formed taller would need their expertise and they would help formulate the new hierarchy. Most importantly, in their positions of authority, they would be paid salaries rather than by the piece as artisans.[7]

PEDRO CASTILLO GALLEGOS

At the Taller Borda, Pedro was a *maestro* in the handwrought silver workshop and later became the *jéfe* or foreman in that division. Every morning, his responsibility was to distribute the pieces that were to be produced that day. In order to designate what jewelry and decorative objects were to be made by each silversmith, Pedro Castillo had to know well the abilities of the men who worked under him. It was also incumbent upon him to know his craft. Pedro made some jewelry ensembles while at the Taller Borda, but his focus was on the production of flatware.

IV-15 *Pedro Castillo* 1995
Photograph in the Collection of
Penny C. Morrill

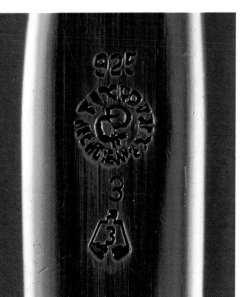

IV-16 *Pedro Castillo's Hallmark*

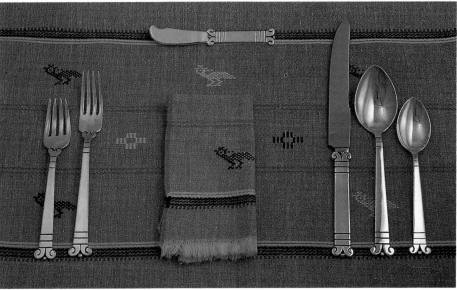

IV-17 Pedro Castillo *Six-piece Place Setting* (Taxco,
Hecho en Mexico around PC. eagle) c. 1950 925 silver
Collections of Jackson and Julia Morrill

After Pedro and his brother Carlos left the Taller Borda, they worked briefly for Rafael Meléndez. Carlos followed Pedro when his brother made the decision to establish a small independent taller, as did Alberto Díaz Ocampo, who left the Taller Borda to join them. The Castillo brothers and Alberto Díaz produced flatware designed by both Héctor Aguilar and Pedro Castillo, giving each design a number on the back of the pieces.

The Castillos stamped their silver designs with *PC* or *ADO*, and, occasionally, with the hallmark *Rancho Alegre*. Pedro Pérez carried their lines of flatware at his store, the Rancho Alegre. The pattern of the flatware in Plate IV-17 with volutes and embossed lines had its origins in designs by Héctor Aguilar (Pl. III-130). In the set in Plate IV-19, the calla lily, so often favored by artists for the sensuality and elegance of its form, was incorporated with imagination into the confines of the fork or spoon handle. The stylization and slowly curving lines of Pedro Castillo's design are reminiscent of Art Deco.

Pedro Castillo takes particular pride in his numerous designs for the crowns worn by the queens of the annual Feria de la Plata [Silver Festival]. Each young woman had her own crown and matching scepter, different from the others, and Pedro has been the designer for fourteen of the reigning queens.[8]

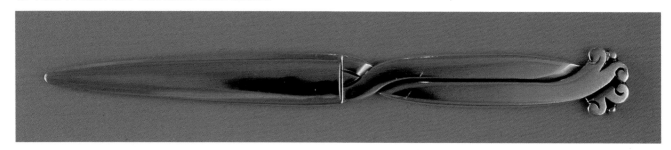

IV-18 Pedro Castillo *Letter Opener* (Taxco, Hecho en Mexico around PC. eagle3. 925) c. 1950
Collection of Penny C. Morrill

IV-19 Pedro Castillo *Calla Lily Six-piece Place Setting*
(Taxco, Hecho en Mexico around PC. eagle) c. 1950 925
silver
Collection of Frederick and Stella Krieger

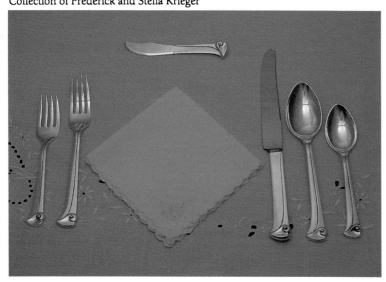

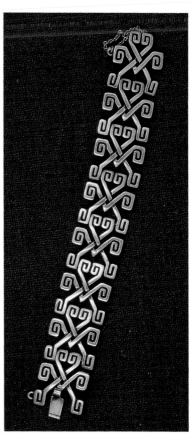

IV-20 Pedro Castillo *Geometric Bracelet* (Sterling. circle – Taxco, Hecho en Mexico around PC. 119) c. 1950 925 silver
Collection of Eric Salter

In 1934, Reveriano Castillo started out at the age of ten as a helper, or *zorrita*, in William Spratling's silver workshop. He was one of the first boys to work in the Taller de Las Delicias and one of the ten young men who left to join Héctor Aguilar in 1939. Reveriano was employed as

REVERIANO CASTILLO

a silversmith in the beginning. Héctor had also worked out an arrangement with Elizabeth Anderson that Reveriano could serve as her chauffeur whenever she needed to go to Mexico City on business.[9]

When the war started and the Taller Borda had gone to mechanized pro-

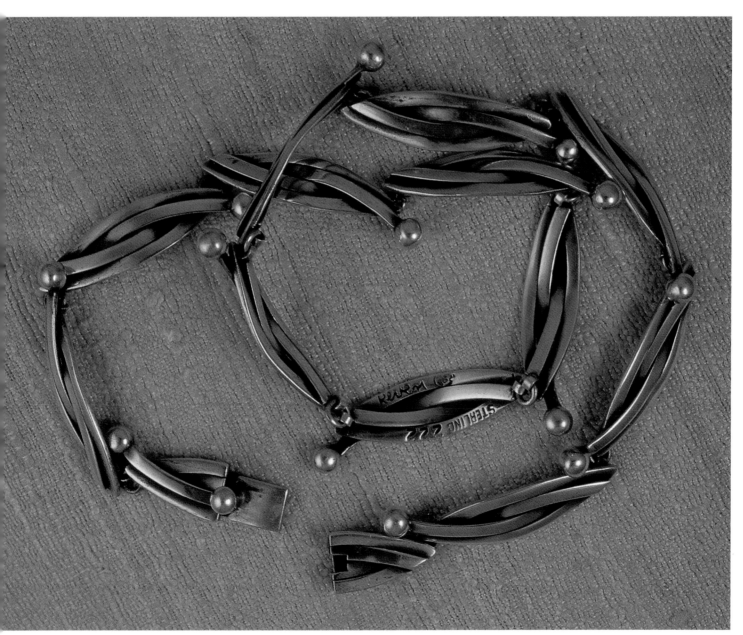

IV-21 *Hallmark for Reveri*
Necklace in the Collection of Charlotte Freeman, "Mollie's Sister"

duction with Coro, a different workshop structure was instituted. Reveriano and his brother Ignacio became *contratistas*, responsible for jobbing out hundreds of machine-stamped pieces which required hand-finishing. Each *contratista* had a room or section where he oversaw the work of about a dozen men. Ignacio was quite the exception, because below him were over fifty workers.[10]

In 1950, Reveriano and María de los Angeles were married in Taxco. María had met Margot van Voorhies Carr in Mexico City, and after Margot's marriage to Antonio

Castillo in the late 1930s, María had come to work for Margot at Los Castillo. Ten years later, after Margot's divorce and Maria's marriage to Reveriano, María left Los Castillo and joined her husband in starting his business.

Before the Taller Borda closed, Reveriano had established his own workshop and his brother Ignacio had gone to Mexico City. For forty years, from 1952 to 1992, the store "Reveri" was across from the Casa Borda on the street from the *zócalo* to the Plazuela de Bernal. Salvador Terán created a mosaic mural for the shop, depicting abstract cloud formations and stars in brown, black, and cream. A close friend of María and Reveriano, Salvador was a cousin of Antonio Castillo and his brothers and contributed many designs for Los Castillo before establishing his own taller.[11]

There are three hallmarks for Reveriano Castillo: a simple *RC* surrounded by the words *Sterling, 925, Taxco Mexico;* the name *Reveri* inscribed across a circle made up of the words *Sterling, Taxco Mexico;* and thirdly, an *R* within a *C.* This last mark can be verified by comparing the hallmark for Reveri stamped on the back of the necklace in Plate IV-21 to an almost identical necklace that appears in *Mexican Silver* (Pl. X-6). This necklace had been originally identified as Bernice Goodspeed's design because the *R* within a *C* seemed like a partly obliterated B

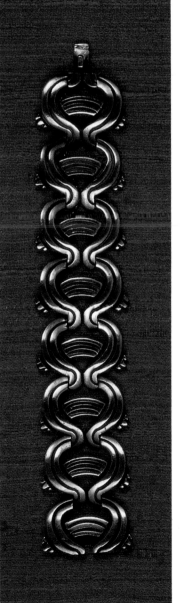

IV-22 *Reveriano Castillo's Hallmark*

IV-23 Reveriano Castillo *Figure-8 Bracelet* (circle – Sterling, Reveri, Taxco, Mexico. eagle. 36) c. 1955 925 silver
Collection of Peregrine Galleries

IV-24 Reveriano Castillo *Money Clip* (circle – Sterling, Taxco around R in a C. eagle3. 103) c. 1955 925 silver
Private Collection

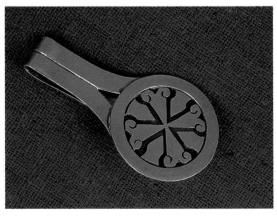

in a circle. Instead, the two necklaces are both the work of Reveriano and identify him with the third hallmark. Further proof is provided by the chain for the large pendant in *Mexican Silver's* Plate X-7 which was attributed to Reveriano and bears the hallmark of the *R* within a *C*.[12]

The taller for Reveri was in the Castillos' house where Reveriano supervised about fifteen to twenty workers. Reveriano and María did all the designing, mostly in silver, although some flatware was produced in mixed metal. They found inspiration in Aztec art for the large bracelets and for the jewelry ensembles. Reveri's style was simple and geometric, embossed with linear patterns that were later oxidized.

Designs occasionally incorporated an element of whimsy as in the wonderful caterpillar pin (Pl. IV-27). This piece required ingenuity to give it the appearance of a tiny creature that could move. The three half-circles which hold the amethyst cabochon in place are the caterpillar's eyes and mouth. The entire piece is flexible, with a pin at the head and a tiny clip at the tail to allow the wearer the freedom to arrange the caterpillar in whatever way suits her.

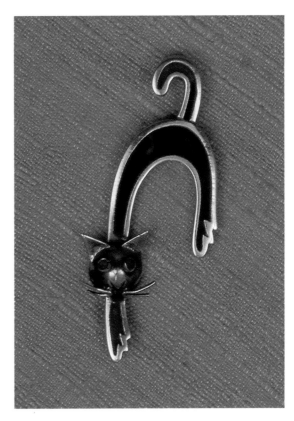

IV-26 Reveriano Castillo *Cat Pin* (circle — Sterling, 925, Taxco around R in a C. 73) c. 1950 925 silver/tortoise
Collection of Eric Salter

IV-25 Reveriano Castillo *Starfish Pin* (R in a C. Mexico. 217. eagle3) c. 1955 925 silver/tortoise
Collection of Penny C. Morrill

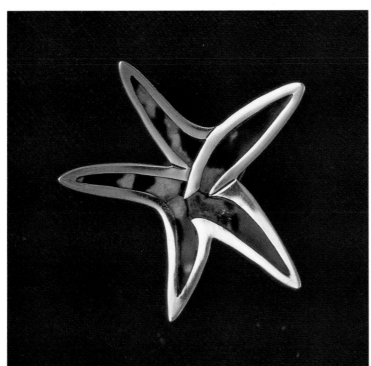

IV-27 Reveriano Castillo *Caterpillar Pin* (RC. circle — Sterling, Taxco Mexico. 238. eagle) c. 1950 925 silver/ amethyst quartz
Collection of Frederick and Stella Krieger

Since its founding in 1939, Los Castillo has been the most prolific of all the workshops in Taxco. At its height, Los Castillo employed over 350 artisans and designers and produced approximately two hundred kilos of silver jewelry and decorative objects every week![13]

In 1938, Antonio Castillo married Margot van Voorhies Carr, an artist from San Francisco. At the time, Antonio and his brothers were working for Spratling, the four of them having been among the first apprentices in the Taller de Las Delicias. Margot and Antonio began to experiment on their own with designs for silver jewelry. The pieces they made sold quickly and Antonio, with his wife; his brothers Jorge, Justo, and Miguel; and cousin Salvador Teran, made the decision to leave Las Delicias and establish a workshop.[14]

The Castillos were always willing to experiment and they developed a variety of innovative techniques and design concepts. In a single year, 1950, the workshop produced more than five hundred new designs.[15] Many fine silversmiths worked for Los Castillo, including some who had been part of the Taller Borda, like Roberto Cuevas. Among the most talented designers in the workshop were Elías Alvarado and two members of the Castillo family, Jorge, known as "Chato," and Salvador. Chato is best known for having invented the technique of married metals, in which various metals, chosen for their color, were cut and fitted into spaces in the background metal (Pls. IV-40-41). Little or no soldering was used, making the technique so difficult, that only a few silversmiths could produce the trays, pitchers, and jewelry that were unique to Los Castillo.[16]

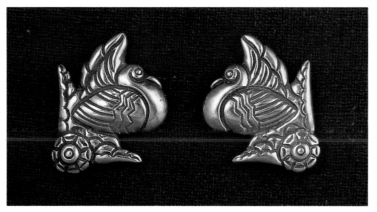

IV-28 Los Castillo *Two Early Folk Art Style Hen Pins* (980. Los Castillo, Taxco) c. 1939 980 silver Collection of J. Crawford

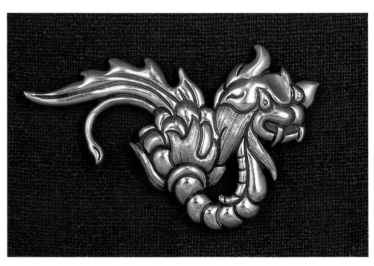

IV-29 Los Castillo *Chinese Dragon Pin* (Los Castillo, Taxco. Sterling, Made in Mexico. 291) c. 1940 925 silver Collection of J. Crawford

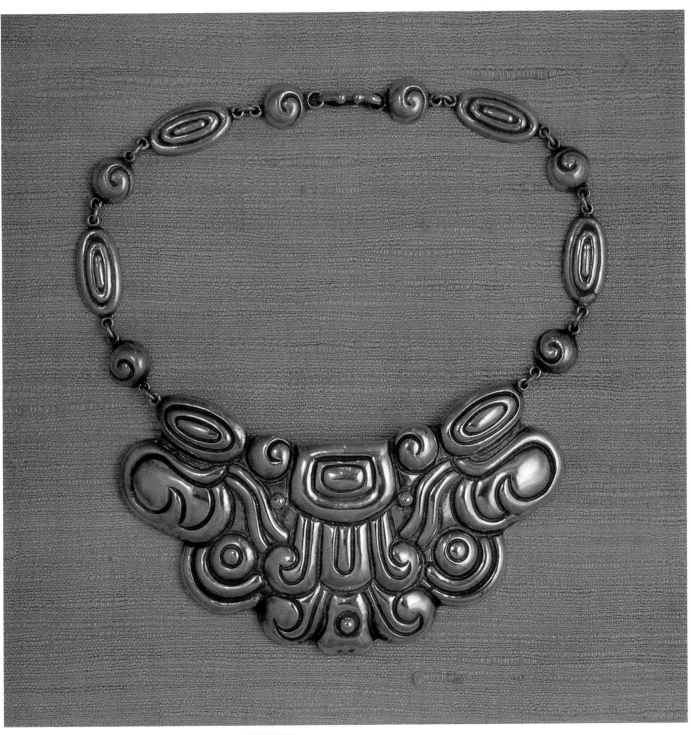

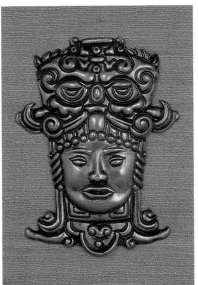

IV-30 Los Castillo *Large Repoussé Pectoral Necklace* (Los Castillo, Taxco. Sterling, Made in Mexico. 144) c. 1940
925 silver
Collection of J. Crawford

IV-31 Los Castillo *Mayan with Elaborate Headress Pin* (980. Los Castillo, Taxco. Made in Mexico. 137) c. 1940
vermeil on 980 silver
Collection of Penny C. Morrill

169

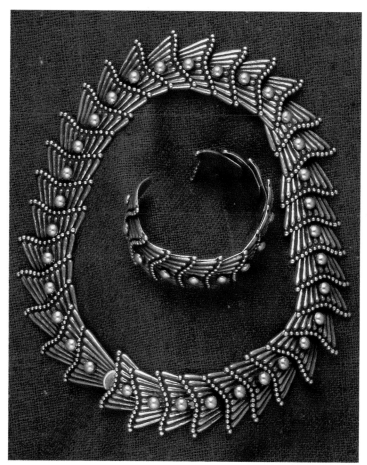

IV-32 Los Castillo *Fish Tail Necklace and Cuff* (Los Castillo, Taxco. Sterling, Mexico. 732) c. 1940-45 925 silver
Collection of Penny C. Morrill

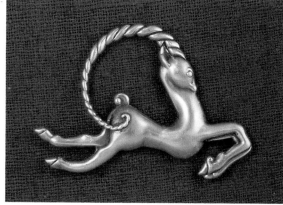

IV-34 Los Castillo *Art Deco Style Antelope* (Los Castillo, Taxco. Sterling, Made in Mexico. 619) c. 1940 925 silver
Collection of J. Crawford

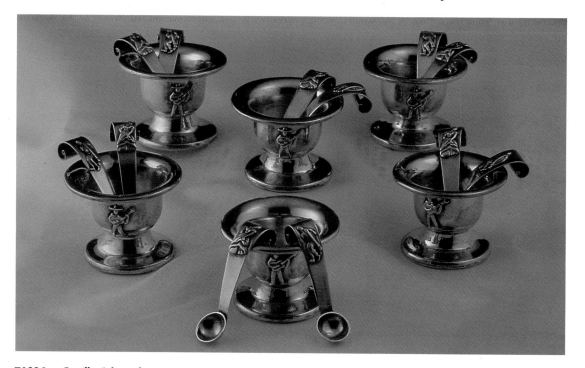

IV-33 Los Castillo *Salts with Musicians and Spoons with Dancers* (122. Handwrought. circle – Los Castillo, Taxco. Sterling, Mexico) c. 1945-50 925 silver
Collection of Carole A. Berk, Ltd.

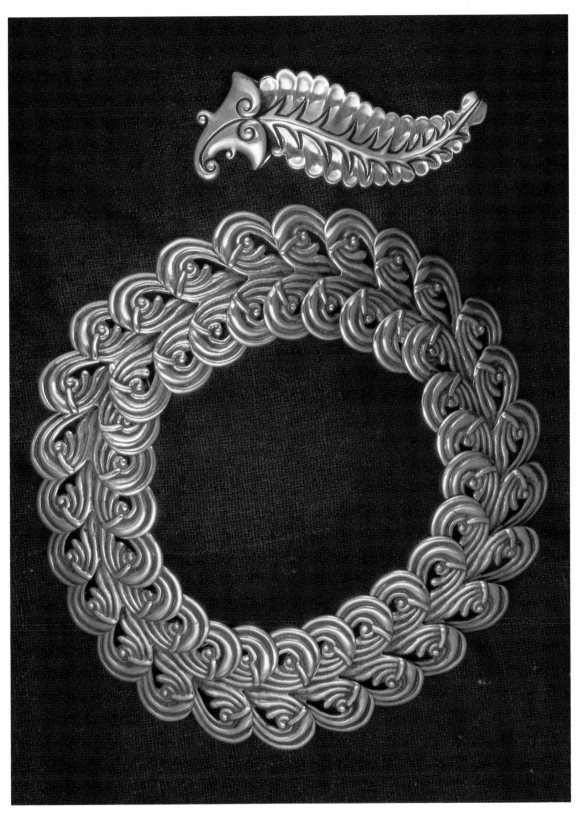

IV-35 Los Castillo *Large Leaf Pin* (Los Castillo, Taxco. Sterling, Made in Mexico. 103); *Repoussé Necklace* (Los Castillo, Taxco. Sterling, Made in Mexico. 650) c. 1940 925 silver
Collections of J. Crawford, and Carole A. Berk, Ltd.

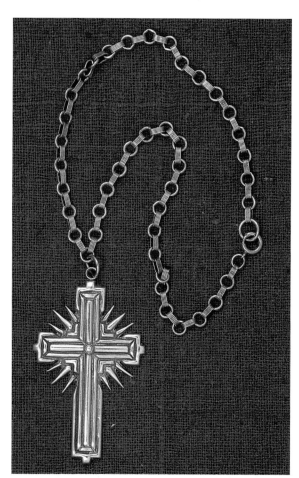

IV-36 Los Castillo *Cross with Rays* (Los Castillo, Taxco. Sterling, Made in Mexico) c. 1940-45 925 silver
Collection of Gunther Cohn and Marc Navarro

IV-37 Los Castillo *Box Ornamented with Pre-Columbian Mask* (300, circle — Los Castillo, Taxco, Hecho en Mexico) c. 1945 silver/rosewood/onyx/malachite
Collection of Gunther Cohn and Marc Navarro

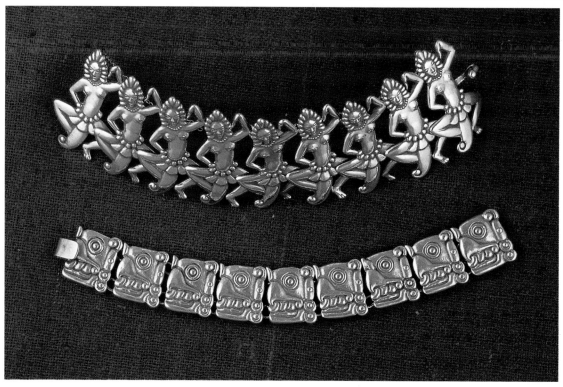

IV-38 Los Castillo *Female Dancers Bracelet* (Los Castillo, Taxco. Sterling, Made in Mexico. 519);
Parrot Head Bracelet (Los Castillo, Taxco. Sterling, Made in Mexico. 266) c. 1940-45 925 silver
Collections of Eric Salter, and Carole A. Berk, Ltd.

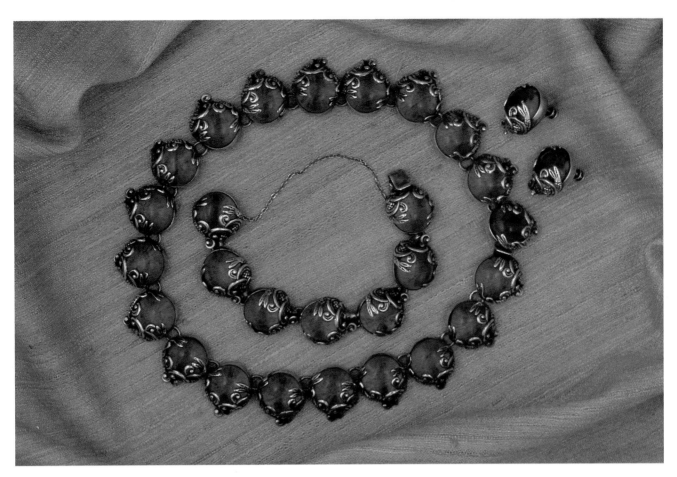

IV-39 Los Castillo *Necklace, Bracelet, and Earrings of Swirling Silver Fish and Blue Glass Domes* (circle – Sterling, Made in Mexico. circle – Los Castillo, Taxco around eagle15) c. 1955-60 925 silver/blue glass
Collection of Carole A. Berk, Ltd.

IV-40 Chato Castillo *Fish in Married Metals* (Hecho en Mexico. circle – Los Castillo, Taxco. 207) c. 1955
Collection of J. Crawford

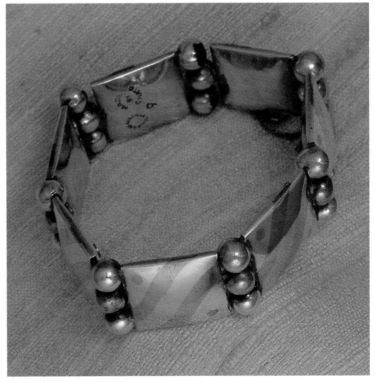

IV-41 Chato Castillo *Mixed Metals Bracelet* (Made by Chato. circle – Los Castillo, Taxco. 9. eagle1) c. 1955
Collection of Gunther Cohn and Marc Navarro

173

Elías Alvarado worked in married metals but was best known for large-scale repoussé Maya-style figures in silver mounted on wood.[17] Alvarado was an artist whose murals and paintings can still be found in Taxco. After Chato's death, he was the principal designer for Los Castillo and, like Chato, his silver designs were inspired by Mixtec and Aztec codices.[18]

Rafael Ruiz Saucedo was a master silversmith and was *jefe* or administrator of the Los Castillo workshop. Rafael was born in Tlapujahua, Michoacan and went to Mexico City to work in silversmithing. He and his brother arrived in Taxco in 1938 and Rafael joined the Taller de las Delicias. In the fifties, after working for Héctor Aguilar briefly,

Rafael was given the responsibility at Los Castillo of making the first models or prototypes for Chato in mixed metals. From 1959 to 1963, Rafael served as a maestro in the workshop of Antonio Pineda. Spratling was able to lure Rafael away to work for him out at the ranch, which he did until Spratling's death in 1967. In the early seventies, Rafael was in semi-retirement, although his mastery of silversmithing was still required in the workshops of both Antonio Pineda and Los Castillo. It was not until after his death (August 18, 1990) that Rafael received a prize in 1994 for his design entitled "El Bule," presented posthumously to his son, Javier Ruiz.[19]

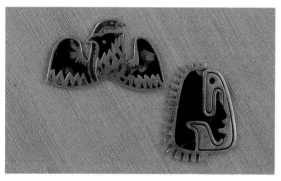

IV-42 Los Castillo *Eagle and Serpent – Symbol of Mexico* (circle – Los Castillo, Taxco, eagle. 158) silver, tortoise, crushed stone inlay; *Mayan Profile with Stylized Bird* (circle – Los Castillo, Taxco. eagle15. 109. onix negro) c. 1955 silver, onyx, tortoise
Collection of J. Crawford

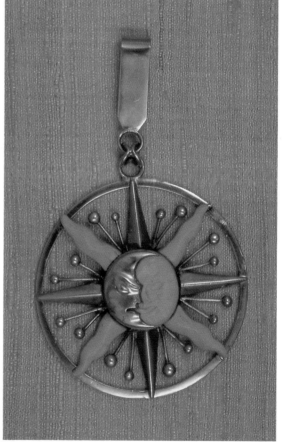

IV-44 Salvador Teran *Sun and Moon Pendant* (Salvador. eagle36. Sterling, Mexico. 179) c. 1955-60 vermeil on 925 silver/ivory
Collection of Penny C. Morrill

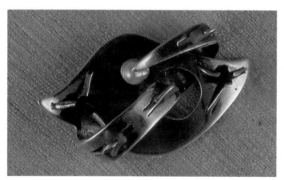

IV-43 Chato Castillo *Modernist Pin* (6. abstract parrot head hallmark. Chato Castillo. Taxco, Mexico. 925) c. 1955 925 silver/ coral/malachite
Collection of Eric Salter

Salvador Teran was with Los Castillo from 1939 until 1952, when he established a taller in Mexico City. The pin and earrings in Plate IV-45 are remarkable examples of his use of overlapping planes to create the impression of three dimensionality. Salvador also developed a style of his own in another medium, glass mosaic. The simple form of the brass pitcher, box, or tray served as a background for the color and texture of the glass mosaic design. In many of these pieces, like the pitchers and glasses in Plates IV-48-49, Salvador was successful in making a strong and colorful statement.

In the early sixties, when tourism in Taxco dropped and taxes and social security became prohibitive, many talleres were forced to cut their workforce dramatically. Los Castillo let go fifty percent of its workers.

Since most of the silversmiths were paid by the piece, the reduction in demand for silver jewelry and objects and the loss of job security led to the formation of a union. When negotiations broke down with the owners of the large workshops, the union leaders called for a strike which lasted four months.

Many of the workshops, among them the Taller Borda, chose to declare bankruptcy when faced with an unstable economy and increased demands from the government and the union. Los Castillo found another solution, the formation of a cooperative. Antonio Castillo, owner of the taller, received direction and advice from a Jesuit priest who had helped organize other cooperatives in the states of Morelos and Guerrero. Don Antonio agreed to turn over the machinery and most of the tools to the cooperative and gave the workers the right to produce the more than eight hundred designs developed at Los Castillo. The finished pieces were to be sold exclusively by Los Castillo.

In the beginning, the silversmiths were enthusiastic at the prospect of working out of their houses and having a ready market for whatever they produced. From their perspective, the members of the cooperative thought

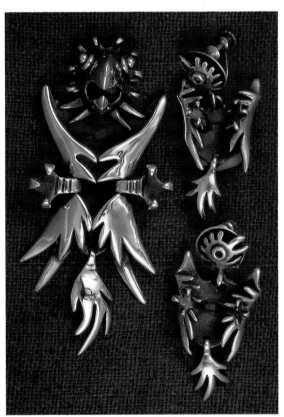

IV-45 Salvador Teran *Bird Pendant and Earrings* (Salvador. Sterling, Mexico. 175) c. 1955 925 silver Collection of Carole A. Berk, Ltd.

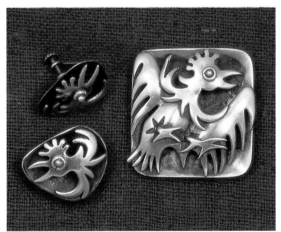

IV-46 Salvador Teran *Rooster Pin and Earrings* (eagle36. Sterling, Mexico. Salvador. 171) c. 1955 925 silver Collection of Gunther Cohn and Marc Navarro

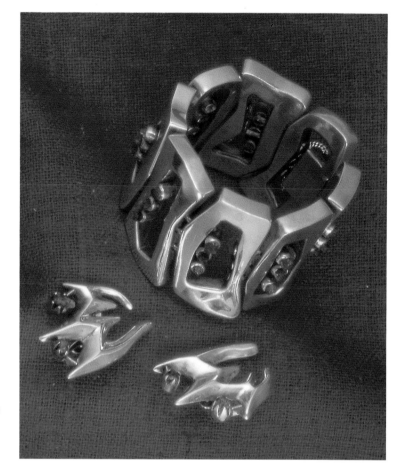

Right:
IV-47 Salvador Teran *Wide Bracelet and Earrings with Emeralds* (Salvador. Sterling, Mexico. eagle36. 130) c. 1960 925 silver
Collection of Gunther Cohn and Marc Navarro

Below:
IV-48 Salvador Teran *Two Pitchers and Eight Glasses in Brass and Glass Mosaic* (Handwrought. Salvador. Hecho en Mexico. glasses-427, pitchers-433) c. 1955-60 brass/glass tesserae
Collections of Carole A. Berk, Ltd., and Penny C. Morrill

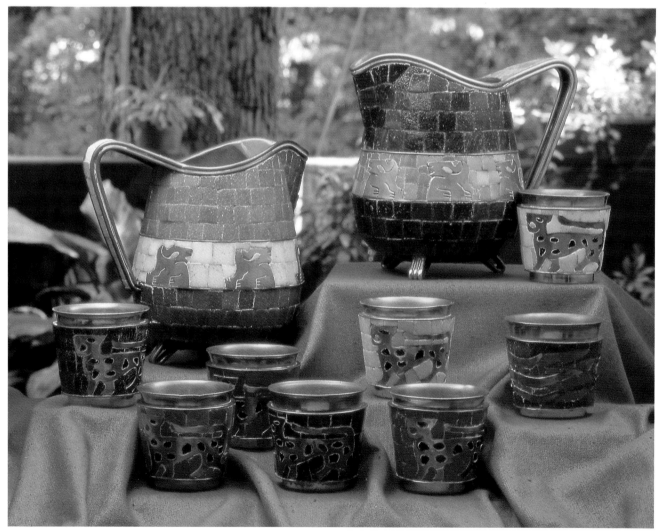

they had replaced the system of the *patrón*. However, according to Gobi Stromberg in her study of Mexico's silver industry, the workers had allowed the president of the cooperative, who had been the leader of the strike, to assume increasingly more power and autonomy in making decisions, until he began to abuse his position of leadership. After only six months, the amount of work had diminished to such an extent, that the silversmiths were only given enough to keep them working three days a week. It was discovered that the president was diverting orders to his own workshop. Soon after, the cooperative was forced into bankruptcy.[20] Although Los Castillo maintained a small workshop, most of the work was done in the houses of former employees.

To this day, the Castillo family continues to take the lead in developing new ideas. Don Antonio has a small taller and showroom at the Castillo ranch in Taxco el Viejo. His daughter Emilia is designing beautiful objects in porcelain with silver inlay, produced at the ranch in a large workshop. Los Castillo has always received major commissions, recently for the altar of the Virgin of Guadalupe at St. Peter's in Rome. Over the last fifty-six years, the remarkable variety of design and the quality and quantity of production have brought admiration for Los Castillo from all over the world.

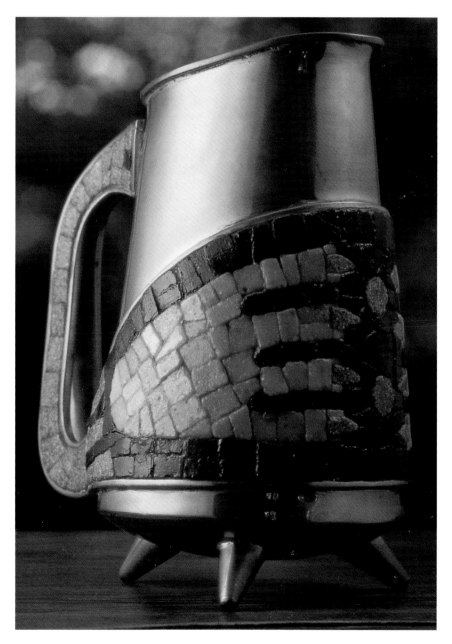

IV-49 Salvador Teran
*Brass Pitcher with Glass
Mosaic Hands*
(Handwrought.
Salvador. Hecho en
Mexico. 414) c. 1955-60
brass/glass tesserae
Collection of Carole A.
Berk, Ltd.

Antonio Pineda began his career as a silver designer in the Taller de Las Delicias as had so many others in Taxco. His studies in painting with artists Alfredo Zalce and Martín Pineda provided him with an artistic vision that later carried over into his work in another medium. In 1939, Antonio left Taxco to work for Valentín Vidaurreta in Mexico City, and it was in this taller that he developed an appreciation for working with powerfully formed but simple shapes in silver.[21]

In 1941, Antonio Pineda established his own workshop and store on the *zócalo*. From 1941 to 1949, Antonio was using the hallmark *AP*. The black mask and silver flange necklace (Pl. IV-54) which bears the *AP* mark closely resembles jewelry that was produced for Fred Davis in Valentín Vidaurreta's Mexico City workshop where

Antonio Pineda worked as an apprentice. The copper and silver necklace and bracelet in Plate IV-53 hold evidence of Valentín's influence on Antonio's early work. The U-shaped motif, linked with bands of copper and silver beading, brings to mind the influence of Pre-Columbian art. However, Antonio added texture and dimension to these forms to give the ensemble a sophisticated twentieth century interpretation.

From 1949 to 1953, Antonio used the mark *Jewels by Toño* and after 1953, began stamping all of his silver with the crown hallmark. The period from 1955 to 1970 was his most prolific and successful. Antonio had over one hundred and sixty people working for him. Among them were several artisans who had started out in the Taller Borda, like Rafael Ruiz Saucedo and Fuljencio Castillo.

IV-50 *Antonio Pineda's Early Hallmark*

IV-51 *Antonio Pineda's Later Hallmark*

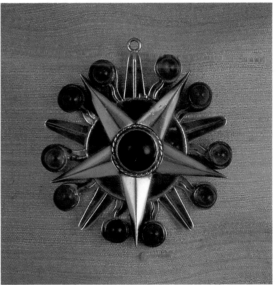

IV-52 Antonio Pineda *Sun and Star Pin/Pendant with Amethyst Cabochons* (Taxco. AP. 980) c. 1945 980 silver Collection of Gunther Cohn and Marc Navarro

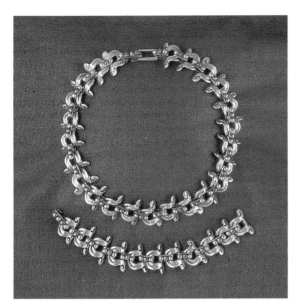

IV-53 Antonio Pineda *Silver and Copper Necklace and Bracelet* (Mexico. AP. Silver) c. 1945 silver/copper
Collection of Penny C. Morrill

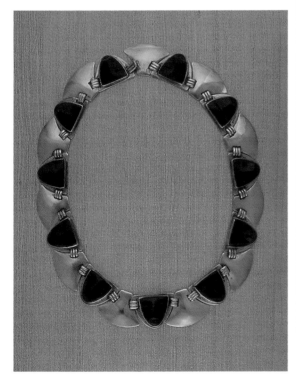

IV-54 Antonio Pineda *This Necklace Indicates the Strong Influence Valentín Vidaurreta had on Antonio Pineda, Especially in his Earliest Work.* (AP. Silver. Made in Mexico) c. 1945 silver/onyx
Collection of Gunther Cohn and Marc Navarro

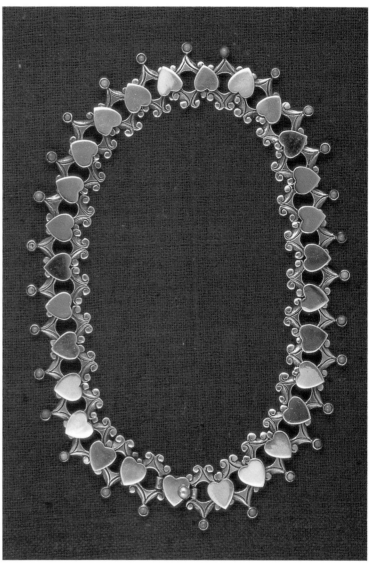

IV-55 Antonio Pineda *Hearts Necklace* (Mexico. 970. eagle17. Antonio crown) c. 1955-60 970 silver/turquoise
Collection of Linda and Steve Nelson

The comparison between the early necklace and bracelet and the ensemble in Plate IV-56 reveals Antonio's development towards an international style. In the later pieces, Antonio achieved an effect that is dramatic, sensuous, and commanding without weight, as in the leaf bracelet in Plate IV-57. As he had throughout his career, Antonio insisted on technical quality and the use of almost pure silver. Many of his pieces are wearable works of art produced by a designer who continues to warrant attention.

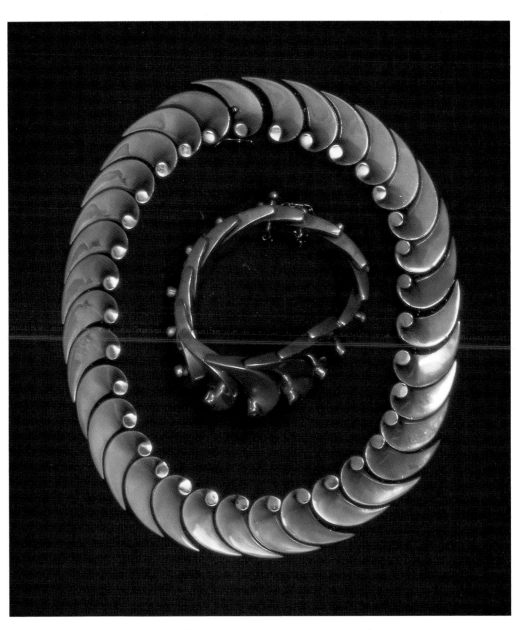

IV-56 Antonio Pineda *3-D Wave Necklace and Bracelet* (Antonio crown. Sterling Mexico. YY. 525. eagle. 970 silver) c. 1955-60 970 silver
Collection of Leah Gordon

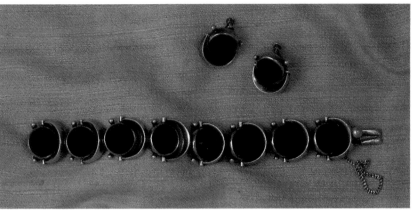

IV-57 Antonio Pineda *Leaf Bracelet* (970. Sterling,
Mexico. Antonio crown. Z. eagle13. silver. 609) c. 1955
970 silver
Collection of Eric Salter

IV-59 Antonio Pineda *Black Discs and Swiveling Setting Bracelet and Earrings*
(eagle. Antonio crown. Hecho en Mexico. 970) c. 1955-60 970 silver/onyx
discs
Collection of Eric Salter

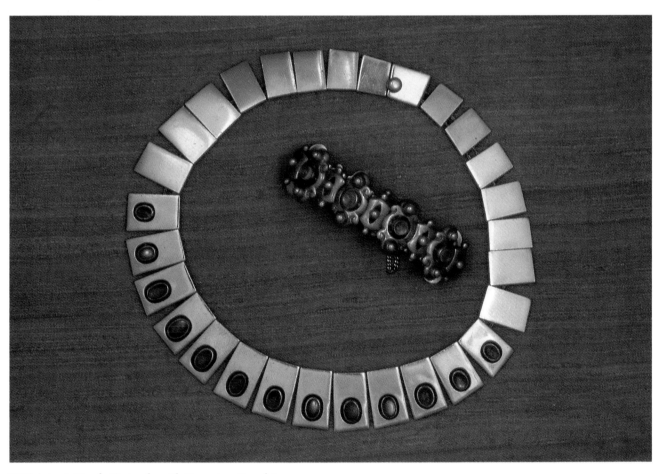

IV-58 Antonio Pineda *Cartouche with Moonstone Bracelet*
(Sterling, Mexico. 970. Antonio crown. silver); *Moonstone
Necklace* (Silver. Sterling, Mexico. 970. Antonio crown.
eagle17) c. 1955 970 silver
Collections of Carole A. Berk, Ltd., and Eric Salter

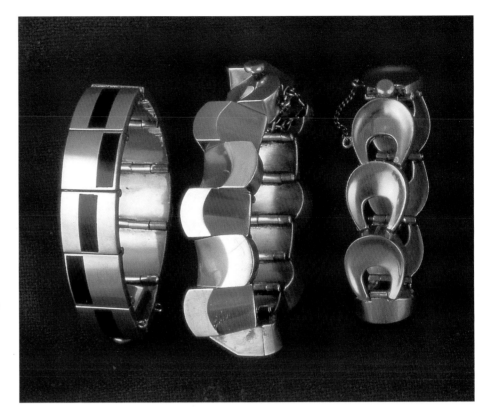

IV-60 Antonio Pineda *Squares with Bands of Tortoise Bracelet* (Antonio crown. eagle. 970. Taxco, Sterling) 970 silver/tortoise; *Thumb Print Bracelet* (Hecho en Mexico. OHC. 970. Antonio crown. silver. ZZ. 753) 970 silver; *Concave Ovals Bracelet* (970. Antonio crown. Taxco. eagle. Sterling) c. 1960 vermeil on 970 silver
Collection of Eric Salter

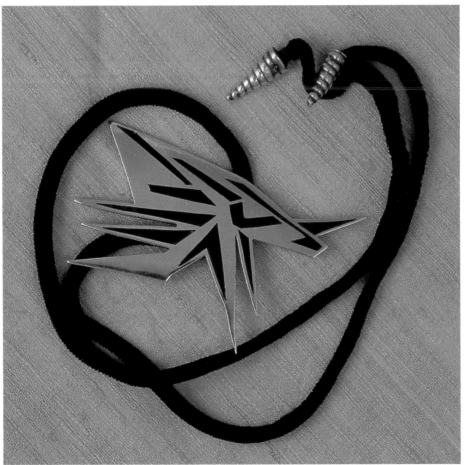

IV-61 Antonio Pineda *Modernist Pendant with Velvet Cord* (Antonio crown. eagle. 970. silver. Hecho en Mexico. YY. 610) c. 1955-60 970 silver/obsidian
Collection of Eric Salter

Dámaso Gallegos was already a silversmith when he arrived in Taxco. He had learned his trade in the village of Ixcateopán, making baptismal shells in silver for the church and ornamentation for riding gear. During the Revolution, he manufactured shotguns, then went back to silversmithing and took on his brother-in-law Isidro García as an apprentice.[22]

DAMASO GALLEGOS

commission. Dámaso worked for Héctor Aguilar for three years, then made the decision to go out on his own. He established his taller and shop "La Amatista" next to the entrance of the Hotel Victoria. He continued to operate the taller until his death on January 9, 1976. His wife maintained the shop until her death ten years later in 1986.

By 1940, there were several workshops in Taxco that were enjoying success, including the Taller Borda and Los Castillo. William Spratling's Taller de Las Delicias had grown to number three hundred artisans.[23] Opportunity drew Dámaso and Isidro to Taxco in 1940, where, after only a few years, they both developed their own successful workshops (Pl. IV-62).

Dámaso entered the Taller Borda where he quickly proved himself a *maestro*. He was also considered a *joyero*, called upon to work in gold if the workshop received a special

The war brought a flood of contracts from North American companies and a push towards mechanized production. Only the large talleres, like Las Delicias, Los Castillo, and Taller Borda, could afford to buy the machines when they became available in Mexico City. Dámaso Gallegos acquired a mill for making wire, a rolling mill, and presses for die-cuts. In 1943 there were about twenty workers in his taller, producing small silver pill boxes and heavy identification bracelets for North American soldiers.

IV-63 *Dámaso Gallegos's Hallmark*

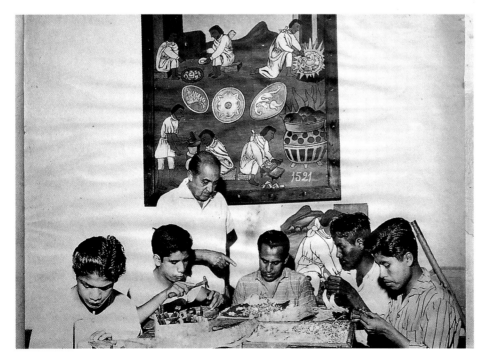

IV-62 *Dámaso Gallegos and his Workshop* c. 1945
Photograph in the Collection of Antonio Gallegos

183

The move to machine production was permanent for all the big talleres. Dámaso's workshop continued to make hair clips, bracelets, and floral pins which were formed in part by machine and finished by hand. He also designed and produced flatware and decorative pieces like flower vases, bowls, and candlesticks. The most popular item sold was the Christmas pin with tiny silver bells (Pl. IV-65). The parts were stamped out by machine, then shaped and finished by hand. The Embriz family made most of the dies for Dámaso as they had for the Taller Borda. However, Dámaso also made dies himself and occasionally ordered them from Mexico City.[24]

Damaso sold his work not only in his own shop, but at Rancho Alegre, where his silver was featured right from the beginning in 1956. His pieces were also sold at Carlos Acosta's store, California.

Dámaso's ability as a designer and silversmith is evident in the amethyst bracelet in Plate IV-64. The boldly braided hinges repeat the beading surrounding the amethysts. The flanged squares into which the amethysts were set provide movement and a variety of surfaces. The verticality of the stones and hinges was offset by the repeating oxidized and embossed lines.

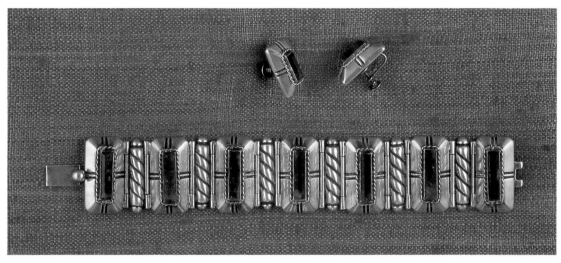

IV-64 Damaso Gallegos *Rectangular Amethyst Bracelet and Earrings* (DG. 925. Sterling, Taxco) c. 1940-45 925 silver Private Collection

IV-65 Dámaso Gallegos *Three Christmas Pins with Bells* (DG) c. 1945 925 silver Collection of Antonio Gallegos

Rafael Melendez began his career as a silversmith in 1932, at an early point in the history of the Taller de Las Delicias.[25] Like others among his peers, he made the decision to leave Las Delicias in 1939. Rafael started his taller and shop next to the Hotel Melendez, across the street from Las Delicias. The Platería Melendez occupied half the space, and "El Nivel," Rafael's hardware store, was in the other half. On the level below, Rafael had an unfinished area where metals were smelted, cast, and hammered or rolled flat.

Rafael Melendez operated the taller until 1952 when he began buying the work of independent silversmiths and selling it in his shop. He had about twenty men working for him, some of whom were exceptional craftsmen. At various times, members of the taller included Alfonso Mondragón, Pedro Castillo, Adán Alvarado, Carlos and Ignacio Castillo, and Alfonso Gómez.[26]

Most of the jewelry designs by Rafael Melendez were based on Pre-Columbian motifs and owed much to the style of William Spratling who remained a constant influence. Rafael's signature line was called "Para Ti" [For You], an ensemble including a necklace, bracelet, and earrings in a stylized leaf pattern.

RAFAEL
SALVADOR
MELENDEZ
ADAN

IV-66 *Rafael Melendez's Hallmarks*

IV-67 Rafael Melendez *Circular Pre-Columbian Pin* (Taxco. RM. 980) c. 1935-40 980 silver
Collection of Lolly Commanday

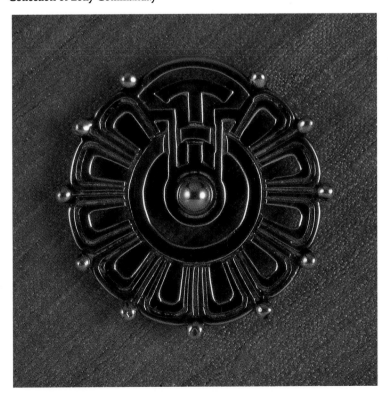

The pin in Plate IV-67 is characteristic of work produced in Rafael Melendez's taller in that it was made in a thick gauge of 980 silver. The roughness on the back indicates that before the pin was cut out, the silver plaque was hammered flat, in the days when there were no rolling mills.

Rafael Melendez moved his shop into the Patio Colonial of the Casa Borda, across the street from Reveri. After a short time, he moved to the Calle de la Muerte [the Street of the Dead], where his niece Emma Melendez later had her shop. He converted part of the building into a small hotel known as the Hotel Jardín.

Rafael held property in Taxco-el-Viejo along the river. In about 1940-1942, he sold the land to William Spratling, and it became the famed Spratling Ranch. Rafael Melendez died in 1968, leaving behind a fairly substantial body of work. What distinguishes his pieces are the two slightly different hallmarks bearing his initials *RM* and the heavy modeling, the strength of form and surface, and the immediacy of the artisan's hand.

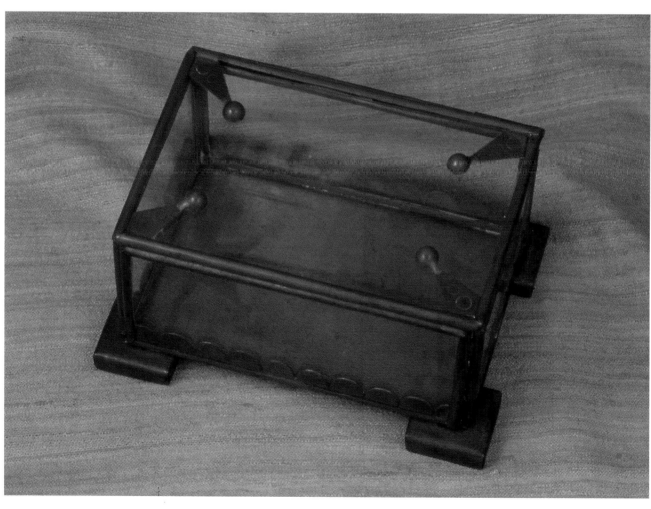

IV-68 Rafael Melendez *Copper and Glass Box* (Taxco Mexico. RM) c. 1935-40
copper/glass
Private Collection

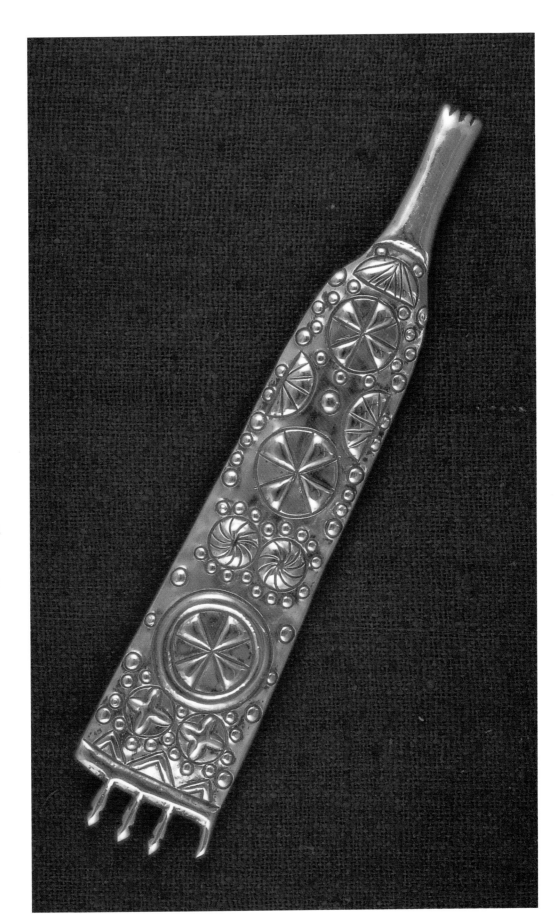

IV-69 Rafael Melendez
Bizarre Pin in Repoussé,
Seven Inches in Length
(Taxco Mexico. RM) c.
1935-40 silver
Collection of Eric Salter

Hubert Harmon was clever, witty, and outrageous. Freddie Jennison's letters from Taxco to Natalie Scott during the war abound with stories of his antics. Hubert was reported to have been a very amusing storyteller: "Hubert was at his best. . . ([He] should have been an actor!)." In 1943, Hubert and his wife gave a New Year's Eve party at which he appeared dressed in formal evening wear from the waist up, over a pair of bathing trunks and bare legs. The central event of the party was the unveiling of a portrait of Louise Harmon by artist Paul Cook who was living at the Harmons' house while painting and

HUBERT HARMON

working on sobriety. The festivities went on until six in the morning on New Year's Day.[27]

Hubert's cartoon-like burros frolicking on the walls of the Bar Paco (Pl. I-48) indicate his humor but do not define his creative spirit. His silver designs are a better indication of his inventiveness. The pieces which he signed with his hallmark, a pair of bare feet with wings, are remarkable for their wit and for the attention given to detail and finish. Hubert Harmon obviously had several fine silversmiths working for him in Taxco.

IV-70 *Hubert Harmon's Hallmark*

IV-71 Hubert Harmon *Fish and Pole Pin* (Sterling. Hubert Harmon. Made in Mexico) c. 1940-45 925 silver/amethyst quartz
Collection of Gunther Cohn and Marc Navarro

IV-72 Hubert Harmon *Winged Pilgrim Head Pin* (Sterling. Hubert Harmon. Made in Mexico. flying feet) c. 1940-45 925 silver/onyx
Collection of J. Crawford

The painting of the Roman forum by Harmon (Pl. IV-83) places him in Rome in the mid-fifties. Hubert Harmon did return to Mexico but chose not to live in Taxco. His work in silver can therefore be dated in the forties.

One of his most remarkable brooches is the fish attached to a fishing pole (Pl. IV-71). The size of the pin — the pole is about four inches in length — certainly adds to the dramatic effect. The silver chain which acts as a fishing line can actually be "reeled in" on a miniature amethyst-bejeweled reel. The exaggerated length and wildly curling motion of the fish's tail fins are made even more incongruous with the addition of wings and a band of tiny amethyst cabochons. The visual impact of this piece is incomparable for its humor, technical perfection, and vitality. It could only have been designed by Hubert Harmon.

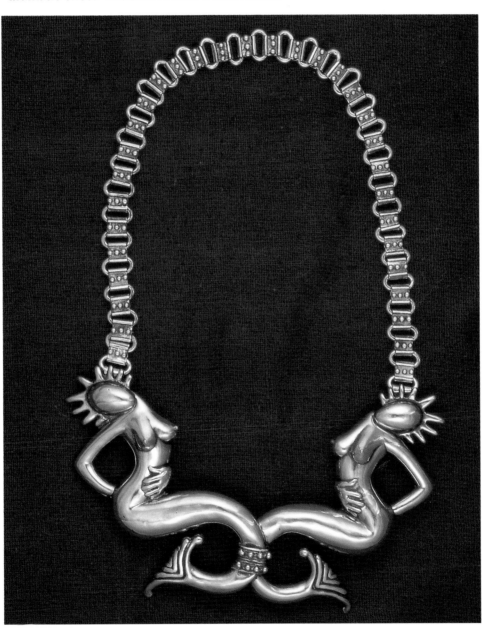

IV-73 Hubert Harmon *Double Mermaid Necklace* (hieroglyph. Hubertus. Sterling. Taxco, Mexico) c. 1940-45 925 silver
Collection of Gunther Cohn and Marc Navarro

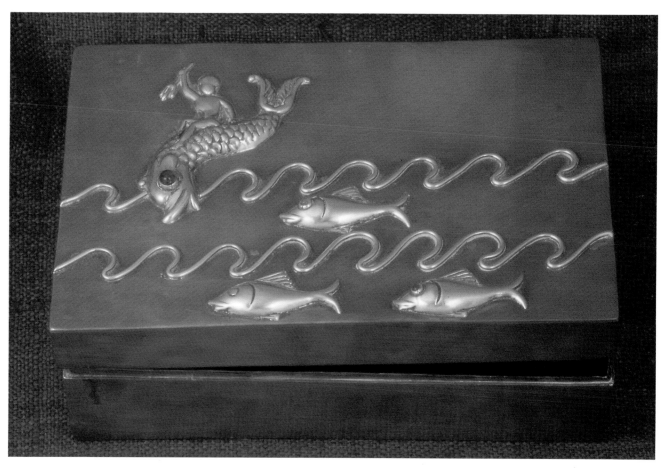

IV-74 Hubert Harmon *Mermaid Box*
(Hubert Harmon, Made in Mexico) c.
1940-45 copper/925 silver/amethyst
cabochons
Collection of Orlando Rigono

IV-75 Hubert Harmon *Hand Wearing
Ring Cuff and Matching Ring*
(Sterling. Hubert Harmon. Made in
Mexico. flying feet) c. 1940-45 925
silver/amethyst quartz
Collection of Gunther Cohn and Marc
Navarro

IV-76 Hubert Harmon *Wide Brass Cuff with Silver Domes*
(Handmade. flying feet. Made in Mexico) c. 1940-45
silver/brass
Collection of Gunther Cohn and Marc Navarro

Left:
IV-78 Hubert Harmon *Abstract Animal Ring* (Sterling. Hubert Harmon. Made in Mexico) c. 1940 925 silver/onyx;
Los Castillo *Ring with Stone Mosaic of a Woman's Face* (Los Castillo. eagle3. Mexico. SMM. 925. 14)
Collection of Carole A. Berk, Ltd.

Below:
IV-79 Hubert Harmon *Wings and Stars Earrings* (Sterling. Hubert Harmon. Made in Mexico. flying feet) c. 1940-45; Salvador Teran *Abstract Human Figure Earrings* (Salvador. 128. Sterling, Mexico) c. 1955 925 silver
Collection of Gunther Cohn and Marc Navarro

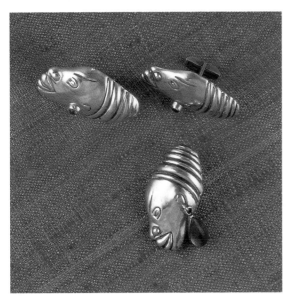

IV-77 Hubert Harmon *African Woman Pin and Cufflinks*
(Sterling. Hubert Harmon. Made in Mexico) c. 1940-45
925 silver/amethyst quartz
Collection of Gunther Cohn and Marc Navarro

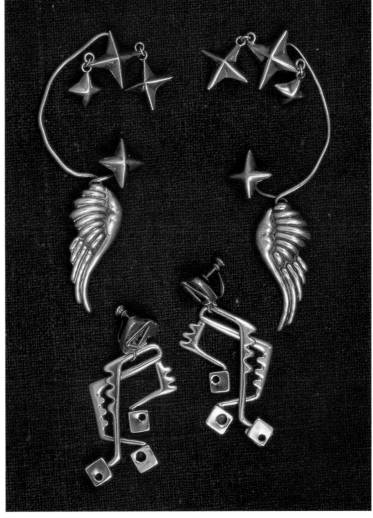

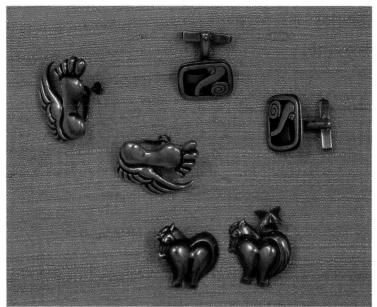

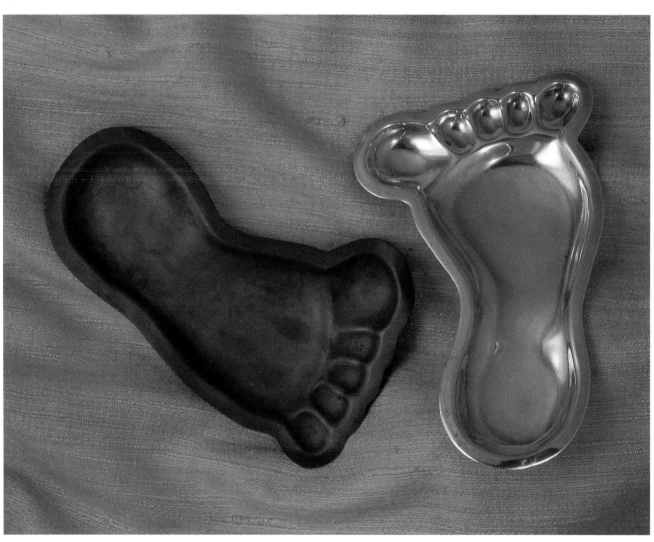

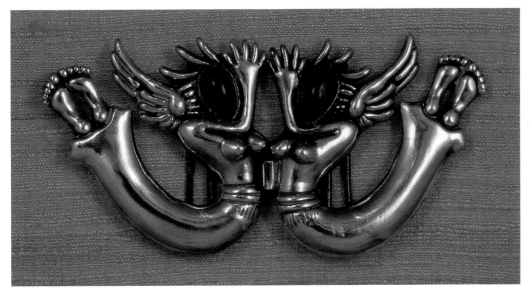

IV-82 Hubert Harmon
*Double Angel Belt Buckle
with Amethyst Faces*
(Sterling. Hubert Harmon.
Made in Mexico. flying
feet) c. 1940-45 925
silver/amethyst quartz
Collection of Gunther
Cohn and Marc Navarro

IV-83 Hubert Harmon *Foro Romano* watercolor signed by Hubert Harmon
and dated 1956
Collection of Gunther Cohn and Marc Navarro

Enrique Ledesma was a painter, silversmith, and lapidary. His early training as an artist was at the San Carlos Academy of Art in Mexico City. He had apprenticed at his father's silver workshop, and worked for a large taller while he was in art school.

Ledesma joined the Taller de Las Delicias after his move to Taxco. In 1944, he created a portrait in silver of Spratling, commemorating the opening of the new workshop at the restored hacienda, La Florida. It is likely that Ledesma worked for Las Delicias until Spratling left the company in 1945.[28]

Sometime after the war, Ledesma was at the Taller Borda for perhaps a year or two. He did some lapidary work, but was mostly employed in manufacturing silver hollo-

ware.[29] In 1949, Spratling asked Ledesma to work for him at the ranch. Ledesma participated in a project initiated by Spratling, training a group of Alaskans who had come to Taxco to learn silversmithing. A year later, in 1950, Ledesma put together his own taller and opened a shop at Exconvento No. 10.

Ledesma signed and numbered all his designs. For the most part, his work is modern, fluid, and elegant, as in the beautiful tortoiseshell and silver ensemble in Plate IV-89. He is best known for his integration of stone in silver settings (Pl. IV-85). The mark on the back of this obsidian and silver necklace, "Platería Cortés," refers to one of the shops that carried Ledesma's jewelry.

IV-84 *Enrique Ledesma's Hallmark*

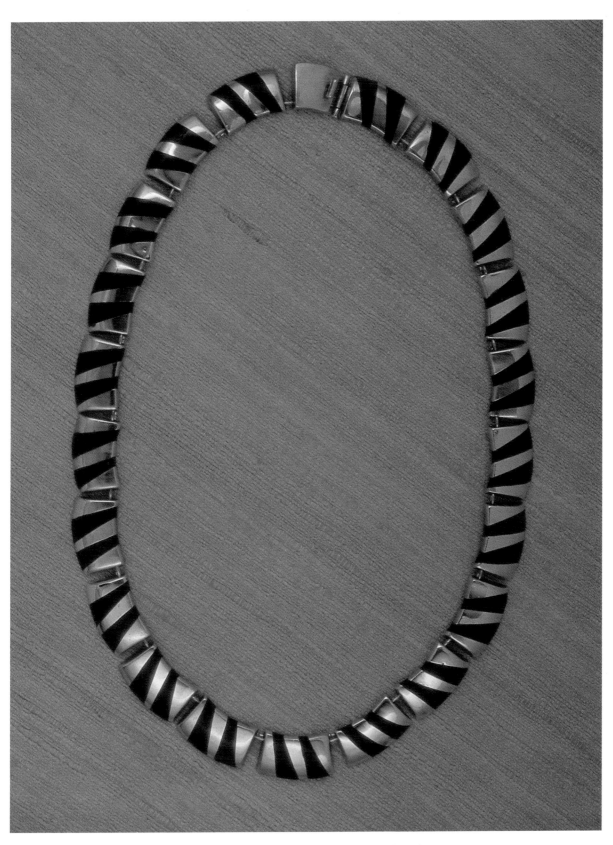

IV-85 Enrique Ledesma *Necklace of Stone and Silver Rectangles* (Platería Cortés.
Taxco. Ledesma. eagle3. 925. 505. HM) c. 1955-60 925 silver/obsidian
Collection of Carole A. Berk, Ltd.

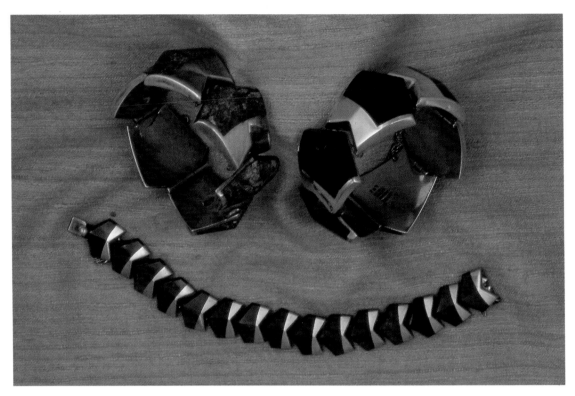

IV-86 Enrique Ledesma *Large Chevron Bracelet* (207. Hecho en Mexico. Taxco. Ledesma. 925. eagle3) 925 silver/obsidian; *Small Chevron Bracelet* (206. 925. F. eagle3. Mexico. Taxco. Ledesma) 925 silver/obsidian; *Large Chevron Bracelet in Azurite* (Ledesma. Taxco. 207. eagle3. Platería Cortés. Hecho en Mexico. 925) c. 1955 925 silver/azurite
Collections of Gunther Cohn and Marc Navarro, Jan Duggan, and Eric Salter

IV-87 Enrique Ledesma *Cuff Bracelet with Faceted Alexandrites* (Hecho en Mexico. Taxco. Ledesma. 925. eagle3. 11) c. 1955-60 925 silver/alexandrites
Collection of Eric Salter

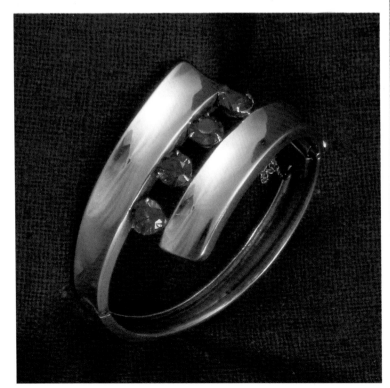

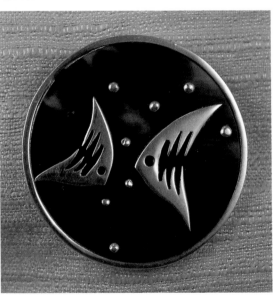

IV-88 Enrique Ledesma *Fish against a Tortoise Sea Pin* (Ledesma. Taxco. eagle3. Hecho en Mexico. 7. 925) c. 1955-60 925 silver/tortoise
Collection of Carole A. Berk, Ltd.

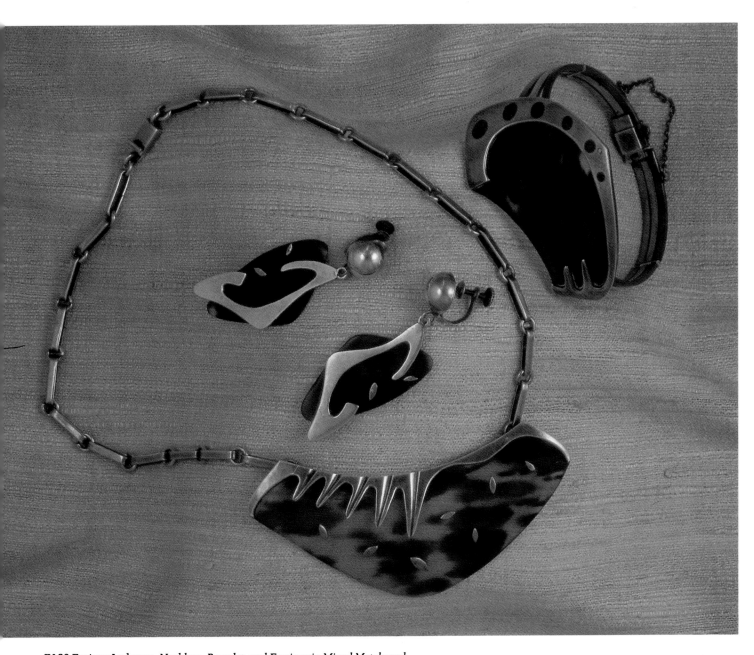

IV-89 Enrique Ledesma *Necklace, Bracelet, and Earrings in Mixed Metals and Tortoise* (2. Ledesma. Hecho en Mexico. 925. eagle3) 925 silver/brass/copper/tortoise
Collection of Gunther Cohn and Marc Navarro

Manuel Altamirano worked for many years for Valentín Vidaurreta. The ensemble in Plate IV-91, although signed by Altamirano, was designed by Valentín and can be compared to the sets which were hallmarked *HA* (Pl. IV-92). Altamirano was given permission by Valentín to continue producing the jewelry under his own hallmark.[30] Because of his reputation as a fine silversmith, Altamirano also worked for Héctor Aguilar at the Taller Borda and later for Ana Brilanti at the Taller Victoria.

MANUEL ALTAMIRANO

All the pieces in this ensemble have presence without weight. The shaping of the rounded squares, the overlapping, and the diminution in size contribute to an air of graceful femininity. Valentín adapted these same elements in other jewelry and belt buckle sets. In the buckle in Plate IV-93 marked *Valentín* and the cuff bracelet in Plate IV-94 hallmarked *HA*, Valentín used the oval shape to achieve elegance of proportion and line.

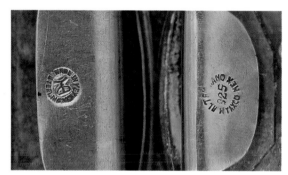

IV-90 *Manuel Altamirano's Hallmark Compared to the Taller Borda's Mark*

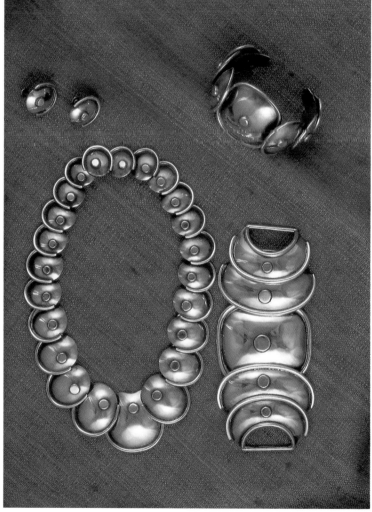

IV-91 *Valentín Vidaurreta's Design Made by Manuel Altamirano for the Armadillo Cuff, Necklace, Earrings, and Buckle* (circle — M. Altamirano, Taxco, Mex around 925) c. 1945-50 925 silver
Collection of Penny C. Morrill

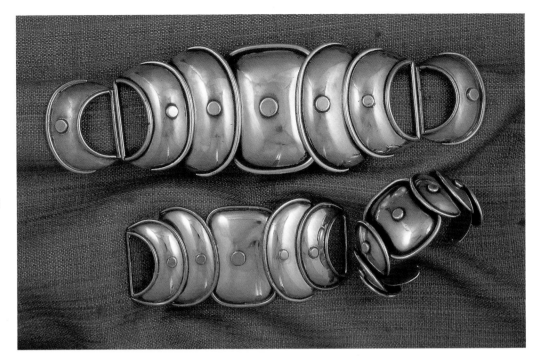

IV-92 Valentín Vidaurreta
*Large Armadillo Buckle
and Cuff* (F) c. 1945 925
silver; *Armadillo Buckle*
(F) c. 1945-50 sterling/
copper
Collections of Gunther
Cohn and Marc Navarro,
and Lolly Commanday;
Private Collection

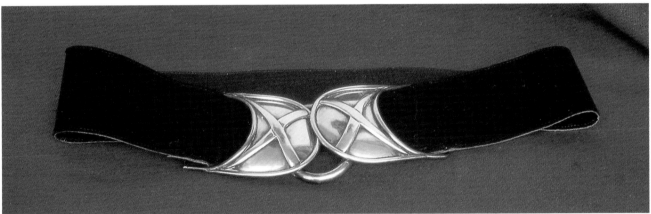

IV-93 Valentín Vidaurreta *Oval Belt Buckle* (Valentín. eagle) c. 1950 925
silver
Collection of the Cartwright Family

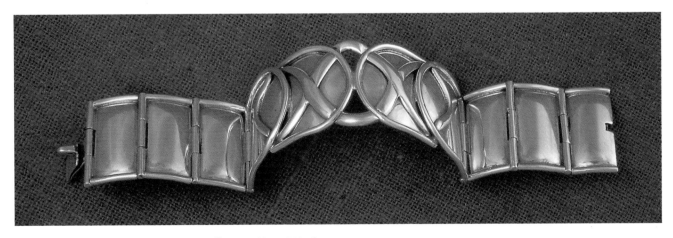

IV-94 Héctor Aguilar *Oval, Criss-cross Cuff* (J) c. 1955 940 silver
Collection of Gunther Cohn and Marc Navarro

CONQUISTADOR

Conquistador was the largest silver factory in Mexico in 1943, the year the company was purchased by Axel Leonard Wenner-Gren. This Swedish industrialist seemed poised to capture the silver market in Mexico. Besides Conquistador, he acquired Plata Sol, Gremio de Orfebres Mexicanos, Talleres Unidos, and Laminadora Platería, all silver factories in Mexico City. Another related acquisition was a monthly magazine about silver, *Arte y Plata*, directed towards the Mexican elite.[31]

Wenner-Gren's rise in power and wealth began in 1921 when he formed the company Electrolux, producer of vacuum cleaners. He followed this success with others – he manufactured refrigerators, purchased the largest wood pulp company in Sweden, and in 1935, bought a one-third interest in Bofors Munitions Works from the German company Krupps and later became the principal shareholder. As a philanthropist, Wenner-Gren gave more than generously. He and his wife established several foundations which focused on scientific and archeological research.[32]

Wenner-Gren and his wife were invited to Mexico in the early forties at the behest of Maximino Avila Camacho, brother of the President Manuel Avila Camacho. Wenner-Gren initiated plans for a multi-million dollar investment in a new company which was to be managed by Maximino Camacho. These plans changed dramatically when, in January 1942, Wenner-Gren was placed on the American Blacklist for his questionable

Left and below:
IV-95 *Hallmarks for Conquistador*

IV-96 *Hallmarks on the Pieces that Were Made at Conquistador for Héctor Aguilar Include an Eagle 31.*

business connections to Germany. Wenner-Gren had advocated appeasement of the Germans to the point where the United States became suspicious of his motives, particularly in the manufacture and sale of munitions. His assets were frozen in the United States and Great Britain, so that in order to keep active management of some of his funds, Wenner-Gren accepted a proposal from the Mexican government to invest in Mexican businesses. Among his many acquisitions, Wenner-Gren bought a cement factory, six haciendas, a dairy industry, a stockfarm, and several silver factories.[33]

Horacio de la Parra was a good friend of William Spratling and Héctor Aguilar. He and a Sr. Galván were managers of Conquistador in 1950 and may have been the original owners who were bought out by Wenner-Gren. Spratling signed a contract with Conquistador in 1949 to provide designs that were to be manufactured and sold by the company. After one year, Spratling broke the contract because he felt his designs were not being produced or marketed as he had stipulated.[34]

Spratling was not the first silver designer to develop new ideas in order to bring prestige to a silver factory owned by Wenner-Gren. In 1946-1947, the magazine *Arte y Plata* carried several full-page advertisements and a lengthy article on the artist Lorenzo Rafael, who was designing for Gremio de Orfebres Mexicanos (Pl. IV-104).[35]

IV-97 *Horacio de la Parra's Hallmark*

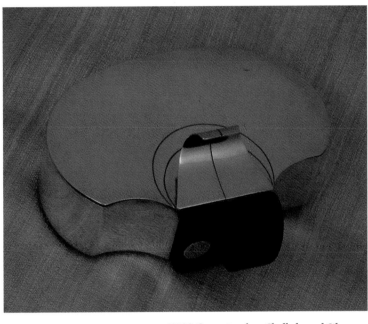

IV-98 Conquistador *Shell-shaped Silent Butler* (Conquistador. shield. Sterling, Mexico. 925/1000. eagle13)
c. 1950-55 925 silver/wooden handle
Collection of Carole A. Berk, Ltd.

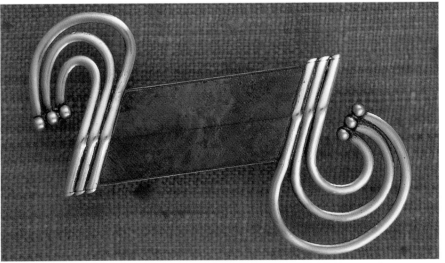

Left:
IV-99 Conquistador *Large Rectangular Malachite Pin* (Sterling, Mexico around Conquistador shield. eagle13)
c. 1950 925 silver/malachite
Collection of J. Crawford

201

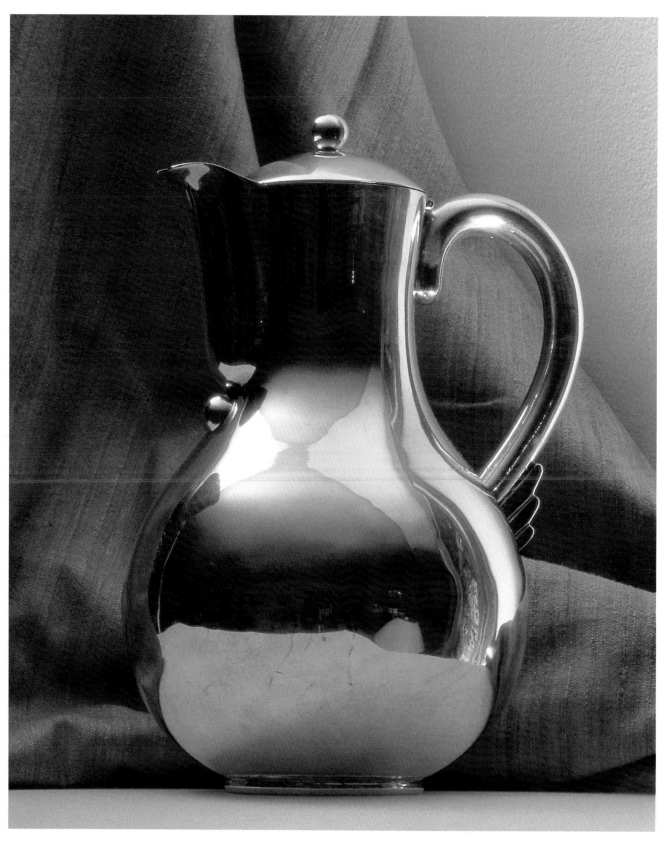

IV-100 Conquistador *Héctor Aguilar Pitcher* (eagle13. Conquistador. shield. Sterling, Mexico. 925/1000) c. 1955-60 925 silver
Collection of Anni and Ed Forcum of Rosebud Gallery

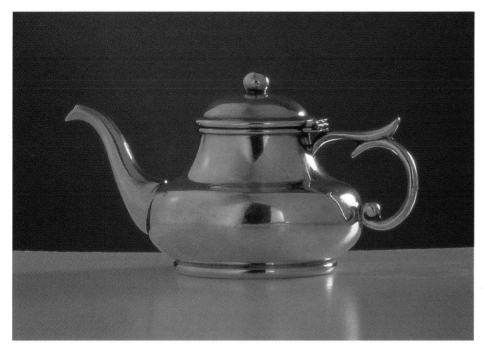

IV-101 Héctor Aguilar *Tiny Teapot* (J. Sterling. Hecho en Mexico. 925. eagle. signature – Felrith?) c. 1950-55 925 silver
Collection of Gunther Cohn and Marc Navarro

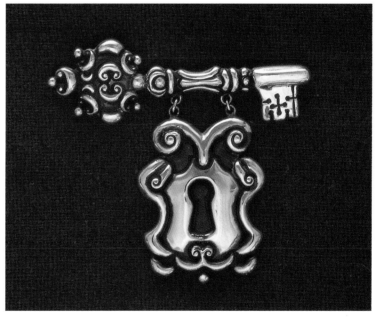

IV-103 Horacio de la Parra *Lock and Key Brooch* (Sterling. Parra. Mexico) c. 1945 925 silver
Collection of Christine Till

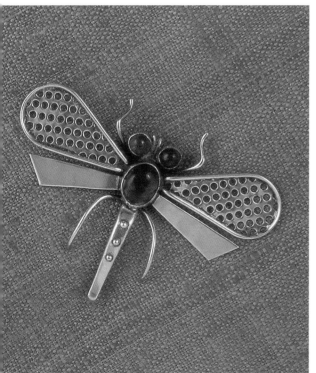

IV-102 Horacio de la Parra *Industrial Dragonfly* (Silver. Parra. Mexico) c. 1945-50 silver
Private Collection

Around 1949, Horacio de la Parra approached his good friend Héctor Aguilar to ask if he would carry silver holloware manufactured by Conquistador. According to Luis Reyes, who managed the Taller Borda shop, the holloware was in the popular style and carried the Conquistador hallmark, consisting of a shield with the figure of a Spanish conqueror astride a horse. Héctor Aguilar's business dealings with the company lasted several years, but the marks on some of the holloware suggest that the relationship may have been more collaborative.

Rob Cartwright recalls visiting Horacio de la Parra's workshop in Mexico City numerous times. According to Cartwright, Horacio had machines that the Taller Borda did not have, leading to Héctor's decision to have the holloware produced at Conquistador according to his specifications. Moises de la Peña, author of a book on Guerrero's economy in the late 1940s, received much of his information about the silver business in Taxco from Héctor Aguilar. According to de la Peña, "Taxco is principally a production center for silver jewelry; the silver holloware,

like pitchers, trays, glasses, spoons, etc., is not made because this work requires machinery for chasing, stamping, or die-cutting. Almost all of the pieces of this type that are sold in Taxco are produced in Mexico City."[36]

There are several tea sets and pitchers which carry the Taller Borda hallmark and a circular mark consisting of the words *Hecho en México* around the number *0.925* (Pls. III-97, 106, 117, 119). This circular mark resembles the one stamped on Spratling-designed silver made by Conquistador. Several of these pieces of Taller Borda holloware were also given inventory numbers. It was not a practice at the Taller Borda to stamp inventory numbers on the backs of silver jewelry and holloware. There seems little doubt, then, that the holloware with the circular mark and the inventory number was manufactured by Conquistador, although this relationship was short-lived, lasting perhaps six years. Rob Cartwright confirms that his father and Spratling had experienced similar problems with Conquistador.[37] The existence of a pitcher designed by Héctor

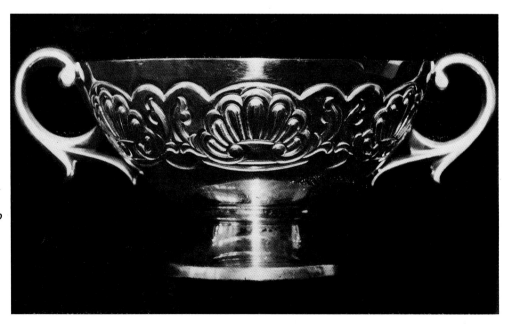

IV-104 *This Double-Handled Bowl Appeared in a Lengthy Article Highlighting the Work of the Well-Known Silver Designer, Lorenzo Rafael.* (October 1946 *Arte y Plata* p. 24) Photograph Courtesy of the Library of Congress

Aguilar without his hallmark (Pl. IV-100) indicates the source of those disagreements. Both Spratling and Aguilar had lost control of the production of their designs.

In *Artesanía de la Plata*, Héctor wrote that in the early years, the Taller Borda was one of only three workshops in Taxco where holloware was handwrought. After 1942, his silver holloware designs were being produced at the Borda by machine and finished by hand.[38] Considering the number of pieces with dual hallmarks and inventory numbers, what can be assumed is that much of the holloware signed by Héctor Aguilar and in existence today was produced in the fifties by Conquistador. Those pieces which show the marks of the hammer were made in the few years (1939-42) before the arrival of the machine. After 1942 and until the Taller Borda closed in 1962, silver pitchers, ashtrays, and other holloware were handwrought or formed by machine and finished by hand in the workshop, but never at a high level of production.

IV-105 *Advertisement for Conquistador* June 1945 *Arte y Plata* p. 22. Photograph Courtesy of the Library of Congress

When Pedro Pérez opened his store the Rancho Alegre on July 1, 1956, the era of the large workshop in Taxco was coming to an end.[39] The gifted silversmiths, like Pedro Castillo and Luis Flores, who had worked for Héctor Aguilar or William Spratling, had started their own small independent workshops. The Rancho Alegre, located on the highway near the hotel, the Posada de la Misión, and accessible to bus tours coming on one-day excursions from Mexico City, became the largest and most popular silver shop in Taxco.

Pedro Pérez had been with the Taller de las Delicias for seventeen years as shop manager. He had also worked as a salesman for Carlos Acosta at his store, the California, before starting his own business.[40] With the establishment of the Rancho Alegre, Pérez created a setting which might be considered a

bridge from the talleres like Las Delicias to the era of the small independent workshop. Downstairs below the store he had a large room with tables. The silversmiths had their own work surfaces and tools; and whatever they produced was purchased for the Rancho Alegre. On Saturday Pérez received the merchandise and bought selections for the week. The pieces were given the hallmark, *Rancho Alegre* and an eagle stamp.

Miguel García, a cousin of Pedro Pérez's wife, liked to design and draw. At the Rancho Alegre, he had three or four silversmiths, including Melecio Rodriguez, who produced his designs. He was the only designer for the workshop and was not a silversmith. The jewelry based on his designs was marked *Rancho Alegre*, with either the initials *MGM* for Miguel García Martinez or *Miguel* written out in script.

IV-106 *Miguel García Martinez's Hallmark*

IV-107 Miguel García Martinez *Large Cutout Cuff* (Rancho Alegre. Sterling 925. Taxco. Miguel. 1969) c. 1969
925 silver
Collection of Gunther Cohn and Marc Navarro

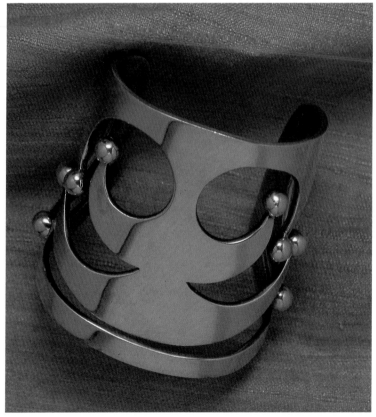

Miguel García's ideas were made into silver, many with the addition of turquoise or abalone. His jewelry has a strong geometric quality, inspired by Aztec imagery, but interpreted with imagination. The cuff bracelet in Plate IV-107 was fairly simple to produce but carries a dramatic impact. The design gives importance to the negative space formed by the cutout. The beads and the upturned tips of the pattern have a happy feeling about them, perhaps because they are suggestive of a decorated Christmas tree.

Pedro Pérez also bought the work of independents. Each silversmith had his own line, a group of pieces that he could provide for sale in a style that was identifiable as his alone. Pedro Castillo made flatware for Rancho Alegre for many years in a number of different patterns. The holloware that was sold in the store came from Mexico City, mostly from Guillermo Nava, with the stamp of the producer.

In 1980 it was recognized that there was a need for change in the way silver was hallmarked. A North American had come down to Taxco and was buying silver but not producing jewelry. Instead, the silver was being sold in the United States at a profit. The Mexican government instituted a system of hallmarking in order to control the sale of silver out of Mexico. All silversmiths had to be registered so that the amount of silver purchased could be measured against the weight of the jewelry or holloware produced.[41]

Today a silversmith cannot buy silver at the bank unless he has registered. His hallmark consists of a series of letters and num-

IV-108 Los Castillo *Buttons* (Los Castillo, Taxco. Made in Mexico. Sterling. 494, 104, 445, 376) c. 1940-45 925 silver
Collection of Gunther Cohn and Marc Navarro

bers. An example might be TC-45, Antonio Castillo's mark. The first letter refers to the name of the town where the silversmith has registered which is Taxco and the second, is the initial for his name, Castillo. The number indicates where he appears on the list under his initial. He was the forty-fifth person to register under the letter C.

The Rancho Alegre was a successful business for twenty-seven years, from 1958 to 1985. There were several factors that played into Pedro Pérez's decision to sell the store. Tourism had dropped considerably and those who came bought less. Simultaneously, there were more and more shops along the highway, which resulted in greater competition for fewer customers. The store owners also became captive to a form of blackmail perpetrated by the tour guides. Whichever shop gave the biggest commission had tour buses pulling up in front.

What ultimately had the most devastating effect was the growth in the number of *mayoristas*, or wholesalers, both Mexican and North American. The wholesaler who bought directly from the independent silversmiths had no overhead and no loyalties and paid fewer taxes. Their numbers grew until there were more *mayoristas* than there were shops in Taxco. Stores opened which were

IV-109 William Spratling *Buttons* (WS, Taxco, 980. oval Spratling Silver, circle – Spratling, Made in Mexico around WS. circle – William Spratling, Taxco, Mexico around script WS, eagle63) 1935-55 925-980 silver
Collection of Gunther Cohn and Marc Navarro

wholesale/retail but the owners were selling at wholesale prices, undercutting the retail businesses.[42] The technical quality of the jewelry and the emphasis on imaginative design became less and less relevant as *mayoristas* pushed silversmiths in tiny workshops to produce in larger quantity more quickly and at lower cost.

Storeowners like Pedro Pérez were overrun with costs, including salaries, taxes, and social security. When Rancho Alegre was at its height, there were thirty-five silver-smiths at work. Gradually the numbers dwindled until there were only thirteen artisans in the workshop, most of whom had been there since the beginning. In 1985, Pedro Pérez made the decision to sell the store and brought to an end another era in Taxco's silver history.

[1] Tarte, Letter, Mar. 7, 1995.
[2] Nieves Orozco recalls, "[Héctor] loved to play chess and loved to make beautiful chess sets" (Schwartz, interview of Orozco).
[3] Tarte, Letter, Mar. 20, 1995.
[4] José Asención; Alvarado; Rob Cartwright, interviews.
[5] Tarte, Letter, Mar. 20, 1995.
[6] Tarte, Letter, Mar. 7, 1995.
[7] All information about Pedro Castillo was taken from an interview of this silversmith by Penny C. Morrill.
[8] One of the crowns and scepters designed by Pedro Castillo can be seen at Antonio Gallegos's shop, the Rancho Grande.
[9] Miss Anderson had hired a group of seamstresses to produce a line of clothing with native embroidery which proved very successful (Anderson and Kelly, 240-41).
[10] María Castillo de los Angeles G., interview by Penny C. Morrill.
[11] Morrill and Berk, 200, 202, XX-1.
[12] Morrill and Berk, 202, XX-3.
[13] Stromberg, 52.
[14] Morrill and Berk, 82-4.
[15] Stromberg, 51.
[16] Morrill and Berk, 86.
[17] Stromberg, 49.
[18] Ruiz Ocampo, interview.
[19] Ruiz Ocampo, interview, Javier Ruiz Ocampo, "Rafael 'El Chino' Ruiz."
[20] Stromberg, 56-7.
[21] Morrill and Berk, 140-49. The author has seen a pin marked *AP* with a carved onyx mask in a simple architectural silver setting. This pin and the necklace in Pl. IV-54 strongly resemble Fred Davis's well-known black onyx mask necklaces, linking Antonio stylistically to Davis

IV-110 Hubert Harmon *Foot Buttons* (hieroglyph. Hubertus. Taxco, Mexico) c. 1940; Martinez *Square Buttons* (Sterling. Taxco. Martinez) c. 1945-50; *Horse head Buttons* (Sterling) c. 1945-50 Collection of Gunther Cohn and Marc Navarro

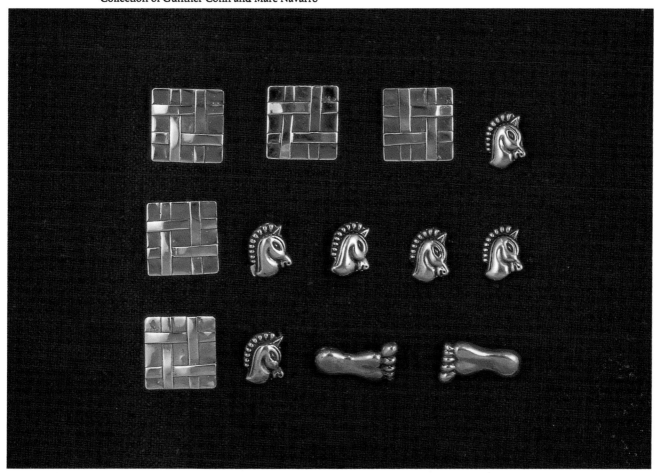

IV-111 Antonio Pineda *Fox head Buttons* (Antonio crown. eagle17) c. 1955
925 silver
Collection of Gunther Cohn and Marc Navarro

IV-112 Antonio Pineda *Large Floral Button* (AP. Silver
Mexico. ZP1) c. 1945 silver
Collection of Gunther Cohn and Marc Navarro

210

through Valentín Vidaurreta. The supposition then can be made that Valentín was the original producer and possibly designer of the black onyx mask jewelry. The existence of these early pieces by Antonio Pineda also raises the possiblity that the black onyx mask jewelry marked *FD* was actually produced during the time Pineda was in Mexico City, thus after Davis joined Sanborn's.

[22] Morrill and Berk, 156-7. Dámaso Gallegos was born in Ixcateopan on December 11, 1895.

[23] Morrill and Berk, 41.

[24] Gallegos, interview.

[25] The information about the Platería Melendez was taken from interviews of Rafael's son Rafael Melendez Sevilla by Penny C. Morrill and Jaime Quiroz Duque.

[26] After Adán Alvarado left the taller, he went to work for Margot doing special pieces, particularly in *repoussé* (Alvarado, interview).

[27] *Natalie Scott Papers*, Jennison to Scott, Dec. 31, 1943.

[28] Morrill and Berk, 182-5.

[29] Rob Cartwright; Carbajal, interviews.

[30] Reyes, interview.

[31] Ross, 17-8. The magazine seems to have been rather self-serving. There were frequent advertisements for a large dairy company, for Electrolux, and for several silver companies, all of which were owned by Wenner-Gren. In 1945, the ads for Conquistador were illustrated with quite ordinary silver holloware and jewelry (Pl. IV. 105).

[32] Maxine Block, ed. *Current Biography*, 883-4.

[33] Ross, 15-8.

[34] Morrill and Berk, 71-2. The address for Conquistador given in a 1948 business directory was Guillermo Prieto No. 77, the same address Spratling gave when he registered his hallmark in 1950. Horacio de la Parra's address was given as Calle de Gabino Barreda, No. 118 in Mexico City and he was listed as having four workers in his taller. Wenner-Gren lived at Paseo de la Reforma 107 (*Primer Directorio Industrial*, 921; *Registers of Marks and Commercial Names in Mexico*, May 27, 1950; *William Spratling Papers*, letter from Wenner-Gren to Spratling, Dec. 1, 1950; Ross, 20-1).

[35] *Arte y Plata*, Dec. 1946, 4; Jan. 1947, 22-4. Although Spratling was originally approached by Wenner-Gren, all of his correspondence was with Galván and de la Parra (Spratling, *File on Spratling*, 124-5; *William Spratling Papers*, letter from Spratling to Sres. Galván and de la Parra, Dec. 17, 1950).

[36] Rob Cartwright, interview. de la Peña, 431.

[37] Rob Cartwright, interview.

[38] Aguilar Ricketson, 105, 108-10.

[39] Most of the information about Rancho Alegre is from an interview of Pedro Pérez's widow, Doña Eva Carbajal de Pérez (Eva Carbajal de Pérez, interview by Penny C. Morrill).

[40] José Asención, interview.

[41] Morrill and Berk, xi; Stromberg, 79.

[42] An exceptional study, Gobi Stromberg's *El Juego del Coyote*, describes the silver industry and its demise, brought on by the *mayoristas* or *coyotes* as they are known. Eva Carbajal Pérez, interview.

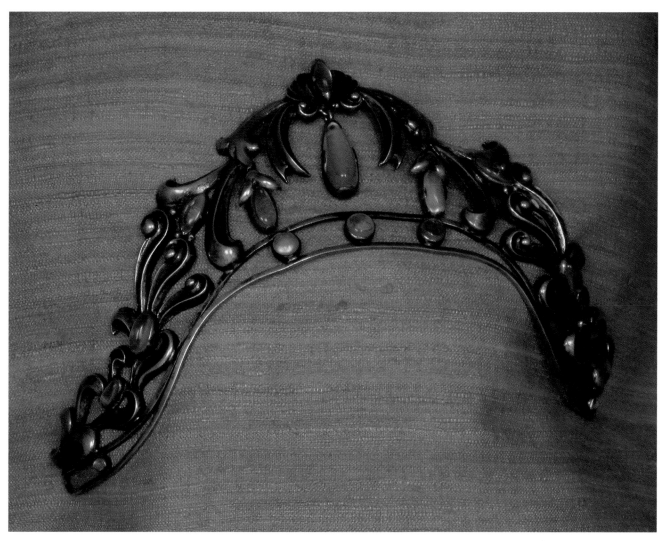

IV-113 Antonio Pineda *Crown for the Silver Queen* (Silver. Antonio crown) c. 1955-60 silver repoussé/moonstones
Collection of Gunther Cohn and Marc Navarro

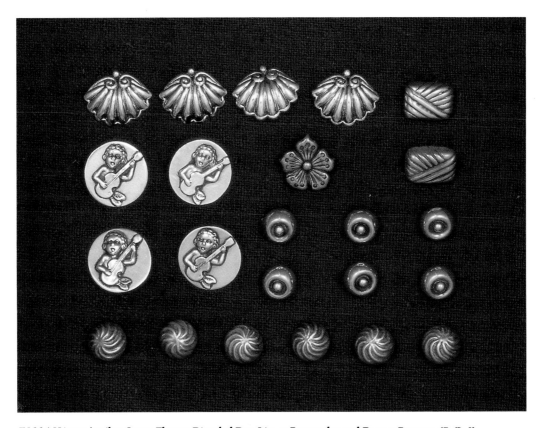

IV-114 Héctor Aguilar *Large Flower, Dimpled Dot, Linear Rectangles and Domes.Buttons* (B, D, I) c. 1940-55 925-940 silver; Margot Van Voorhies Carr *Shell and Musical Angel Buttons* (Margot de Taxco. circle — Sterling, Made in Mexico around eagle16. angel — 5168, shell — 5149) c. 1955 925 silver
Collection of Gunther Cohn and Marc Navarro

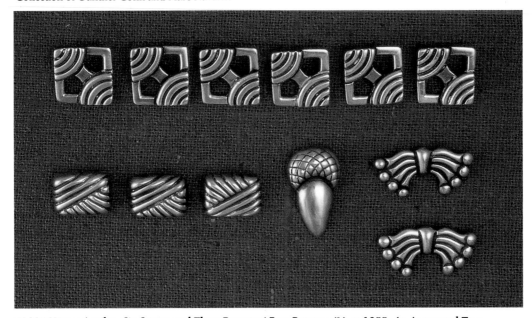

IV-115 Héctor Aguilar *Six Square and Three Repoussé Bars Buttons* (L) c. 1955; *An Acorn and Two Bows Buttons* (B) c. 1940 940 silver
Collection of Gunther Cohn and Marc Navarro

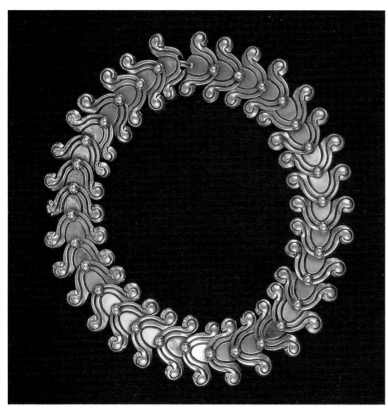

IV-116 Héctor Aguilar *Curled U-shaped Necklace* (A)
c. 1940 980 silver
Private Collection

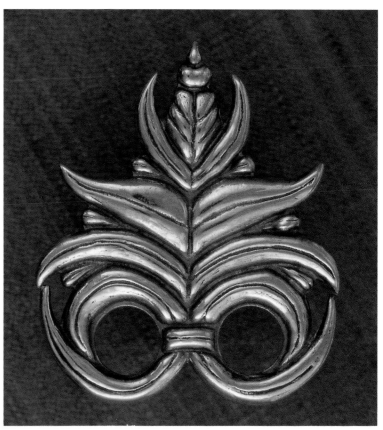

IV-117 Héctor Aguilar *Large Pyramidal Pine Branch Pin*
(C) c. 1945 silver
Collection of Gunther Cohn and Marc Navarro

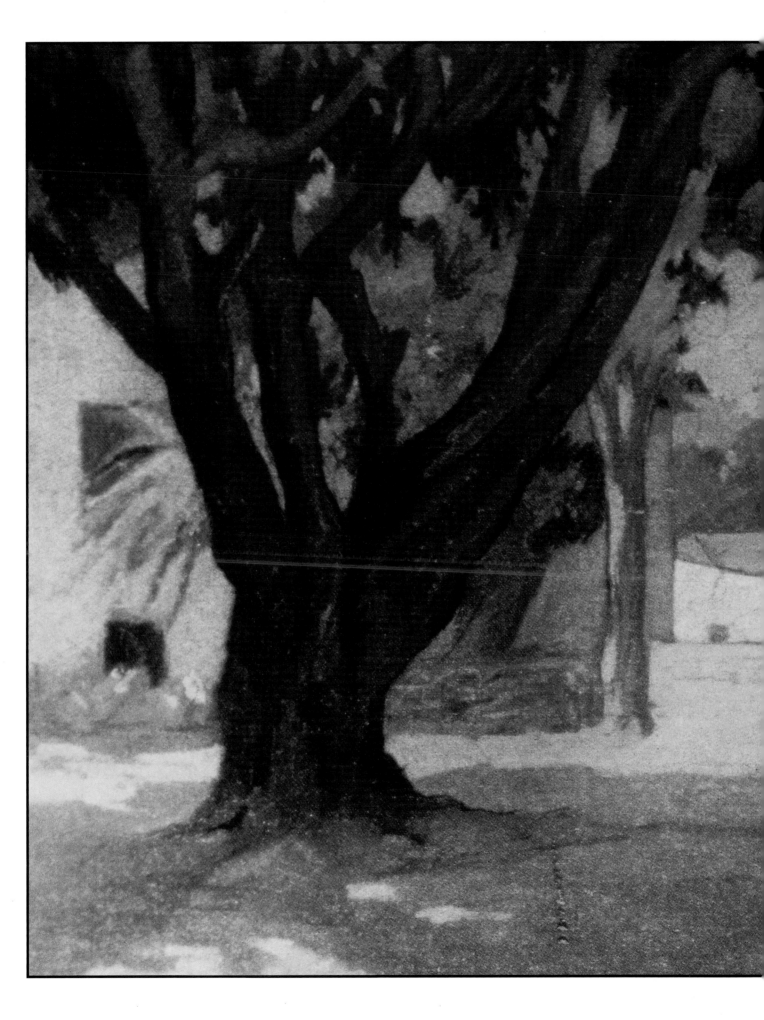

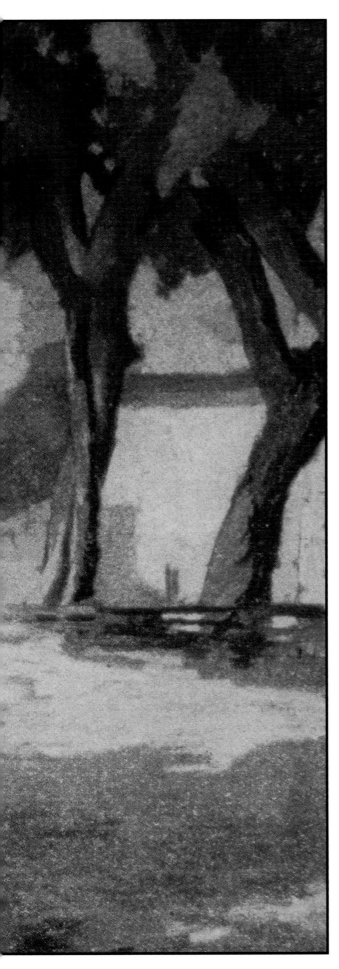

APPENDIX

Valentin Vidaurreta *Laurel
Trees* May 1934 cover of
Mexican Life
Courtesy of the Columbus
Memorial Library

List of Artisans at the Taller Borda

Héctor Aguilar *S-curve Three-bead Earrings* (I) c. 1950 940 silver
Private Collection

Valentín Vidaurreta *Money Clip* (B) c. 1940 940 silver
Collection of Carole A. Berk, Ltd.

MAESTROS

SILVER
Julio Carbajal López
Pedro Castillo
Dámaso Gallegos
Simeon Montero
Jesus Pérez

COPPER
Fuljencio Castillo Hernandez
Delfino Hernandez

CARPENTRY
Roberto Cuevas Bárcenas
Genaro Juarez

IRONWORKS
Daniel Embriz
Gabriel Embriz

DESIGNERS

Hector Aguilar
Gabriel Flores
Valentín Vidaurreta

SILVERSMITHS

Manuel Altamirano
Adán Alvarado
José Asención Monroy Duarte
Julio Carbajal López
Carlos Castillo
Eduardo Castillo
Ignacio Castillo
Juan Castillo
Pedro Castillo Gallegos
Reveriano Castillo
Felipe Cuevas Martinez
Alberto Díaz
Leopoldo Espinoza
Gabriel (Chato) Flores
Mario Flores
Manuel Galindo
Pancho Galindo
Dámaso Gallegos
Salvador García

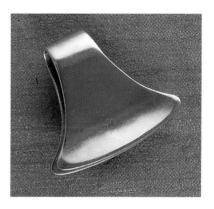

Héctor Aguilar *Money Clip* (L) c. 1955
sterling
Collection of Gunther Cohn and Marc Navarro

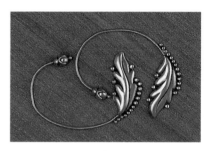

Héctor Aguilar *Over-the-ear Earrings* (I) c. 1950 925 silver
Collection of Gunther Cohn and Marc Navarro

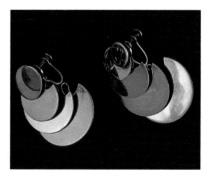

Héctor Aguilar *Circle Earrings* (O) c. 1955 940 silver
Collection of Leah Gordon

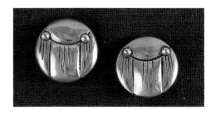

Héctor Aguilar *Abstract Animal Round Earrings* (I) c. 1950 940 silver
Collection of J. Crawford

Alfonso Gómez
Hector Gómez
Martín Gonzalez
Manuel Gutierrez Morales
Agustín Jacobo Rodriguez
Ermilo Jaimez Díaz
Bardomiano López Salgado
Bertoldo López García
Memo López
Saul López
Tomás Marín
Rey Martinez
Andrés Melbi
José Pérez
Rafael Ruiz Saucedo
José Sagal Gomez
Eduardo Vizzuett Nova
Cliserio Zaragoza

HOLLOWARE

Raúl Contreras
Alberto Díaz Ocampo
José Diaz - from Mexico City
Enrique Ledesma
Jesús (Chucho) Pérez

CARPENTRY

Roberto Cuevas Bárcenas
Luis Flores de Castro
Genaro Juarez
José Mesa
Carpoforo Rodarte

COPPERWORKS

Fuljencio Castillo Hernandez
Delfino Hernandez
Rafael "El Chino" Ruiz Saucedo

FOUNDRY

Rafael Loza
Porfirio Peña
José Portillo
Cliserio Zaragoza

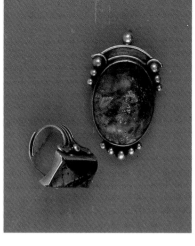

Héctor Aguilar *Rectangular Ring and Malachite Pendant* (D) c. 1945 940 silver/malachite
Collection of Gunther Cohn and Marc Navarro; Private Collection

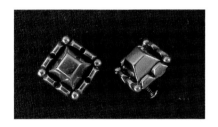

Héctor Aguilar *Square Pyramid Earrings* (I) c. 1945-50 940 silver
Collection of Leah Gordon

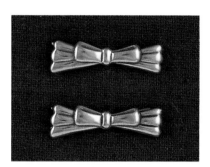

Héctor Aguilar *Pair of Bow Barrettes* (B) c. 1940 940 silver
Private Collection

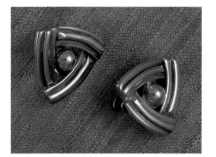

Héctor Aguilar *Triangle and Bead Earrings* (I) c. 1950 940 silver
Collection of Frederick and Stella Krieger

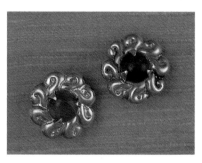

Héctor Aguilar *Amethyst Flower Earrings* (F) c. 1945-50 925 silver/amethyst quartz
Collection of Penny C. Morrill

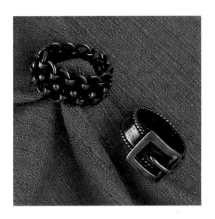

Héctor Aguilar *Belt Ring* (B) c. 1940
940 silver; Valentín Vidaurreta *Chain
Ring* c. 1950 silver
Collection of Penny C. Morrill

Héctor Aguilar *Wood and Silver Ear
Clips* (J) c. 1955 940 silver
Collection of Eric Salter

MECHANIZED PRODUCTION

Ignacio Castillo — Contratista
Pepino Castrejón
José Luis Flores — Contratista
Salvador García
Manuel Gutierrez

LEATHERWORKS

Severo Estrada

IRONWORKS

Daniel Embriz
Gabriel Embriz

POLISHING AND FINISHING

Efrén Castillo

LAPIDARIES

Daniel Martinez
Saul Martinez

ADMINISTRATION

Martín Ocampo
Benjamín Perez
Benito Reyes
Luis Reyes

CASHIERS

Enrique Arriaga
Adolfo Melbi

WOMEN ASSISTANTS

Teresa
Margarita Jimenez
María Pineda
María Sanchez

Bibliography

Aguilar Ricketson, Héctor. *Artesanía de la Plata.* Sección 6: Tecnología. No. 366. México: Unión Tipografica Editorial Hispano Americana, 1968.

Alvarado, Adán. Interview by Penny C. Morrill. January 1995.

Anderson, Elizabeth, and Gerald Kelly. *Miss Elizabeth: A Memoir.* Boston, Mass.: Little, Brown and Co., 1969.

Asención Monroy Duarte, José. Interview by Penny C. Morrill. January 1995.

Bargalló, Modesto. *La Amalgamación de los Minerales de Plata en Hispanoamerica Colonial.* México, D. F.: Compañia Fundidora de Fierro y Acero de Monterrey, 1969.

_____.*La Minería y la Metalurgía en la América Española Durante La Epoca Colonial.* México: Fondo de Cultura Económica, 1955.

Block, Maxine, ed. *Current Biography: Who's News and Why.* 1942. New York: The H. W. Wilson Company, 1942.

Brenner, Anita. *Your Mexican Holiday.* New York: G. P. Putnam's Sons, 1935.

Bustos Guardarama, Jesús. Interview by Javier Ruíz Ocampo with Penny C. Morrill. February 1995.

Carbajal López, Julio. Interviews by Penny C. Morrill. January-February 1995.

Cartwright, Rob. Interviews by Penny C. Morrill. January-August 1995.

Castillo Hernandez, Fuljencio. Interview by Penny C. Morrill. February 1995.

Castillo, María de los Angeles G. Interview by Penny C. Morrill. May 1995.

Castillo Gallegos, Pedro. Interview by Penny C. Morrill. January 1995.

Castrejón Diez, Jaime. "Una Ciudad Minera en sus Orígenes." *Artes de México.* No. 5. (Fall 1989): 26-33.

Castrejón Gómez, Manuel. *Setenta Años en la Industria Embotelladora.* Taxco, 1988.

A Century of Progress International Exposition: Chicago 1933-1934. Prints and Photographs Division of the Library of Congress. Lot 12616: page 24.

Codex Nuttall: A Pictorial Manuscript from Ancient Mexico. Zelia Nuttall, ed. Introduction by Arthur G. Miller. New York: Dover Publications, 1975.

Commire, Anne, ed. *Something About the Author.* Vol. 39. Detroit, Michigan: Gale Research Co., 1985.

Cuevas Bárcenas, Roberto. Interview by Penny C. Morrill. February 1995.

Davis, Mary L., and Greta Pack. *Mexican Jewelry.* Austin: University of Texas, 1963.

Davies, Richard L. Interview by Penny C. Morrill. May 1995.

Day, Michael. "Mexico's City of Silver." *Popular Mechanics.* Vol. 97, No. 6, June 1952. (Chicago, Ill: Popular Mechanics Co., 1952): 120-24.

Delpar, Helen, ed. *Encyclopedia of Latin America.* New York: McGraw-Hill Co., 1974.

_____. *The Enormous Vogue of Things Mexican: Cultural Relations between the United States and Mexico: 1920-35.* Tuscaloosa and London: The University of Alabama Press, 1992.

Directorio General de Socios de las Cámaras Nacionales del Comercio. México, D. F.: Confederación de Cámaras Nacionales de Comercio, 1943.

Fergusson, Erna. *Fiesta in Mexico.* Illustrations by Valentín Vidaurreta. New York: Alfred A. Knopf, 1934.

_____. *Mexican Cookbook.* Illustrations by Valentín Vidaurreta. Santa Fe, New Mexico: The Rydal Press, 1934.

Figueroa, Leslie C. *Stuffed Shirt in Taxco.* Taxco: The Taxco School of Art, October 1961.

_____. *Taxco: The Enchanted City.* México, D. F.: Editorial Fischgrund, 1950; 1965.

Flores, José Luis. Interview by Penny C. Morrill. February 1995.

Foscue, Edwin J. *Taxco: Mexico's Silver City.* Dallas: University Press, Southern Methodist University, 1947.

Gallegos, Antonio. Interviews by Penny C. Morrill. January-May 1995.

Grosvenor, Gilbert. "Insignia of the United States Armed Forces." *National Geographic.* Vol. LXXXIII, No. 6 (June 1943): 651-722.

Héctor Aguilar *Bar Repoussé Bow Pin* (C) c. 1945 925 silver
Collection of Gunther Cohn and Marc Navarro

Héctor Aguilar *Branch Pins with Silver Domes or Onyx Cabochons* (F) c. 1945-50 925 silver/onyx
Collection of J. Crawford

Helm, MacKinley. *Journeying through Mexico.* Boston: Little, Brown, and Company, 1948.

Hernández Serrano, Federico. "La Minería." *Artes de México.* No. 10 (December 1955): 39-42.

Hotel Taxqueño Guest Registers. 1931-38. Private Collection.

International Geneological Index. The Church of Jesus Christ of Latter-day Saints. 1993.

Ireno, Gloria. Interview by Penny C. Morrill. May 1995.

José, Irene Phillips Olmedo de. Interview by Penny C. Morrill. May 1995.

Lugo, Amador. Interview by Penny C. Morrill. February 1995.

MacGregor, Luis. *Tasco.* Colección Anahuac de Arte Mexicano: Ciudades. México, D.F.: Ediciones de Arte, S. A., 1949.

Martha Robinson Papers, Tulane University Special Collections. New Orleans, Louisiana.

Mejía, Andrés. Interviews by Penny C. Morrill. January-May 1995.

Melendez Sevilla, Rafael. Interview by Jaime Quiroz Duque. February 1995. Interview by Penny C. Morrill. May 1995.

Mexican Life. Howard S. Philips, editor. 1928-50.

Mexico: Splendor of Thirty Centuries. Introduction by Octavio Paz. Metropolitan Museum of Art exhibition catalogue. New York: The Metropolitan Museum of Art and Bulfinch Press, 1990.

"Mexico's Wonderful Metals." *Mexico This Month.* (June 1969): 22-26.

Modern Mexican Artists. Introduction by Frances Toor. Critical Notes by Carlos Mérida. Mexico City: Frances Toor Studios, 1937.

Montgomery Ward Catalogue. University of Wyoming, American Heritage Center Collection. Christmas 1943.

Morrill, Penny C. *Hecho en México.* Washington, D. C.: Colortone Press, 1990.

Morrill, Penny C., and Carole A. Berk. *Mexican Silver: 20th Century Handwrought Silver and Metalwork.* Atglen, Pennsylvania: Schiffer Publishing, Ltd., 1994.

Motten, Clement G. *Mexican Silver and the Enlightenment.* The American Historical Association. Philadelphia: University of Pennsylvania Press, 1950.

Natalie Scott Papers. Tulane University Special Collections. New Orleans, Louisiana.

Olmedo Patiño, Dolores. Interview by Penny C. Morrill. May 1995.

Pappe, Carl. Interviews by Penny C. Morrill. February, August 1995.

Peña, Moises T. de la. *Guerrero Económico.* Tomo II. México:

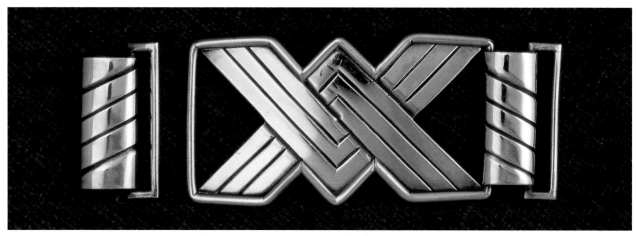

Héctor Aguilar *Double-X Rectangular Buckle* (N) c. 1955 940 silver
Collection of Penny C. Morrill

Gobierno del Estado de Guerrero, 1949.

Phillips, Henry Albert. *New Designs for Old Mexico*. New York: National Travel Club, 1939.

Pineda Gómez, Antonio. Interview by Penny C. Morrill. January 1995.

Pineda, María. Interview by Penny C. Morrill. February 1995.

Primer Directorio Industrial Nacional: 1947-48. La Confederación de Cámaras Industriales de los Estados Unidos Mexicanos. México: D. F.: Publicaciones Rolland, S. de R. L., 1948.

Read, David. Interview by Penny C. Morrill. July 1995.

Registers of Marks and Commercial Names in Mexico. Secretaría de Comercio y Fomento Industrial. October 1950, December 1950. Photocopies held by Phyllis Goddard.

Reyes, Luis. Interviews by Penny C. Morrill. January-August 1995.

Rivas, Guillermo. "The Art of Valentín Vidaurreta." *Mexican Life*. Vol. 4, No. 11 November 1928 (México, 1928): 25-28.

_____. "Valentín Vidaurreta." *Mexican Life*. Vol. 11, No. 7 July 1935 (México, 1935): 29-30.

Ross, Stanley. *Axel Wenner-Gren: The Sphinx of Sweden*. News Background Report, No. 7. New York: 1947.

Ruiz Ocampo, Javier. Interviews by Penny C. Morrill. January-May 1995

_____. "Rafael 'El Chino' Ruiz: Notable Orfebre de Taxco." *Revista Raices Surianas*. Organo Informativo de la Asociación Guerrerense de Profesionistas. No. 5, 1991.

Schlubach Carr, Henrik. Letters to Penny C. Morrill. May 6 and May 20, 1995.

Schwartz, Edwin J. Personal interviews of Nieves Orozco. 1994.

Shipway, Verna Cook and Warren. *Decorative Design in Mexican Homes*. Stamford, Connecticut: Architectural Book Publishing Co., Inc., 1966.

_____. *Mexican Homes of Today*. Stamford, Connecticut: Architectural Book Publishing Co., Inc., 1964.

_____. *Mexican Interiors*. Stamford, Connecticut: Architectural Book Publishing Co., Inc., 1962.

_____. *The Mexican House Old and New*. New York: Architectural Book Publishing Co., Inc., 1960.

Sonneschmid, Don Federico. *Tratado de la Amalgamación de Nueva España*. Sacado a luz por DJMF. Mégico: Librería de Bossange (Padre), Antoran y Co., 1825.

Spratling, William P. *File on Spratling: An Autobiography*. Boston: Little Brown and Co., 1967.

_____. "Modern Mexican Silversmithing." *Mexican Art and Life*. No.3, July 1937.

_____. "The Silver City of the Clouds: Taxco, A Forgotten Gem of Colonial Spain." *Travel*. Vol. 53, No. 3 (New York: Robert M. McBride and Co., Publishers, July 1929): 22-23.

Stromberg, Gobi. *El Juego del Coyote: Platería y Arte en Taxco*. México: Fondo de Cultura Economica, 1985.

Tarte, Robert D. Interviews by Penny C. Morrill. January-May 1995.

_____. Letters to Penny C. Morrill. February 9, 1995; March 7, 1995; April 18, 1995; December 18, 1995.

Tissot, Mrs. Felix. Interview by Penny C. Morrill. February 1995.

Toor, Frances. *Guide to Mexico*. New York: Robert McBride and Co., 1940, 1946.

_____. *New Guide to Mexico*. New York: Crown Publishers, 1957.

Toussaint, Manuel. *Oaxaca y Tasco*. Lecturas Mexicanas. Secretaría de Educación Publica. México, 1985.

_____. *Tasco*. Illustrated by William P. Spratling. México: Editorial "Cultura," Publicaciones de la Secretaría de Hacienda, 1931.

Vaccaro, Michael A. "Tony." Interview by Penny C. Morrill. December 1995.

Variety Obituaries. Vol. 9: 1980-83; Vol. 10: 1984-86. New York and London: Garland Publishing, Inc., 1988.

Weil, Thomas E., et al. *Area Handbook for Mexico*. 2nd ed. Washington, D. C.: U. S. Government Printing Office, 1975.

Who's Who and Buyers' Guide: Compendium of Mexican-American Business of the American Chamber of Commerce of Mexico. México, D. F., 1942.

Wilhelm, John. *Guide to Mexico*. 3rd ed. New York: McGraw-Hill Book Company, 1966.

William Spratling Papers. Private Collection of Sucesores de William Spratling.

Williams, Adriana. *Covarrubias*. Austin: University of Texas Press, 1994.

_____. Letter to Penny C. Morrill. July 26, 1995.

Values Reference

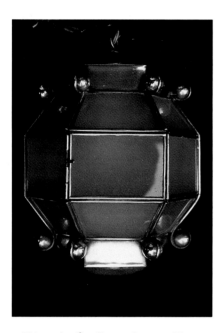

Héctor Aguilar *Copper Lantern* (R) c. 1940-45 copper/glass
Collection of Thomas Guarrera Antiques, New York.

The powerfully designed handwrought jewelry and decorative objects that were produced in the Taller Borda in copper and almost pure silver have proven to be timeless in their appeal. Both Héctor Aguilar and Valentín Vidaurreta found expression for their artistry in beautifully designed objects. Their work was highly desirable when it was produced in the forties and fifties and continues to be sought out and worn or used.

The value given to any of the many pieces that appear in this book is based on an individual emotional response and an aesthetic judgment. What follows are monetary values for certain types of objects, but these values can vary according to the area of the world, to the whim of the seller or buyer, the supply and demand, what the market will bear, and the unique character of the piece.

For all of these pieces, the value could be higher if the object is quite unusual.

Jewelry by Héctor Aguilar can range in value as follows:

A silver bracelet from US$650 to US$1800.
A silver necklace from US$850 to US$2500.
Pins from US$300 to US$1500.
Earrings from US$200 to US$500.
Jewelry sets are more desirable and harder to find intact, so these sets are usually more expensive, perhaps US$1000 to US$3500.

Holloware by Héctor Aguilar can range in value as follows:

A small bowl might cost US$400.
A tea set might cost US$5500.

Flatware in silver or silver and wood holds a great appeal:

Salad sets are US$1500.
A six-piece place setting will cost about US$750.

Copper by Héctor Aguilar is known for its strong character:

The copper and silver jewelry is as costly as pure silver. Candelabra in copper and brass are US$550 to US$1800. Pitchers in copper and brass are US$550 to US$1800. Copper bowls, depending on size, are US$350 to US$1500. The large trays in wood and copper sell for approximately US$1200 to US$2000.

It is best to buy from a reliable dealer whom you trust. Study hallmarks and learn the style of the Taller Borda by looking at as many pieces as you can. Then you are ready to buy what pleases and intrigues you with some confidence.

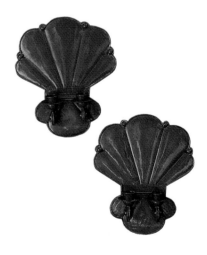

Héctor Aguilar *Copper Sconces* (R) c. 1940-45 copper
Collection of Gunther Cohn and Marc Navarro

Index